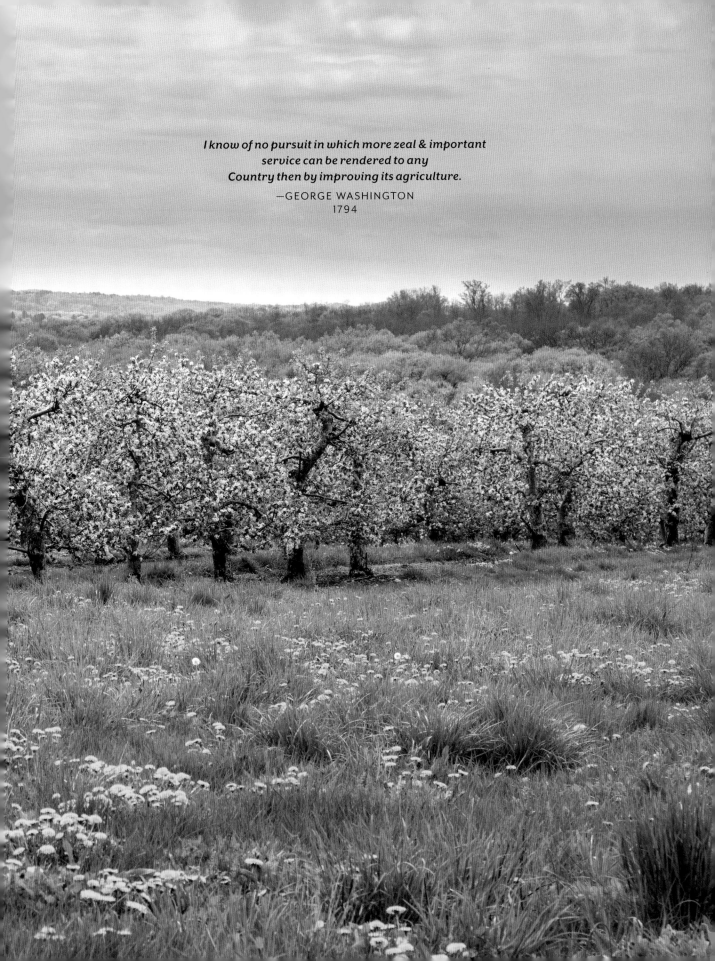

*I know of no pursuit in which more zeal & important
service can be rendered to any
Country then by improving its agriculture.*

—GEORGE WASHINGTON
1794

BACK TO THE LAND

A NEW WAY OF LIFE IN THE COUNTRY

FORAGING, SYRUP TAPPING, BEER BREWING, CANNABIS GROWING,
ORCHARD TENDING, VEGETABLE GARDENING, CHEESEMAKING, BEEKEEPING,
AND ECOLOGICAL FARMING IN THE HUDSON RIVER VALLEY

**WRITTEN AND PHOTOGRAPHED
BY PIETER ESTERSOHN**

RIZZOLI
NEW YORK

New York · Paris · London · Milan

CONTENTS

INTRODUCTION

Driving from farm to farm during the course of writing and photographing *Back to the Land*, I remained inspired by the beauty and history present along the country roads that weave throughout the Hudson River Valley. The images appearing in this introduction will convey the magnificence of this region that has captivated artists, writers, and visitors for centuries. The Hudson River Valley is a region that is defined by food—an arcadia with one of the most diverse foodscapes on the planet.

A new generation has been making its home in this area in the last few years, drawn to pursue goals not available in an urban environment. The farmers that work the land here stand out as resilient individuals who are rooted in self-reliance. The reevaluation that has unfolded for them takes into consideration the distinction between a job and a vocation, a desire to provide a grounded upbringing for their children, and the joy of immediately seeing their efforts contribute to the close communities where they live.

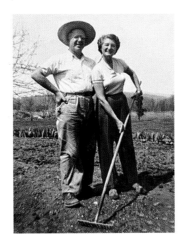

While attending Sarah Lawrence College years ago, I worked for *Interview* magazine, writing about iconic photographers such as Alfred Eisenstaedt and Louise Dahl-Wolfe. The magazine's office was located in Andy Warhol's Factory, then situated on the north end of Union Square. I certainly could not have imagined at the time, that as I walked through the Union Square Greenmarket and peered out the windows that overlooked the market, the seeds for this book were sown.

Following the much earlier lead of Pieter Stuyvesant, who established Manhattan's first farmers market near today's Tompkins Square Park in 1647, Barry Benepe founded the Union Square Greenmarket in 1976 to address the fact that urban dwellers had become distanced from the source of their food. The environment that led up to this was that throughout the mid-twentieth century, conventional large-scale farming had taken over the food chain and was squeezing out independent farmers due to higher short-term profits. At the same time, greenwashing, the practice of disseminating disinformation to present an environmentally responsible public image, was introduced into the discourse. Big Ag's business model became dependent on synthetic fertilizers and pesticides as well as monoculture (the practice of growing only one crop), which had depleted the soil—a practice that still continues today. An unhealthy soil environment without a proper support system leaves the soil vulnerable to drought, winds, and flooding, which all lead to accelerated soil erosion. Soon, due to Benepe's efforts, fresh produce, much from the Hudson River Valley, was available to New Yorkers. New York chefs who had been sourcing fresh local produce from the valley, which has been famous for farming since the seventeenth century, began opening restaurants within proximity to the market. They now could simplify the process of finding the healthiest produce available without having to make the long hauls upstate.

Adjectives on menus and at the farmers markets like "heritage," "heirloom," and "old-fashioned" speak

If I were to name the three most precious resources of life I should say books, friends, and nature; and the greatest of these, at least the most constant and always at hand, is nature

to our collective interest in our agrarian past. The area was first inhabited by the Lenape people, who referred to this region as part of *Lenapehoking*, and were adept farmers who cultivated grains, vegetables, and fruit trees as well as medicinal herbs. There are centuries of documentation covering the bounty offered by this region, starting in 1609 when Henry Hudson sailed the Halve Maen up the present-day Hudson River, on behalf of the Dutch East India Company. He found wild grapes, walnut trees, beans, pumpkins, melons, fish, turkeys, tobacco, corn, and wheat, and wrote his impressions upon witnessing this bounty: "I am therefore of the opinion that scarcely any part of the Americas is better adapted for the settlers of the colonies from our country." Following Hudson's exploration of this verdant valley, the region became populated by the Dutch, but shortly thereafter the English, Germans, Palatines,

French Huguenots, and an enslaved population of Africans joined them.

Starting in 1631, the Dutch initiated a Patroon system in the area with Kiliaen Van Rensselaer, a Dutch diamond merchant, gaining sovereignty over vast amounts of land. Leases were given to tenants to work the land in exchange for ten to twenty bushels of winter wheat, four fat fowl, and a day's labor with a team of horses.

Since the seventeenth century, the name Livingston continues to be associated with the Hudson River Valley. Robert Livingston, the first in a line of dozens by the same name, married Alida Schuyler Van Rensselaer in 1679, creating a path forward for the Livingstons to become the largest landowners in the region, with holdings stretching from the border of the Berkshire Mountains to the west through the Catskills. A feudal manorial system was in place,

PREVIOUS PAGES: Ken Migliorelli haying the back field at Staats Hall, my home in Red Hook. My grandparents, Melville and Julia Humbert, in the 1950s at Briarcliff Farm, their fruit and dairy farm in Yorktown Heights. TOP ROW FROM LEFT: The Potts Farm barn in Tivoli with views of the Catskill Mountains; a quote from early naturalist and celery farmer John Burroughs on a tree at his historic 1895 home, Slabsides, in West Park; interior and exterior views of Slabsides.

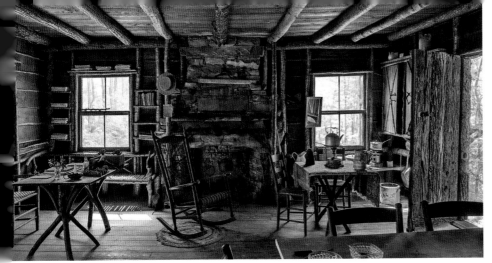

where massive agricultural estates were owned by the lord of the manor with tenants working the land but unable to possess their own property.

Several things occurred during the nineteenth century that changed agriculture in the region. The Erie Canal opened in 1825 making vast tracts of land to the west accessible and connecting New York City to the Great Lakes and the land in between. This brought prosperity to greater New York State but created challenges for the Hudson Valley as the majority of the grain that the valley had supplied to New York was now being grown on cheaper land in the Midwest. Being resourceful, the farmers in this region pivoted by growing apples and opening dairies, as their closer proximity to Manhattan and her ports created an advantage.

Following America's independence, and despite the end of primogeniture, this antiquated feudal sys-tem persisted until 1839 when the Anti-Rent Wars began in earnest. Following the death of Stephen Van Rensselaer III that year, his sons made efforts to pay off his debts by collecting back rents. The farmers revolted when the rent collectors arrived, presenting themselves as the "Calico Indians," dressed in sheep-skin masks with costumes made of their wives' calico dresses. Due to these widespread revolts, laws were initiated granting tenant farmers the right to pur-chase the land they had been farming.

In the 1840s, the railroad started to make its way north, along the east bank of the Hudson River, pro-viding even quicker transport of produce and milk. Due to this, new pockets of wealth started to build along the Hudson.

During this period, Andrew Jackson Downing's nursery in Newburgh became famous worldwide following the publication of his horticultural writ-

BOTTOM ROW FROM LEFT: An elevated nineteenth-century corn crib in Milton; the early barn complex at the 1795 Fulton Homestead in Milan; the Pieter Bronck House in Coxsackie, part of an agricultural complex that began in 1663 with the building of the stone structure seen on the left. It was connected by a hyphen hallway to the brick structure on the right in 1738; silos perched above a pond during peak fall season in Pine Plains.

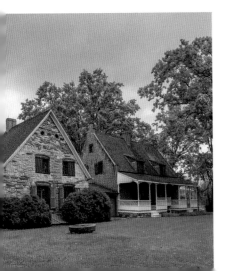
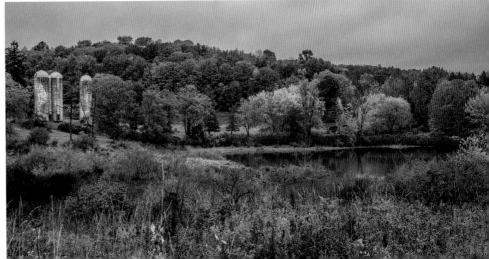

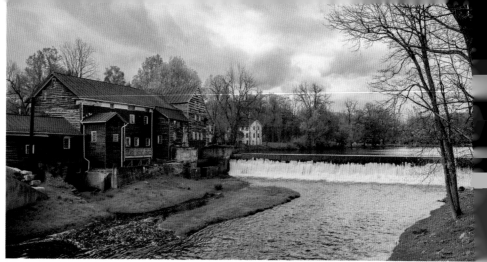

ings, which were considered the leading resource on the subject. Through his work in *The Horticulturist*, his voice became the authority on pomology, the study of fruit trees. He brought the teachings of British landscape designers Lancelot "Capability" Brown, Humphry Repton, and John Claudius Loudon to Americans, adapting their design schemes to suit American climates. Pastoral architecture by Downing, Alexander Jackson Davis, and Calvert Vaux became popular due to the proliferation of these ornamental farms.

At the turn of the nineteenth century, geographer and naturalist Alexander von Humboldt, who later greatly inspired the Hudson River School's most famous painter, Frederic Edwin Church, wrote extensively on the interconnectedness he witnessed in nature. He was a master at observation, which he conducted with a Prussian attention to detail. This same talent echoes throughout these profiles; farm-

ers today are often weaving together all the disparate parts of their farms into one harmonious organism like the one Church depicted in his iconic 1857 painting *Mount Chimborazo at Sunset* in homage to von Humboldt's writings.

Philosopher Rudolf Steiner spoke about fertility in his agricultural lectures delivered in the 1920s. He discussed in depth the inherent potential of biodynamic farming. He documented the specific preparation of the soil based on the dynamic relationships at work in nature that still resonates today. A biodynamic farm is one that is self-sustainable; everything needed to maintain the farm comes from within the confines of the farm itself—a concept that environmentalist Wendell Berry wrote about extensively.

When I considered purchasing a home upstate, I came upon Staats Hall, built by Henry Staats in 1839 on property he had purchased from Robert L. Liv-

TOP ROW FROM LEFT: A weathered mailbox ornament in Ancram; the mill complex on the grounds of the Jacob Rutsen Van Rensselaer property, which is situated on Claverack Creek and was established in the eighteenth century; the veranda of the 1730s stone Evert Terwilliger House, an early farmstead in Gardiner that is now part of the Locust Lawn estate; the William Pitcher farmstead in Red Hook, which dates from 1747 and has been recently restored.

ingston. Henry farmed over 2,000 acres and was the President of the Dutchess County Agricultural Society. In the middle of his farm, he built his Greek Revival house beside two ponds that were used during the season to hydrate the fields. The reason Staats located his home there was that the soil it was built on ranks as some of the best in the state. The land surrounding Staats Hall is still being farmed; I have an agreement with Ken Migliorelli, one of the earliest farmers to sell his produce at the Union Square Greenmarket, to farm the fields and help with bush-hogging and the removal of downed trees. With a nod to early nineteenth-century practices in the region, it is an arrangement that works well for all.

My grandparents, Melville and Julia Humbert, owned Briarcliff Farm in Northern Westchester before selling the property to IBM. Eero Saarinen later designed the IBM Thomas J. Watson Research Center there. As a kid, I was captivated by the stories that my mother, Betty, and my grandparents used to tell me about enjoying fresh milk and picking apples during their time spent at the farm. I, however, am not a farmer. I am a photographer, writer, and historian. For *Back to the Land*, I wanted to present a pulse point of agriculture in the Hudson River Valley by profiling people who are part of a diverse and energetic movement that is very much thriving.

This collection of voices represents a broad range of individuals who have flocked to this region, or intentionally decided to stay put, in order to implement their considerable knowledge, problem-solving skills, humility, and ability to be hyper-present in their work. Many have reintroduced practices learned from past generations and pre-industrialized food systems, and a large group is expanding the discourse on what the next step in farming entails. The weak of heart

BOTTOM ROW FROM LEFT: A nineteenth-century barn at Olana, the Persian-style home and studio of Hudson River School painter and farmer Frederic Edwin Church; the view from Olana in Greenport; Larry Thetford's impressive collection of historic farming implements housed in an 1820s Dutch barn on the Feller Farmstead in Upper Red Hook; the rusty red hook that symbolizes the village name on the wall at the Feller barn. FOLLOWING PAGES: A winter scene in Germantown.

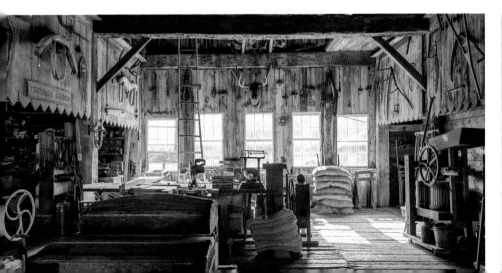
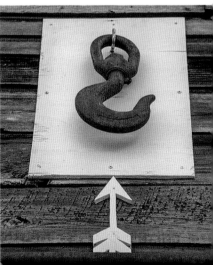

tend to quickly return to the city on the next Amtrak train that hugs the Hudson River.

For the last ten thousand years, farmers have been addressing the subject of sustainability. If ancient farmers didn't rotate their crops and fertilize them, they diminished over time. Often fields left fallow eroded without cover crops in windy weather. Henry Staats made endless notations about plaster and ashes as fertilizer while strategizing his fields' productivity. Growing crops removes the nutrients from the ground, so to avoid eventual depletion of the soil, they must be replaced if a sustainable environment is to continue. Von Humboldt was responsible for discovering that bird droppings from the Chincha Islands in Peru have gigantic amounts of nitrogen and phosphorus, both essential in remedying soil exhaustion. Tilling can destroy the mycorrhizal fungi networks that store carbon through their underground threads. The microbes in the soil act like an ecological memory, letting the ecosystem remember how to come back to life. Therefore, soil is the make-or-break component in agriculture, and every soilophile (a soil-obsessed farmer) that I interviewed attested to the prime importance it plays in both their business model as well as their commitment to sustainable practices.

What does one do when nature becomes out of balance due to the hand of man? One solution for thoughtful investors is to take a stake in the more than 18 trillion dollars held in publicly accessible funds that follow the investment principle know as ESG, an acronym that represents the prioritization of environmental, social, and governance issues.

There is a consensus among farmers that the word "organic" was fine until Congress first stepped in with the Organic Foods Production Act, finalized

First came farming. It was humanity's first form of business and its first industry. You cannot understate its importance to historians or to any of us in the here and now. How and where and what we farm—indeed, who farms—is our cultural narrative.

—SUZY WELCH

in 2002, which regulates who is eligible to use the label. Many small farms aren't certified as "organic" now because the paperwork and time needed to document their practices is overwhelming for farmers and detracts from the time necessary to attend to their fields. Certified Naturally Grown (CNG) is one of a series of labels that offers solutions for farmers who want to communicate to their customers the attention that goes into their produce. It's clear, however, to everyone involved that these labels can be extremely confusing.

One of the reasons I wanted to write *Back to the Land* is to showcase so many of the amazing people who are finding pride, honor, and nobility in their work. The enthusiasm expressed by the farmers profiled here from the moment they get up in the morning until they observe the end-of-the-day's results has been inspiring. If we consider that the average Amer-

ican farmer is fast approaching sixty-five years old, it is not hard to do the math and see where the demographic of farming is heading. It was encouraging to see a diverse group of farmers in this region, and I am further looking forward to seeing the long-term ramifications of the 5.3 billion-dollar allocation to assist a racially diverse population of farmers that was tucked into the Inflation Reduction Act of 2022. I hope that this book inspires readers to support the crucial work illustrated on these pages by being willing to pay a bit more for food from independent farms, or, even better, enter the field of farming. A recent Gallup poll documented the fact that while eighty percent of Americans live in urban areas, rural life is the most desired. The subject of what we eat speaks to everyone; nearly one third of all American jobs is tied to food and agriculture. I encourage the reader to seek out food that is healthy for us as well as the Earth.

STONE BARNS CENTER FOR FOOD & AGRICULTURE

POCANTICO HILLS

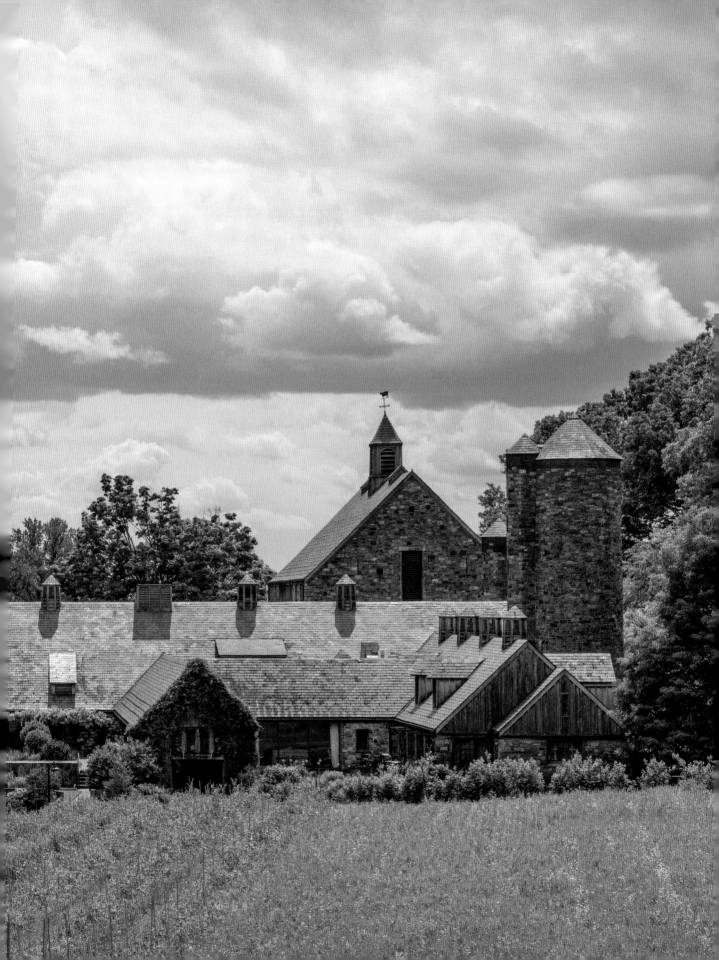

The massive scale of Stone Barns Center for Food & Agriculture is apparent upon catching a first glimpse of the barn complex. This is Pocantico Hills in Westchester County, about an hour north of Manhattan, which is to say we are in Rockefeller territory. Kykuit, the family's historic home, is a short drive to the west. The stone farm buildings, designed by architect Grosvenor Atterbury for oil baron and philanthropist John D. Rockefeller in the early 1930s, were inspired by the agricultural structures found in Normandy, France. Rockefeller then ran a private dairy farm here for about twenty years. In the 1970s, after the farm lay dormant for two decades, Peggy Rockefeller, wife of John's son, David, who had inherited the property, became actively involved in farming. She raised Simmental cattle on their Bartlett Island property in Maine, eventually continuing this activity on the family's Westchester farm. In 1980 she founded the American Farmland Trust, a nonprofit that fosters environmentally conscious farming practices and the use of conservation easements that protect agricultural land from development.

Following her death in 1996, David and his daughter, Peggy Delany, began an extensive renovation of the barns and started a nonprofit organization with a farm situated on eighty acres donated by the family that is meant to connect the public with their food source throughout the year. This country's large, industrialized farms still at work today do just the opposite; the products delivered to supermarkets often are imported from other countries and grown during seasons that don't necessarily align here.

At Stone Barns, groundbreaking research on innovative ways to farm in an ecological way is consistently being conducted. Caitlyn Taylor, the managing director of the Stone Barns Center, said, "We are a team of really curious people, who all come to the farm to question the status quo. . . . Everyone arrives here from different careers."

We're trialing cane sorghum varieties in the field and testing processing techniques to produce a mild-flavored Northeast sorghum syrup, modeled after the rich sorghum molasses tradition of the South. . . . These crops need to become celebrated in the US so that rotations become not just environmentally necessary, but in demand by the people that are eating them.

—DAN BARBER

Since 2003, when the first crops went in, the information disseminated by the farmers, chefs, and teachers on staff has included a holistic set of principles that have guided farmers for millennia. Emphasizing the importance of the hearty soil needed for an ecologically sound farm, Peggy Dulany, chair of the board, told me that, "regenerative soil practices are the foundation of a healthy farm." Further discussion among the Stone Barns staff members continues on the topic of biodiversity, which is integral to creating a farm that has no waste. To achieve this, crop production incorporates systems that include a seven-year vegetable rotation, a ten-year greenhouse rotation, and a seven-year ley (land used for grazing) rotation.

There are more than 300 varieties of seeded crops on site. The farm collaborates and exchanges findings with the agriculture programs at Cornell University College of Agriculture and Life Sciences and University of Wisconsin, among others.

The cattle and sheep are one-hundred-percent grass-fed, and the goats serve as the invasive species control program on the neighboring Rockefeller State Park Preserve. "Forest edge browsing" is the term used to describe the scavenging that goats are famous for. All the animals on the farm contribute to the carefully balanced equation needed for elevated biodiversity that includes carbon sequestration and water absorption. The animals are led to new fields daily in close herds and flocks as they would naturally gather in the wild. Rigorous protocol is in place to ensure the welfare of the animals with the bulk of the standards coming from the Certified Humane program.

Sharing the magnificent barn complex is Blue Hill at Stone Barns—the restaurant with Michelin-starred chef Dan Barber at the helm. Caitlyn said, "What makes our work different here is due to the fact that we have both a farm and a restaurant on the property; we can be interdisciplinary. In order to do that, we have to provide examples of how food

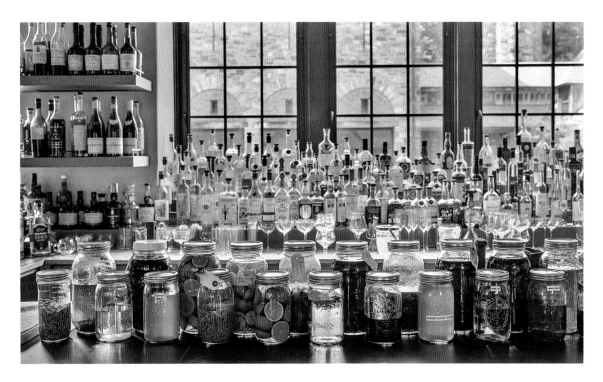

PREVIOUS PAGES: The Norman-style stone barns were designed in the early 1930s by architect Grosvenor Atterbury for John D. Rockefeller. The restaurant, Blue Hill at Stone Barns, is located on the left. Adjacent are the vegetable fields that yield produce used by chef Dan Barber. ABOVE AND BELOW: A selection at the restaurant's bar of many ingredients grown on the farm and used in preparing beverages. Peaches ripening in the orchard; Poppies for sale in the Blue Hill Cafeteria.

CLOCKWISE FROM TOP LEFT: Some views inside the greenhouse at Stone Barns Center for Food & Agriculture include a row of larkspur, a patch of statice, sweet pea, and a storage station for tools. OPPOSITE: The original compost shed on the property, adjacent to the main dining room, is now used for intimate meals.

is grown, and we have to change how people eat through intentional food preparation. . . . we can connect this to the culinary efforts being explored in the kitchen." Rotation Risotto, one of Barber's signature dishes, consists of millet and buckwheat, along with food scraps normally discarded.

Regarding the intersection between crops and food, I learn about the farm's exploration of growing sorghum, the grain that is often used as a sweetener in the South. "Sorghum is unusual in this area. We planted twenty varieties that we had received from collaborators in the South to see what might grow best here. The kitchen processed the grains and experimented with using it in syrup, desserts, and

other sweeteners so that by the end of the season we had a mountain of information," Caitlyn said.

Stone Barns presently employs thirty-two people on the farm. The restaurant, which has a global reputation as being in the forefront of the farm-to-table movement, has sixty cooks and front-of-the-house on staff.

Caitlyn said, "We are now a bioregional organization, acting on a larger regional scale. There are some key features in the food system beyond the borders of our farm, and we feel well positioned to address these. We are at an inflection point as we now think of this organization as a research institution that is committed to experimentation, which is multidisciplinary."

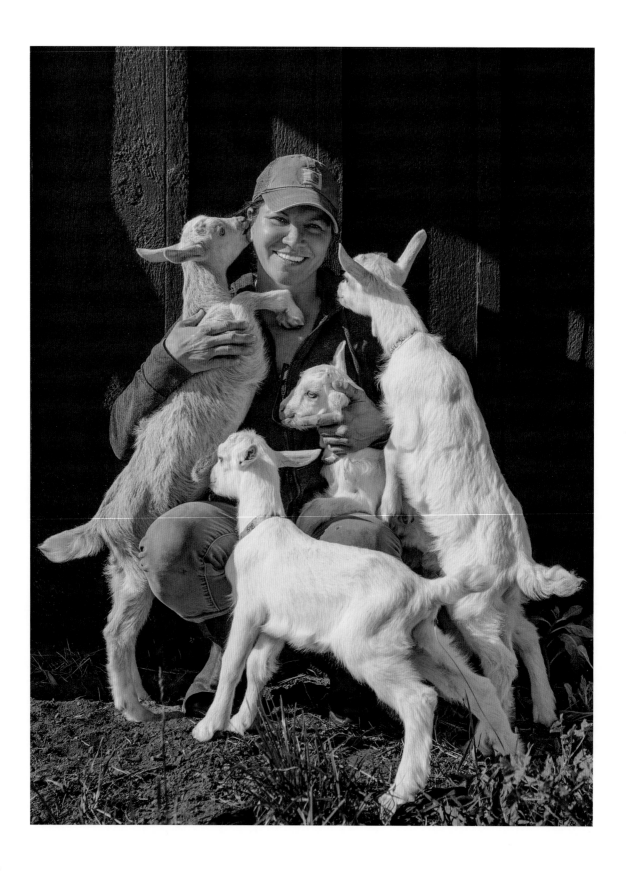

ARDITH MAE FARMSTEAD

STUYVESANT

Shereen Alinaghian makes a chèvre as well as many French-style cheeses that rival any I have tasted in France. When I attended university in Paris, I was a vegetarian and survived the first year on cucumber and chèvre salads.

While growing up in Los Angeles, Shereen fell in love with goats while helping care for her friend's menagerie. After moving to Brooklyn as a young woman, she took extended trips upstate to the Hudson River Valley to go fishing. "Despite being a full-on city girl, I was done," she said. "I loved the country to the point that it became obvious that I needed to live here." With her then-husband, she found an internship in cheesemaking in Vermont in 2004; they packed up and headed north. When it was time for the couple to hang out their own shingle, they established a starter herd, which included Saanen goats from Switzerland and LaMancha, a breed of goats that came from Spain to America in the 1920s. After much experimenting with the breeding to get the best result, the herd is now "closed," which means that no other animals are brought onto the site that might contaminate the herd. When you develop the ideal herd with great genetics, you stay put. Biosecurity, Shereen confirms, is of paramount importance. In residence now are fifty-eight females and one male.

Shereen bought out her husband's share of the farm when they split up. Ironically it had the same name, Ardith Mae, as his mother. "We had spent ten years leasing property; it was time to ratchet up my game and buy my own land." This is a refrain I hear often from young farmers, where land sovereignty is becoming increasingly a challenge. With some creativity, there are options. Shereen arranged a small business loan with the help of the Hudson Valley AgriBusiness Development Corporation, the not-for-profit that aids farmers in obtaining land, getting loans, and coming up with a business plan. "When visiting the city's farmers markets, I noticed that many of the farms I gravitated toward were in Columbia County, so I started looking there. There is such an amazing community here, with so many farmers that I can call on for help or resources. They show up in a way that I never experienced in the city.

There is an absence of competition. It is an environment that supports this degree of generosity and kindness. Sarah Chase [of Chaseholm Farm] has been amazingly helpful."

When we discussed my experience as a vegetarian, Shereen said that she had been a vegetarian for many years and that this experience helps drive her practice. "As a twelve-year old, I saw *Faces of Death*, a documentary on slaughterhouses, and I was done with meat. No one will love these animals as much as I do. When challenges occur, I just fight harder for them. I am up at six and am asleep at ten. I don't get my nails done. Forever."

Her dairy is Animal Welfare Approved, meaning thresholds have been met for the ethical treatment of the animals. "I monitor the somatic cell count, which can be a barometer of when they are stressed or have an infection. When this happens, I isolate that goat and give them a little extra TLC." Shereen lets me know that her products are not labeled "organic." If one of her animals becomes sick,

> *One of our main goals is to allow our animals to be animals. We make sure the goats explore and sample as many types of forage as possible.*
>
> —SHEREEN ALINAGHIAN

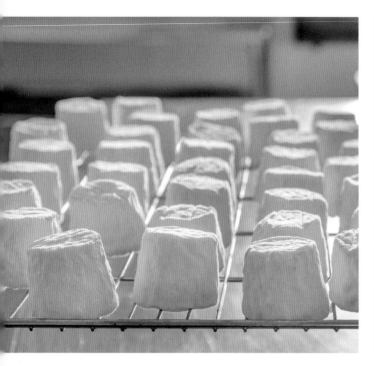
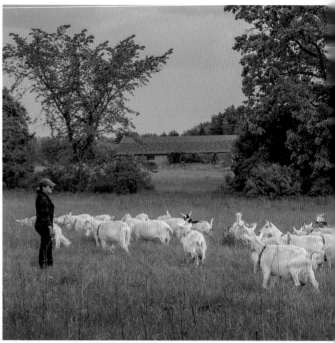

To run a farmstead, you must wear a lot of hats: I am responsible for the animals, making cheese, selling at markets, designing the packaging, and administration.

—SHEREEN ALINAGHIAN

she will administer antibiotics so that they can heal as quickly as possible, which disqualifies her product from this designation. Most dairies breed their goats every year, referred to as "milking off their backs," which exhausts them. At Ardith Mae, Shereen gives the goats a rest by breeding them every other year, providing for a healthier and happier nanny goat. By taking a rest, they can put weight back on, then in the spring, they can start again to be milked when they give birth to kids. This process produces oxytocin, which creates the milk letdown. The goats are fed organic and Non-GMO grains (grains that are not genetically modified). The farm's rotational grazing system provides the goats with their needed forage and exercise while improving the soil.

For her cheesemaking, there are two processes that Shereen utilizes: direct set and lactic set. Direct set is quicker, and lactic uses less culture and rennet, which causes the curds to separate and binds the proteins and fats. The curds are ladled into the molds where they drain, creating a very delicate product. Shereen said, "The more rennet in the mix the thicker the curd will be, so I am always trying to use the least amount of rennet possible to give the cheese a more interesting and layered profile; a little sweet and a little salty. I think the taste is best when cheeses are very young: they are well balanced, and the rind does not overpower."

"My 'Know Your Farmer' bumper sticker has opened some great conversations recently. It is important for me that I advocate for farming that is done correctly. It is all subjective, but I have my firm thoughts on the subject. It is important to ask your farmers how they are producing their food, and this can easily take place at farmers markets. I am now working at seven farmers markets in the region, often clearing $12,000 a weekend. That's a lot of driving and customer interface. People keep thanking me for coming out to feed them with healthy food," Shereen said.

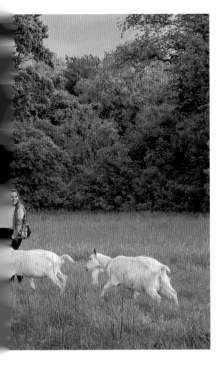

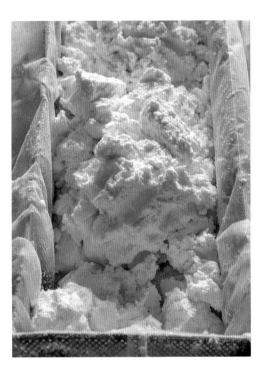

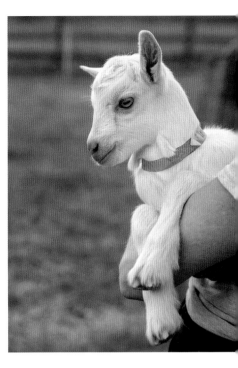

PREVIOUS PAGES: Shereen Alinaghian with her affectionate goats. TOP ROW FROM LEFT: The small round Doolan cheeses, Shereen's favorite, named after Kristin Doolan, who taught her how to make cheese; Shereen and assistant Katie Doyne in the fields with the herd of foraging goats; the fresh chèvre cheese drained in perforated metal molds with cheesecloth; Gigi, a purebred Saanen goat. BOTTOM ROW FROM LEFT: Bigelo, a vegetable ash-coated pyramidal goat cheese; Shereen taking a break in her laboratory; herbed goat's milk feta marinated in olive oil infused with pink and black peppercorns.

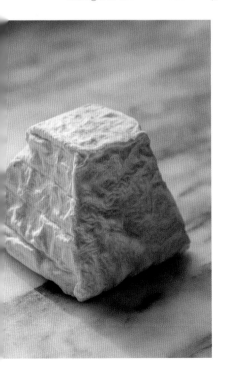

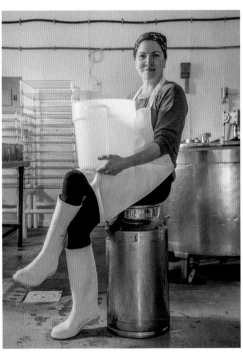

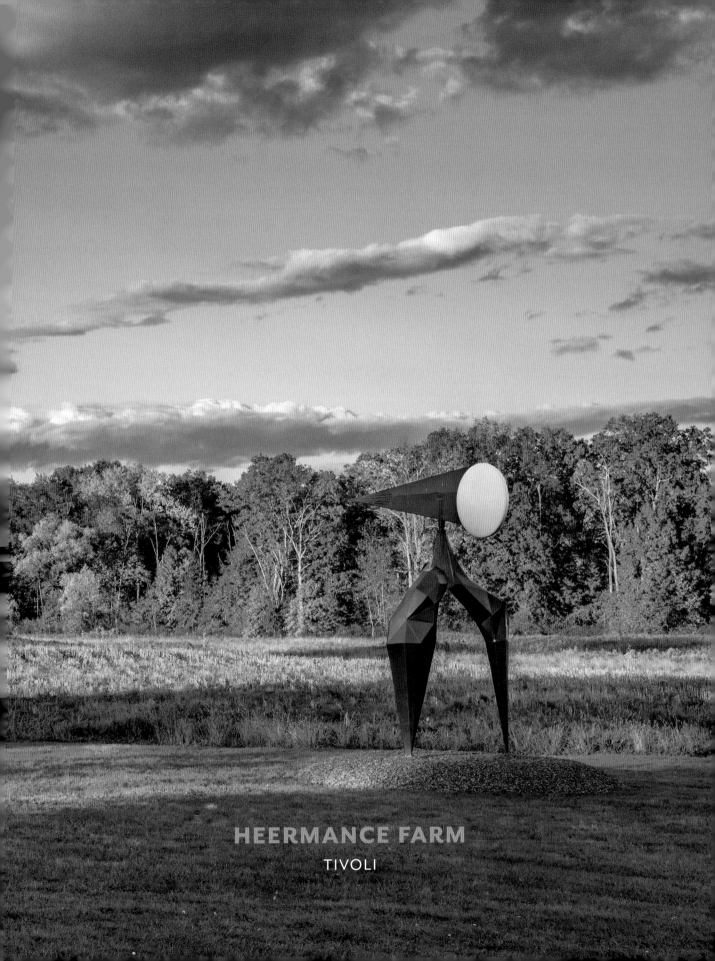

HEERMANCE FARM

TIVOLI

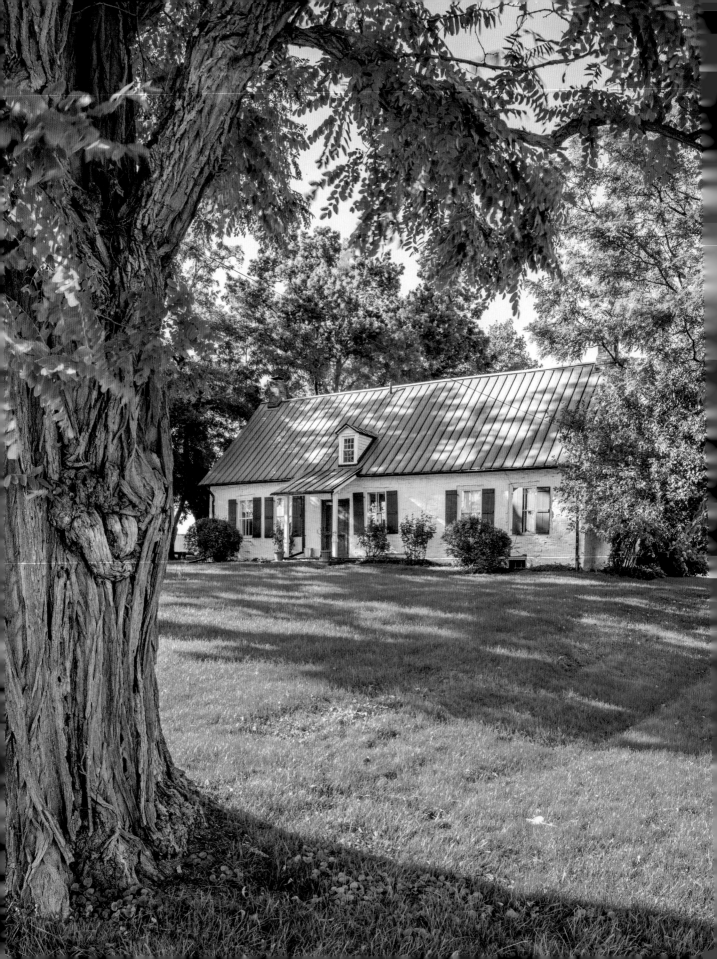

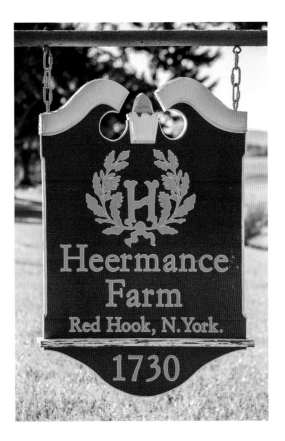

One day while biking with my son, Elio, to the piers by the Hudson River on the west side of Manhattan, we passed a farm stand where there had previously been a marine repair shop on Christopher Street. I curiously eyed the signage, which promoted produce from Tivoli, the village in the Dutchess County Town of Red Hook. When I saw another sign with the name of Heermance Farm (the Dutch surname of the family that established a farm there in 1730), I put two and two together, and realized that this is my neighbor upstate.

Elijah Bender is the present steward of the farm. Following another bicycle ride to visit him in Tivoli, I had the pleasure of sitting down with him and David Bulkeley, whose family had owned the historic property during most of the twentieth century.

David remembered riding a wooden tricycle around the property as a child. "We were either in school or we were doing chores," he said, "being woken up at 7:30 a.m. by my dad who had gotten out of bed two hours earlier to milk the cows. As a teen-ager, I was envious of the kids who went to town, but when they started to all get in trouble, I was glad to have spent the time on the farm. I learned early on that if you put the time in, any animal will know you. My mom not only raised the kids but also bailed the hay and drove the tractor. We were part of a team. Not doing your job was just not an option." He said that the water was hand-pumped into the sink through the early 1950s, and wood stoves were used throughout the fall and winter for pragmatic, not romantic, reasons. "We have the farm; we can eat," David remembered his grandmother Ethel's refrain following the crash of 1929. This family was clearly a model of self-sufficiency.

The property can be traced back to the Schuyler patent of 1688, then through the Staats and Van Benthuysen families until Andries Heermance purchased close to a thousand acres in the early 1700s and built the earliest part of this house. The core of the house, in keeping with the population that inhabited this region in the eighteenth century, was constructed

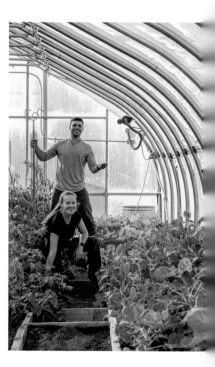

'Agriculture is a good and noble thing' was my dad's refrain when we tried to find the perfect match for ourselves. It caught him, and he wanted to support a sustainable property. We liked that this place was firmly established—it personified many aspects of American history.

—ELIJAH BENDER

using traditional Dutch building techniques and is still largely intact. Later additions by Peter Heermance, who inherited the property on 269 acres, included the Georgian paneling in the parlor from the 1770s, which reflected the English architectural style in fashion at the time. Between 1796 and 1821, The Red Hook Society for the Apprehension and Detention of Horse Thieves held meetings here. The society still meets annually in Red Hook, as it has for more than two and a quarter centuries. Accordingly, this society has evolved past the necessity of overseeing the theft of what amounted to a farmer's greatest asset.

David's great-grandfather, Henry Redder, purchased the farm in 1896 at a foreclosure sale at Hotel Morey in Tivoli, eventually dividing it between two sons, William and Edmund. William inherited the northern portion of the farmstead, which is now today's Heermance Farm. Following the marriage of William's daughter, Alice, to Peter Bulkeley, Wil-

liam retired and the newlyweds took over the farm. The region saw a switch from farming grain to growing fruit trees, especially apples, once the Erie Canal opened in 1825. This farm was no exception, and the family slowly changed the dominant crop to apples. The farm switched again during the Bulkeley period, from apples to raising Holsteins as dairy cattle, which required the clearing of the apple orchard for grazing land. Peter maintained the milking parlor until 1967

PAGES 26–27: A sculpture by artist Kris Perry is installed near Heermance Farm's hay field. PREVIOUS PAGES: The fieldstone farmhouse is one and a half stories and still has its original Dutch door. Locust trees, such as the one seen here, were planted close the houses to act as lightning rods carrying the strike down to the ground. The vintage Heermance Farm sign. ABOVE FROM LEFT: Mediterranean cardoons being blanched before harvesting; heirloom black cherry tomatoes on the vine; members of the farm team, Lucy Jones and Sam Tract, in the greenhouse.

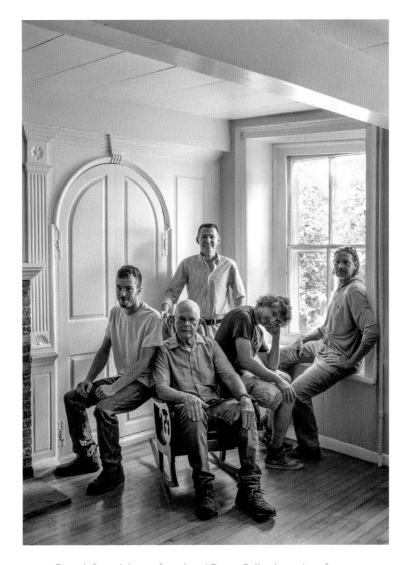

ABOVE: From left to right are farm hand Deven Pollard, previous farm owner David Bulkeley, current owner Elijah Bender (standing), farm hand Zack Kubsch, and farm manager Kevin Ferry in front of the 1772 fielded paneling in the parlor. FOLLOWING PAGES: Round bales of hay in the same fields where Andries Heermance grew wheat in the early eighteenth century.

when he retired, and then David took over. "I promise I'll do the best I can for you," he remembered telling his dad, reinforcing the farming tradition that one of the children brought up on a farm would take over.

"We were very fortunate to find the Benders. I was afraid all of the hard work we had put into this place would go to trash," David said. To this end, David had placed the farm with the Winnakee

Land Trust, based in Rhinebeck, which works in partnership with private landowners to conserve and manage agricultural properties, assuring that this historic property will not be subdivided.

Elijah Bender, with his parents, Neil and Marika, purchased the farm in 2012 after looking at many options. "It was always a dream of my dad to have a farm in the Hudson Valley," he said. "My mom's

family is Ukrainian with a strong history of farming for generations, and my father's father and brother, Russian Jews, were brought to America, to the Lower East Side, as displaced persons, eventually developing an extensive real estate portfolio in Manhattan." These holdings included the shop on Christopher Street where I had seen the farm stand.

Elijah is adamant about continuing the farm in the tradition of David's family, and with the astute oversight of Kevin Ferry, the farm manager, is prepared to continue growing a varied selection of crops. In the mix are heirloom tomatoes, larger leaf crops like cauliflower and broccoli, and eggs that have gained mention in *New York* magazine. Kevin brings to Heermance a wide skill set. He worked on salmon boats in Alaska in his twenties, then moved onto farming in Nepal and Cambodia, and eventually ran the aquaponics program for the Cabbage Hill Farm

Foundation in Mt. Kisco. The farm includes hydroponic greenhouses. The tilled fields are capped with row covers and hydrogel, a polymer that leaves them less vulnerable to climate events, like heavy rainfall that causes erosion.

The Benders are committed to maintaining the oldest continuously farmed property in Dutchess County, going all the way back to the original Schuyler patent. Further illustrating Elijah's appreciation and research into the area's history, he said, "What are the odds that my great-uncle would purchase two buildings on land in Manhattan that had been owned by Freeborn Garrettson, and that I would live in his earliest home in Rhinebeck." Elijah is referring to the eighteenth-century Benner House where he currently resides. Freeborn Garrettson, a minister, lived here in the 1790s with his wife, Catharine Livingston, and this is where he gave Rhinebeck's first Methodist sermon.

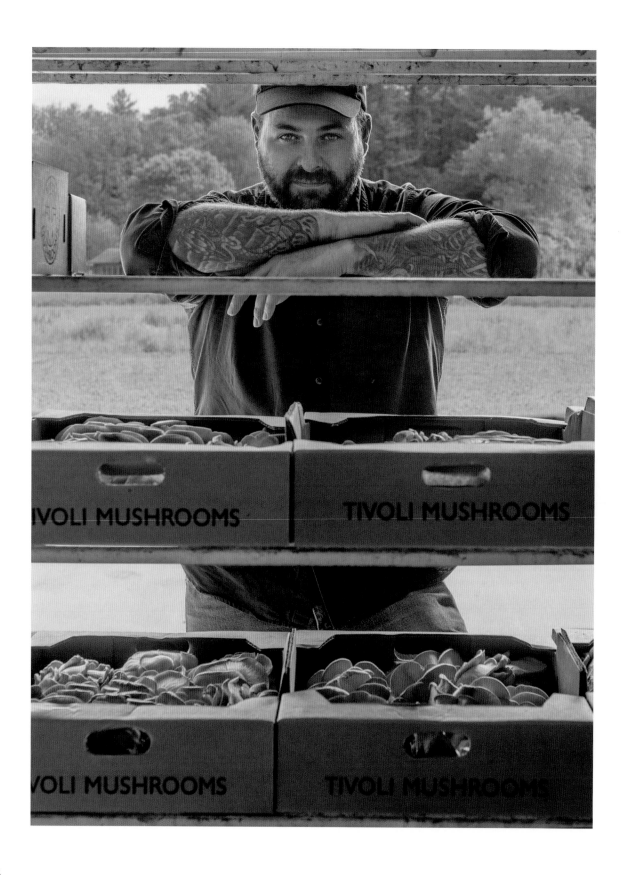

TIVOLI MUSHROOMS

HILLSDALE

Devon Gilroy said, " 'Fungee' or 'fun guy,' it's really like the tomaahtoe-tomayto conundrum. Either is fine to use." Phew, glad to confirm. His thriving mushroom-cultivating farm in Columbia County's Hillsdale produces some of the 1.5 million species of fungi, a kingdom that is neither plant nor animal. "Mushrooms have become the avocado toast of 2024," Devon said. Speaking to the current popularity of mushrooms, he mentions the Netflix documentary *Fantastic Fungi* that addresses the recent interest in the magical and healing properties of mushrooms.

Devon grew up in Manhattan where his dad owned several restaurants, including Employees Only, as well as the Match restaurants. His mom is a landscape designer and horticulturist. The amalgam of his parents' fields of expertise explains the particular path that his professional life has taken. During early stints as a chef at A Voce and Chanterelle in New York City and The Corner in Tivoli, his desire to spread some fungus was ignited. While living in Tivoli, he started his foray into mycology and began foraging for local restaurants in the Hudson Valley. Devon said, "Mushrooms are so secretive, with a lot of contradictory data to sift through. The little black mushrooms (or LBMs) can look great but often they are poisonous. I got a real kick out of collecting different species of mushrooms and then cooking them. Foraging is meditative and the hyper-focus required was different from the kind of concentration needed inside a kitchen." When foraging season ended, Devon consumed books on the subject of mycology

There is a large community of people, including vegans and vegetarians, who are looking for interesting nutrient-rich food, such as mushrooms. My clients are into the most obscure species. Providing specialty products for so many great chefs and others that are appreciative makes my day.
—DEVON GILROY

and reached out to fellow chefs and growers across the country to learn about their experiences. In 2016, while still a chef, he started a mushroom cultivation farm in Hudson in an old chair factory.

His prosperous "spore to door" business now produces four thousand pounds of mushrooms a week that are delivered all over the Hudson Valley as well as to locations in the Berkshires and the Catskills. The list of deliverables includes oysters, Lion's Mane, shiitake, morels, and Cordyceps, which are considered aphrodisiacs and are used for building muscle mass. He also gathers nonfungal selections like fiddlehead ferns, ramps, miner's lettuce, and wood sorrel.

Devon outgrew his Hudson location because the demand for his mushrooms surpassed what he could produce. "Here in the new space, which is about fifteen thousand square feet, I can cultivate strains that are more difficult to grow as well as rare, interesting types of mushrooms that aren't available through other providers. My goal is to continue expanding the list of what we can offer."

Devon and his wife, Caroline, just welcomed their son, Willem. The family live in Red Hook where Caroline's parents Doug and Talea Taylor are running Montgomery Place Orchards. Despite the time crunch of having a newborn and a young business, Devon still finds time to go mudlarking for arrowheads, which harkens back to his earlier period, foraging for mushrooms.

"When cooking, there are so many variables," Devon said. "Unless you can define them and structure things correctly in the kitchen, you'll fail. In mush-

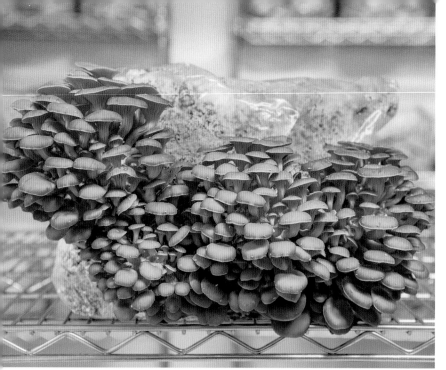
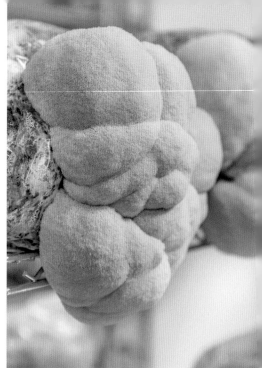

room cultivating, I am doing something that is so rich. I could study my whole life and not completely master mushroom cultivation, but if you follow the rules while doing this in a controlled environment, success is readily available."

In the new facility Devon creates his own substrate, which is a mixture of pellets made from soybean shells and sawdust from a local mill used as a medium on which an organism grows. Basically, he is reusing the remnants of other industries

PREVIOUS PAGES: Devon Gilroy standing in front of an outgoing order of Pink Oyster Mushrooms (*Pleurotus djamor*).
TOP ROW FROM LEFT: Yellow Oyster (*Pleurotus citrinopileatus*); Lion's Mane (*Hericium erinaceus*); one of the mist-infused growing rooms with King Trumpets (*Pleurotus eryngii*); Blue Oyster (*Pleurotus ostreatus*). BOTTOM ROW FROM LEFT: Devon and his sister, Talulah Gilroy, suited up to enter the laboratory; Phoenix Oyster (*Pleurotus pulmonarius*); King Trumpet (*Pleurotus eryngii*); Golden Enoki (*Flammulina velutipes*).

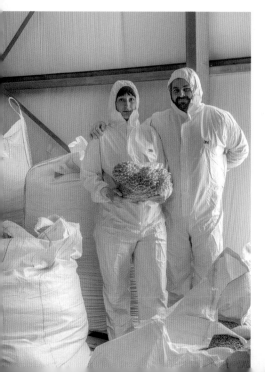
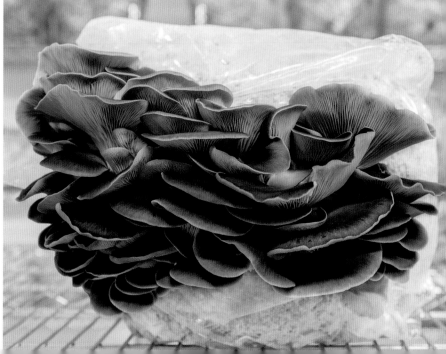

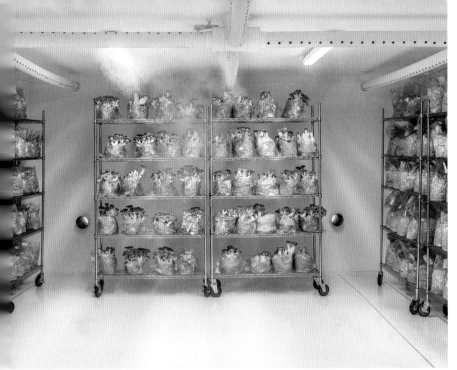

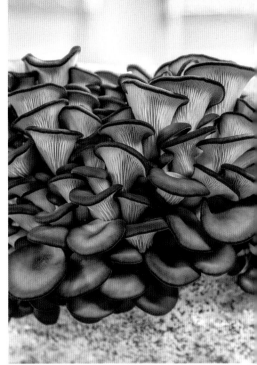

to repurpose material for his. Once the substrate is composed, the grow rooms are set up to isolate and culture genetic material and to provide air flow, humidity, temperature, and light to ensure proper fruiting and a successful harvest.

"Many of the varieties here are actually cloned," Devon said. "We take a piece of the mushroom flesh and isolate it on an agar plate; two weeks later you have a first-stage clone, which is transferred two times until it's ready to be introduced into the substrate to fruit. The mushrooms produced are the result of mycelium, the complex rootlike structure that in nature connects the complex mycorrhizal infrastructure inherent in healthy soil."

The biggest challenge for Devon at this point is scaling the business model to create the correct balance between productivity and quality. "It was a huge swing for me," he said, "from working in a crowded kitchen to a solitary and completely sterile environment." With projections for the American market for edible mushrooms to reach $69 billion this year, Devon is establishing his place at the table.

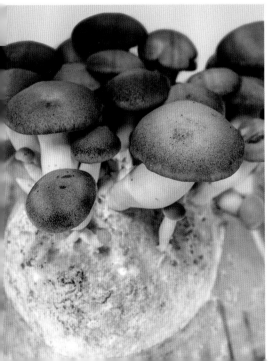

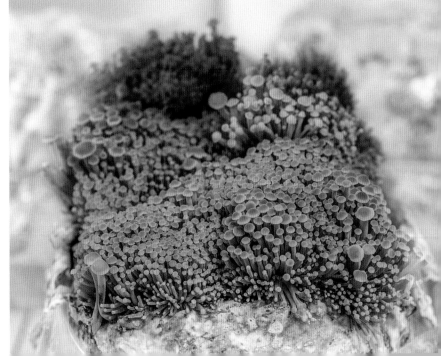

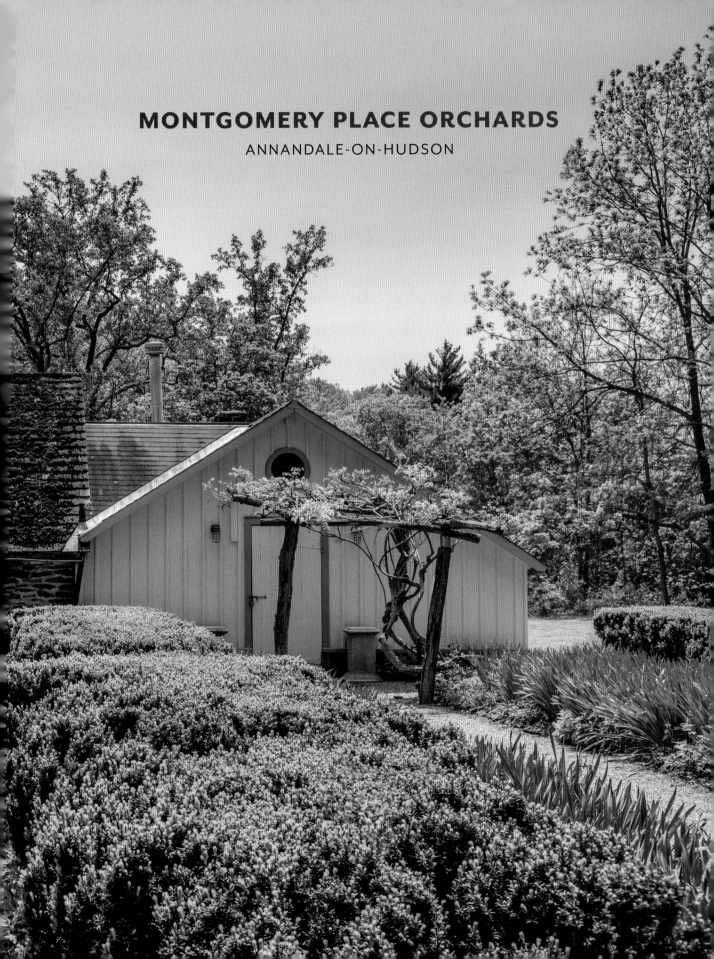

MONTGOMERY PLACE ORCHARDS
ANNANDALE-ON-HUDSON

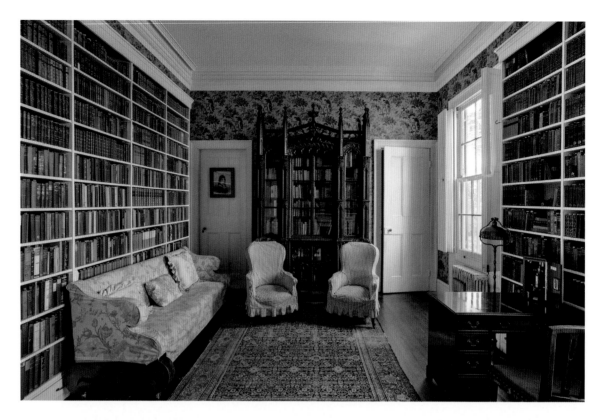

Around Montgomery Place . . . indeed, this air of quiet and seclusion lurks more bewitchingly than in any other seat whose hospitality we have enjoyed whether the charm lies in the deep and mysterious wood, full of the echo of water spirits, that forms the northern boundary, or whether it grows out of a profound feeling of completeness and perfection in foregrounds of old trees, and distances of calm serene mountains, we have not been able to divine; but certain that it is that there is a spell in the very air. . . .

—ANDREW JACKSON DOWNING
1847

Following a long line of tenants working on this property since the eighteenth century, Doug and Talea Taylor have now been farming at Montgomery Place for thirty-seven years. This historic farm was begun in 1802 after Janet Livingston Montgomery purchased 242 acres from John Van Benthuysen. She built a home named Château de Montgomery in homage to her husband, Richard, one of the first causalities of the Revolutionary War. Her brother, Robert R. Livingston, was US minister to France when Napoleon was First Consul of the French Republic and at the time the family embraced all things French. Janet left the farm to her younger brother, Edward, when she died in 1828. Edward's

wife, Louise, and daughter, Cora, are responsible for the impressive surroundings. Louise hired the renowned American architect Alexander Jackson Davis in 1842 to transform the Federal-style house that she had inherited into a Romantic Revival marvel; she also worked closely with him in designing the outbuildings. Davis returned to Montgomery Place in 1859 to complete further designs for the residence as well as the gardener's cottage and the Swiss Factory Lodge, which was built for the millworkers in 1867.

Alexander Gilson, the African American who would eventually be head gardener at Montgomery Place in 1835, had become a free man following New York State's Manumission in 1827. He was born on the

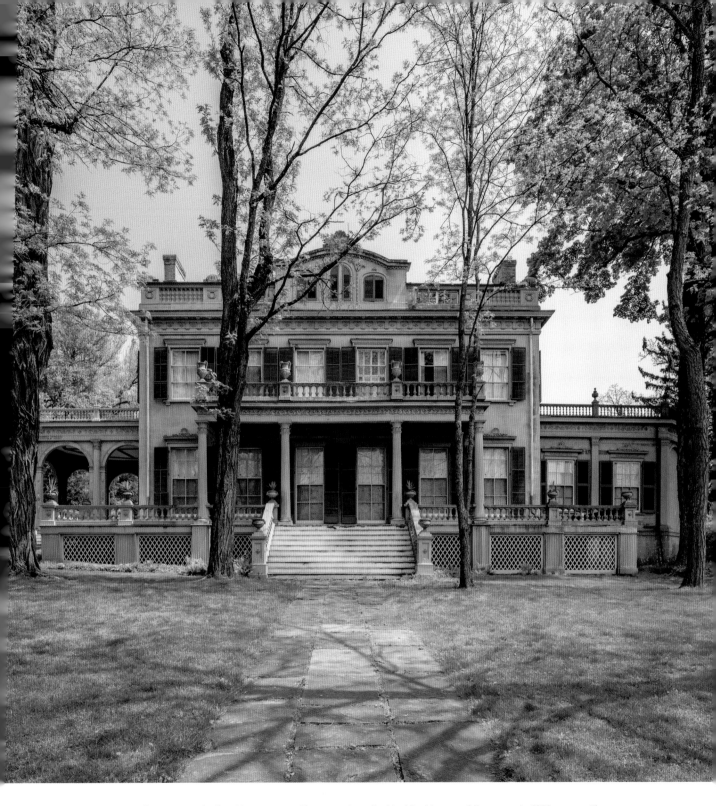

PREVIOUS PAGES: The potting shed at Montgomery Place was installed by Hitchings and Company in 1929. ABOVE: The western facade of the house has classical details designed by Alexander Jackson Davis in 1842. The North Pavilion, seen on the far left, was the prototypical transitional room in America, linking the domestic space with the pleasure gardens. OPPOSITE: Doug Taylor often consulted books in Violetta White Delafield's intact library, which houses an impressive collection of first additions on horticulture and botany from the eighteenth through early twentieth centuries.

farm, and his extensive botanical knowledge won the praise of Edward and the community. In fact, Alexander not only oversaw the gardens but opened his own nursery nearby in the village of Red Hook. Famed landscape architect Andrew Jackson Downing was a great admirer of the grounds at Montgomery Place, and although he didn't work on their design, he pro-

side depot that she called the "Wayside Stand." She wrote, "[It is] intended to spread a good example of good taste so badly needed where goods were sold along the highways." Part of the display structure that she had commissioned for the 1935 Dutchess County Fair was incorporated into the still-flourishing farm stand on Route 9G in Red Hook that is run

ABOVE: A. J. Davis designed the Swiss Factory Lodge in 1867 to house the mill workers that were employed by the Livingstons to process timber and grain on the Sawkill Creek. **OPPOSITE:** The coach house, also designed by A. J. Davis in 1859, implemented the rounded Italianate window headers popular at the time.

vided many of the specimen trees and shrubs that the Livingstons planted on their pleasure grounds.

In 1921, General John Ross Delafield, a relative of Edward Livingston, inherited the estate. As a response to the practice of farmers bringing their produce-filled wagons onto Red Hook's main roads and setting up tents, his wife, Violetta White Delafield, in the 1930s established a prototypical road-

by the Taylors. Today the bay window displays Montgomery Place honey alongside produce from more than fifty-five local farms.

Sitting on the porch of the A. J. Davis-designed gardener's cottage, Doug and Talea shared the story of arriving here in 1987. Talea had grown up on a farm in Pennsylvania where her dad managed an 800-acre apple orchard. After meeting Doug at college,

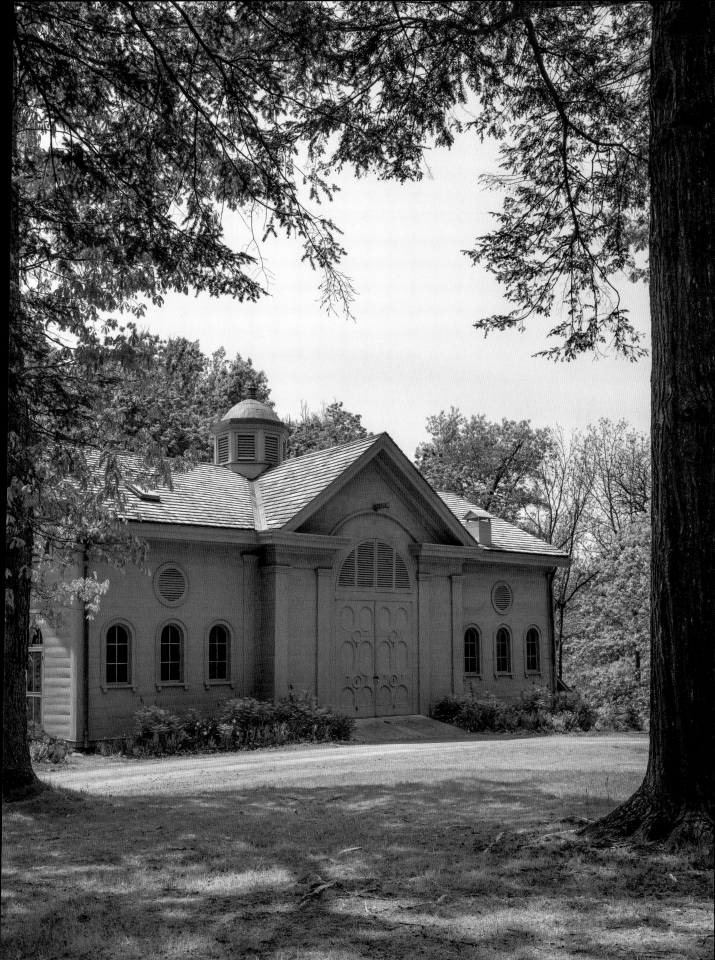

ABOVE AND BELOW: The 1929 greenhouse that is connected to the potting shed is now used by Bard College Farm to start lettuce and vegetable seedlings. These vegetables are eventually served to Bard students in the cafeteria or sold at the on-campus Bard farm stand. OPPOSITE: A view of the pastoral potting shed with its gravel path leading to the coach house.

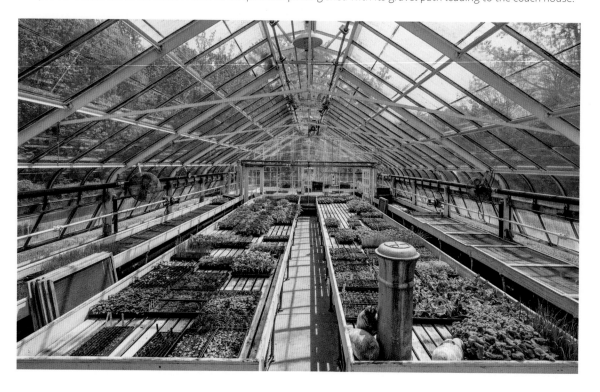

the couple married and worked at her dad's farm for a few years. In 1986 they saw an ad in *American Fruit Grower* magazine for a position overseeing the orchards at Montgomery Place. Dennis Delafield, the last Livingston descendent to occupy the property, had just sold it to Sleepy Hollow Restoration along with a total of 385 acres, about one hundred of which were orchards. The Sleepy Hollow Restoration group was looking for a farm manager. "We were terribly seduced and wanted to show everyone that we could make this farm work," Doug said.

> **The Honeycrisp is the Britney Spears of apples. A lot of work goes into making them look so good.**
> —DOUG TAYLOR

Shortly after arriving, the Taylors planted ten acres with over seventy variety of fruit trees, many of them heirloom examples. Doug made hard cider after spending winters around the applewood-fueled fireplace reading books on pomology (the growing of fruit). Andrew Jackson Downing's *The Fruits and Fruit Trees of America*, along with other first editions on the subject, are found in the comprehensive agricultural library left by Violetta in the main house. "Each apple has such a fun story," Doug said, ". . . Moonshiner apples were, you

guessed it, used to make moonshine liquor during Prohibition. The Empire is the Rodney Dangerfield of apples. The apples are great, but people think they are boring. We have an ancient variety, called the Api Etoile, which hails from the 1600s and tastes like pink grapefruit."

The orchard presently occupies sixty acres. Besides the fruit trees, the Taylors have added tomatoes, sunflowers, and herbs. Talea said, "We started growing grapes a while ago, but sadly there was a late frost this year, which ruined the crop. I'm hoping we can squeeze another growth season out of them."

Doug said, "I oversee a lot of mating disruption. We have to be on top of moths and certain insects. I can spray organic and synthetic pheromones so that the males can't find the females by perfuming the entire field. We are growing things that we are passionate about. I love a great Bartlett pear."

Bard College purchased the property in 2016. "We have been the staunch defenders of this farm for a very long time," Talea said. "We hope that our daughter, Caroline, can continue our family's work."

OPPOSITE ABOVE: Montgomery Place Orchards farm stand offers a selection of fruit and vegetables from the Taylor's farm as well as produce from other local farmers. OPPOSITE BELOW: Doug and Talea Taylor on the porch of their historic farmhouse. ABOVE: In 1861 A. J. Davis designed the board-and-batten gardener's cottage that the Taylors call home.

FISHKILL FARMS

HOPEWELL JUNCTION

Fishkill Farms is a 270-acre apple orchard and vegetable farm that has been in the Morgenthau family for more than 100 years. In 1913, Manhattan resident Henry Morgenthau Jr., with his father, Henry Morgenthau Sr., purchased four farms in the town of East Fishkill and combined them to create Fishkill Farms. He was twenty-two and had spent time at his family's country home in Hopewell Junction. When Franklin Delano Roosevelt was governor of New York and living nearby in Hyde Park at Springwood, the family's estate, the two men had become friends. They were said to have a neighborly rivalry about the cultivation of squash. Many years later on June 20, 1942, Prime Minister Winston Churchill joined then President Roosevelt at Fishkill Farms to discuss world events with Henry Jr., and his son, Robert. Fishkill's present owner, Josh Morgenthau, is Robert's son.

Henry Jr. first studied architecture at Cornell University, then switched to agriculture at the school's renowned Agriculture and Life Sciences program following a summer working on a cattle ranch in Texas. He straddled the dual roles of gentleman farmer and public servant but identified his occupation as farmer on his passport. While farm manager William Morris ran the day-to-day activities on the farm, which included a fruit orchard, a dairy, chickens, and vegetable gardens, Henry Jr. purchased the periodical *American Agriculturist* in 1922. He was also the chairman of the New York State Agricultural Advisory Commission in 1928 and the state's conservation commissioner in 1930. All of these

The President and I often talk about the fact that we went down to Washington together and we are pretty well agreed that we will retire together, and come back to Dutchess County. I will stay with him as long as he and I feel I can be most useful to my country there— but farming is my real business and I'm proud of it.

—HENRY MORGENTHAU JR.
1944

positions paved the way for his appointment in 1933 by President Roosevelt as chairman of the Federal Farm Board, which was created in 1929 to regulate crop prices in America. Roosevelt later recalled that the establishment of the Farm Credit Administration in 1933 under Henry Jr. was a great success as the country needed action to prevent people from losing their farms. In 1934, Henry Jr. became Secretary of the Treasury, a position that he held throughout the Roosevelt administration, even though he had no formal financial training. During this period, he would travel to the farm whenever possible to oversee the production of tens of thousands of bushels of apples annually. Today, the farm produces Treasury Cider, which is made with apples grown on the farm. The apples are fermented slowly at cool temperatures and aged for six to ten months before bottling. Its first release was in 2016.

In the 1960s Henry Jr.'s son Robert inherited three hundred acres of the farm from his father, who had died just shy of 100. The other six hundred acres were divided between two other siblings. Besides growing apples in Dutchess County, Robert was the US attorney for the Southern District of New York during the President John F. Kennedy administration and later Manhattan's district attorney for thirty-five years. The farm manager William Morris's son, Ray, continued his own father's legacy of overseeing Fishkill Farms during this time.

Josh remembered watching his father, Robert, sell some of the acreage for development. This sale

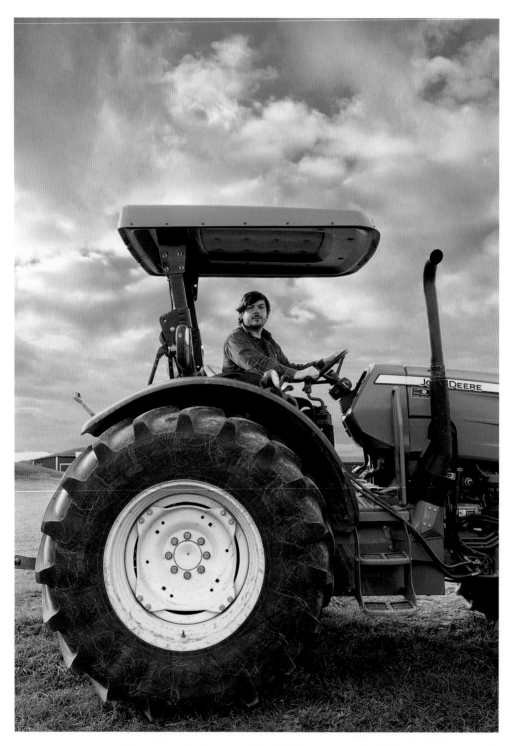

PREVIOUS PAGES: Seasonal flowers and fruits grown at Fishkill Farms. ABOVE: Josh Morgenthau on one of the farm's tractors. He inherited the farm from his father, Robert. Josh's grandfather Henry Morgenthau Jr. established Fishkill Farms in 1913. OPPOSITE: A late afternoon view of the flower, berry, and vegetable fields to the Catskill Mountains from the terrace of the farm's Treasury Cider Bar.

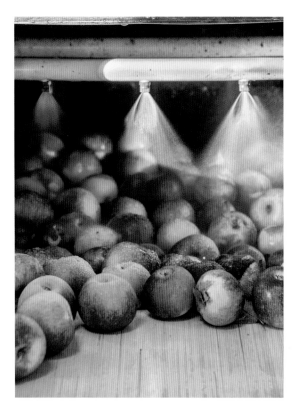
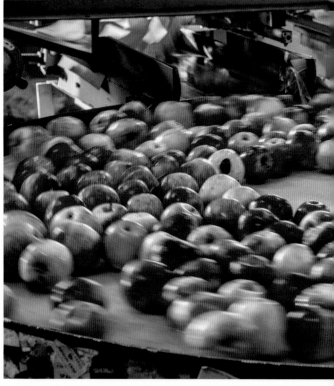

motivated him to get involved with Fishkill Farms. Reflecting on how special this farm was for him, Josh told me that he had planted vegetables here as a kid and remembered when the orchards and dairy were shut down to focus on easier crops to grow. Now, the farm grows organic vegetables and Eco-Certified fruit, beginning with peas and strawberries in the spring and ending with apples and pumpkins in the fall. Many varieties of apples—Gala, McIntosh (Henry Jr.'s favorite), Honeycrisp, Fuji, Macoun, Golden Delicious, to name a few—are offered.

As farms evolve with the times and address the local supply and demand, some big developments need to take place. Following a historic hailstorm in 1965 that decimated much of the fall's apple crop, what remained was not very appealing. A decision was made to revamp the business plan to include pick-your-own fruit that started in 1966. Fishkill Farms became known as a place where families could come and gather their own fruit and enjoy some outdoor fun during the summer and fall seasons. Because of that change, Fishkill no longer needed such a large crew of employees to pick the apples in the orchard. The pick-your-own fruit operation is still popular today. And, the Morgenthaus have increased the different kinds of fruit tree offerings to include pears, cherries, peaches, and plums, creating a longer season for visitors. In the warm weather, the farm hosts yoga classes out in the fields.

In 2008 Robert, along with Josh, took back the reins following a period where the family had rented out the fields to local farmers. Josh returned to Fishkill after graduating from Yale University with a degree in fine arts; he is now running the operation and overseeing its revival while living in the house that his dad built. "The place needed investment and a lot of TLC," he said. "Like my program at Yale in fine arts, here I found that the farm was a giant canvas to explore. That first year was rough. We had to rede-

ABOVE: In the fall, after the apples are picked, they are processed through the farm's vintage apple sorter. This machine cleans them with brushes and water after separating them by weight using centrifugal force.

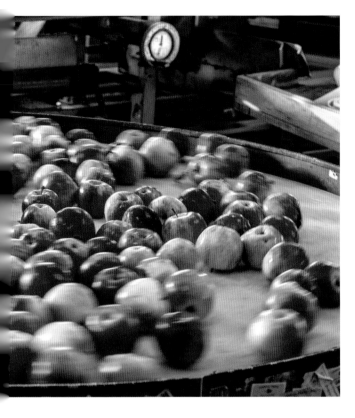
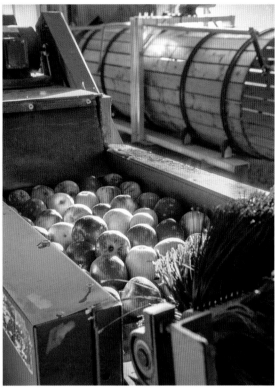

sign the wheel. A new business plan was devised with the assistance of Mark Doyle, who came from South Africa to join the team. We had to address forty acres of overgrown apple trees. There are currently eighty acres of varied fruit trees with half of the orchard certified organic. I am responsible for 150 acres in total. We initiated a Community Supported Agriculture (CSA) program for different seasons, and enlarged our farm store to include a lot of local products. . . . We also started to bring produce to several farmers markets. What is not sold is donated to local communities that are food compromised." The Morgenthaus now have a full-time communications person, who produces newsletters and oversees the farm's social media accounts. And, in 2012 the farm confirmed its organic classification by receiving certification through the Northeast Organic Farming Association of New York for half of its fruits and vegetables.

Farmers are supposed to weed out a certain percentage of apple trees in an orchard every twenty years. Today, we replace five percent of the trees every year to keep the orchard vital.
—JOSH MORGENTHAU

To the farm store, Josh added a gigantic wraparound porch that overlooks the vegetable fields; it is the home of Treasury Cidery Bar where guests can sample varieties of hard cider that are distilled on the property. Fishkill uses a mix of heirloom, bittersweet, and dessert apples that are cultivated, pressed, and then fermented in a variety of ways. "We've brought the farm back into full production in a sustainable way," Josh said. "The business model we put together has really proved itself out. Still, this summer we had less than one inch of rain. All the prepping in the world doesn't act as a foil for nature. But nature has had a gigantic forgiveness with all the rain in September."

In a period when generational farming is not a guarantee, it is wonderful to see that this family is so passionately involved in the farm. Josh said, "My wife, Emily, and I were married here on the farm so it's now very much part of who we are."

SUGAR SHACK

RHINEBECK

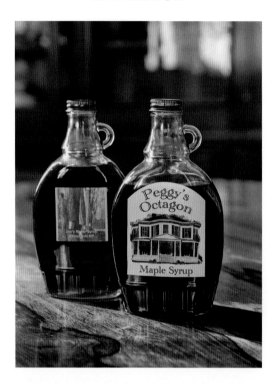

Approaching the picturesque structure that friends Huck Hill and Jon Lawson built twenty years ago on the property at Hill House, Huck's historic octagonal family home in Rhinebeck, renders an experience foreign to twenty-first century eyes. The chimney spewing the smoke and vapor that is a result of processing maple sap into syrup conjures up notions of an earlier America depicted in Currier and Ives lithographs.

"The sap we collect is really the very first sign of spring," Huck said. Indigenous peoples in this region had been producing sap beer and syrup for centuries before the practice was adopted by European settlers. Maple syrup was the primary source of concentrated sugar in the eighteenth century before cane sugar plantations in the West Indies introduced their product to America. The trees store the starch in their roots and trunks before winter starts. This is then converted into sugar that rises in a sap during

the winter and is accessed through taps, or spigots, in late winter and early spring.

Spending an evening inside the Hill House where the bottling occurs, toward the end of winter, it is clear that the syrup production is subordinate to the fraternization going on. Huck and Jon were joined by John Corcoran, a sculptor who had initially started the production with Huck in another location near Shooks Pond in Red Hook, also in northern Dutchess County. On hand were a posse of local friends and neighbors. The social aspect of the Sugar Shack enterprise is much more informal when Jon and Huck are out in the dead of winter keeping the facilities in full throttle. Friends constantly stop by once the smoke and steam are seen billowing out of the chimney, signaling to the Town of Rhinebeck that the duo are at it again.

"I had pleaded with John and Huck ages ago; I wanted to become involved," Jon said, "It struck a

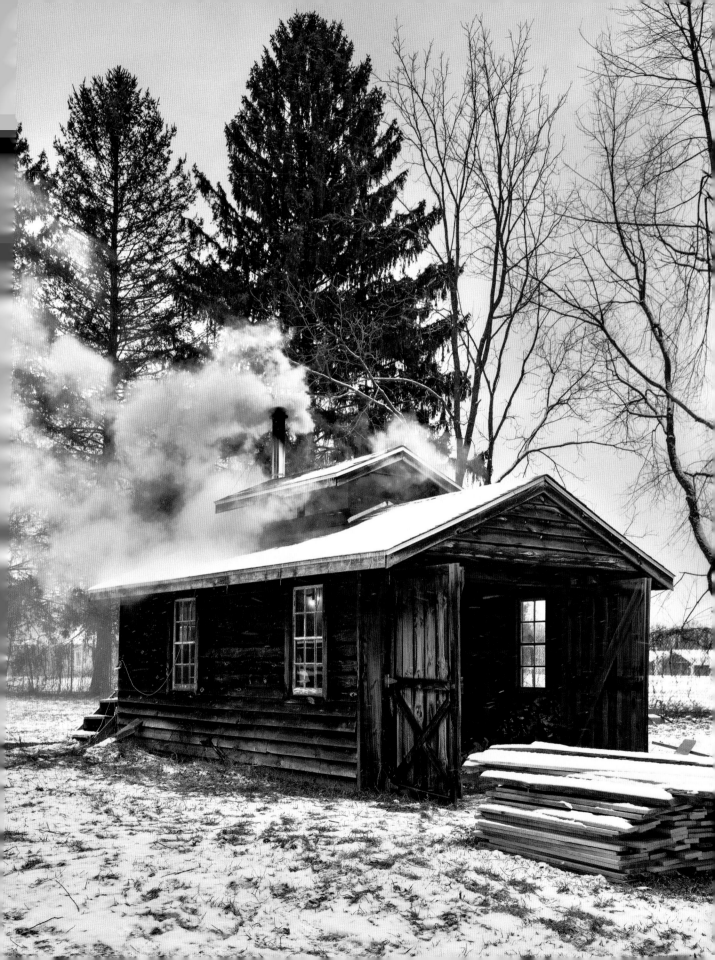

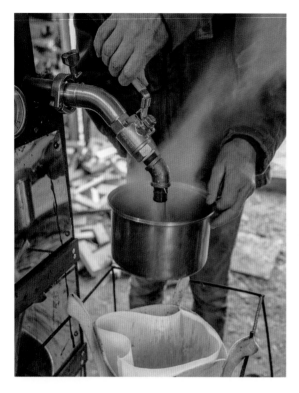
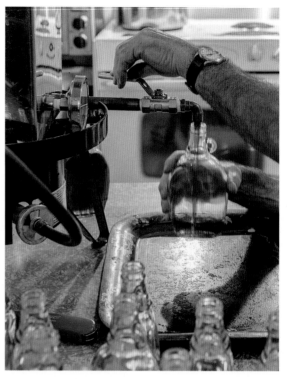

PREVIOUS PAGES: Bottles of syrup with personalized labels created by Jon Lawson and Huck Hill; Sugar Shack in full-throttle production during the dead of winter in Rhinebeck. ABOVE: Jon Lawson releasing the still-processing maple sap to be filtered for the first pass; John Corcoran in the kitchen at Huck's house for an evening of bottling. OPPOSITE: Jon (left) and Huck (right) stoking the fire in the old furnace inside the building.

chord since I had wanted to do this since I was a kid and then had seen everyone making it when I was at Williams College in western Massachusetts." When John made plans to go to Santa Fe to build an adobe house for two years, Jon got the green light. "Jon is a lighting designer for theater so he is very handy and can slap anything together," Huck said. "Being skillful and adept with tools really helps in situations where we are making this up as we go. We've developed quite a team work ethic here. It gets us out of the house and due to the cold, we're quickly very active; chopping the wood that's needed and getting the fire roaring."

This last winter on a hillside in Milan, a town nearby, they used plastic tubing instead of the old five-gallon metal buckets previously taken out of storage every year. The tubing, which expels the sap using gravity, is malleable and can be used on the much younger sugar maples that are at this location.

The one-hundred-year-old maples in Rhinebeck still require classic old buckets. The collected sap is then transferred to tanks in the backs of their trucks, then to holding tanks behind the shack. From there it is fed to a small evaporator, which in turn takes out the water and reduces the material to the beginnings of a syrup in a ration of forty to one (forty gallons of sap produces a gallon of syrup). The filtration process starts at this point with seven or eight passes through to obtain the purest liquid.

The sap collected at the very beginning of the season creates the sweetest product. The four- to five hundred bottles produced each season are filled with syrup and then labeled. Some are given back to the community as gifts. The labels on Huck's bottles bear the name "Peggy's Octagon Maple Syrup," along with an illustration of the facade of Hill House in homage to his mother and his family home.

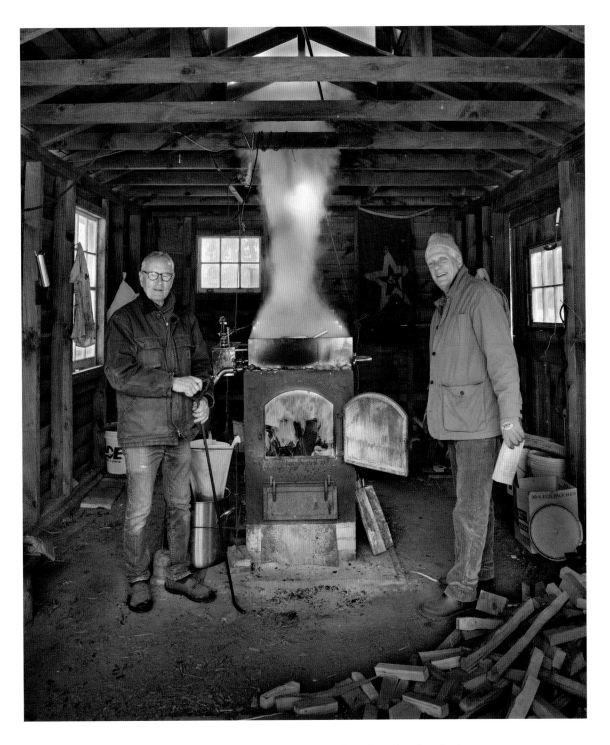

The sap we collect is really the very first sign of spring. In the region's bleakest season, coming here is a pleasure. Everybody likes a fire, and I guess men like chopping wood.

—HUCK HILL

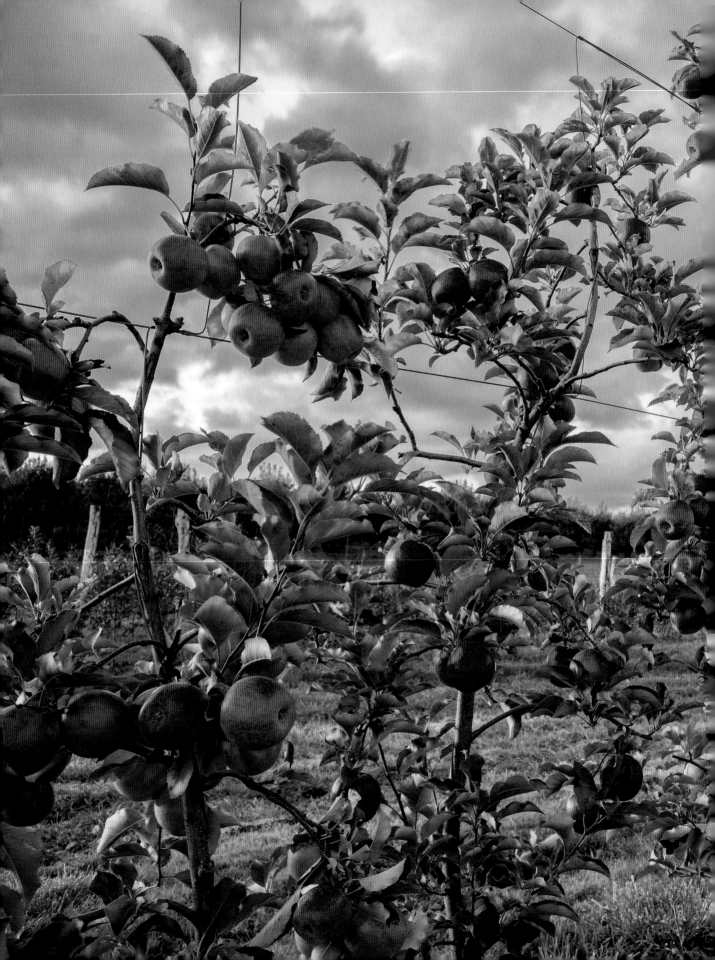

MIGLIORELLI FARM
RED HOOK

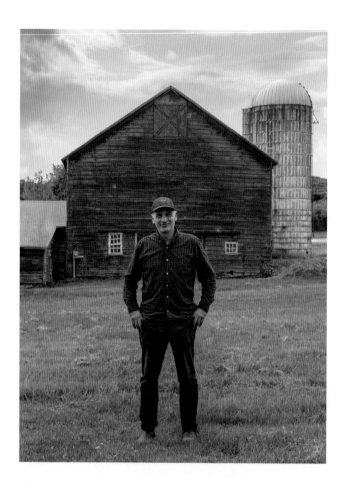

n the spring of 2023, I woke up to the unwelcome sound of fire engine sirens. When I went outside to see what the emergency was, I realized that disaster was much closer than I had thought; I had a clear visual of the barns at the neighboring farm, used by Ken Migliorelli to store his equipment, which were engulfed in flames. "When you go there now, it is like attending a funeral," Ken said. Deeply woven into the local community, he shared that "it almost feels like *It's a Wonderful Life* kind of story." There was such an outpouring of community support for Migliorelli Farm, which produces vegetables and fruit.

When I met up with Ken at the From the Ground Brewery, which was opened in 2015 by Jakob Cirell, in Ken's apple orchard, I welcomed him with mention of his superstar reputation in the region. He said, "I am not feeling much like a superstar these days." His response is testimony to the profound challenges that

farmers face. Farming 650 acres like Ken does requires an ability to pivot on the head of a pin. Farmers need to anticipate the next catastrophic disruption. But the overriding ethos I have witnessed, with Ken a great example, has been to wake up the next day and get on with it. "The normal farm activity has to continue," Ken said. "The show has got to keep going."

The patriarch of the family, Ken's grandfather, Angelo, came over from Italy as a teenager after fighting for his country in World War II—and worked on the construction of the Holland Tunnel before eventually purchasing several lots in the Bronx to

PREVIOUS PAGES: Ripe apples ready to be picked from the Migliorelli orchards along the hills in Red Hook. ABOVE: Ken Migliorelli standing in front of his barn on the western fields of his farm. OPPOSITE: Crates of apples await delivery for the farmers market.

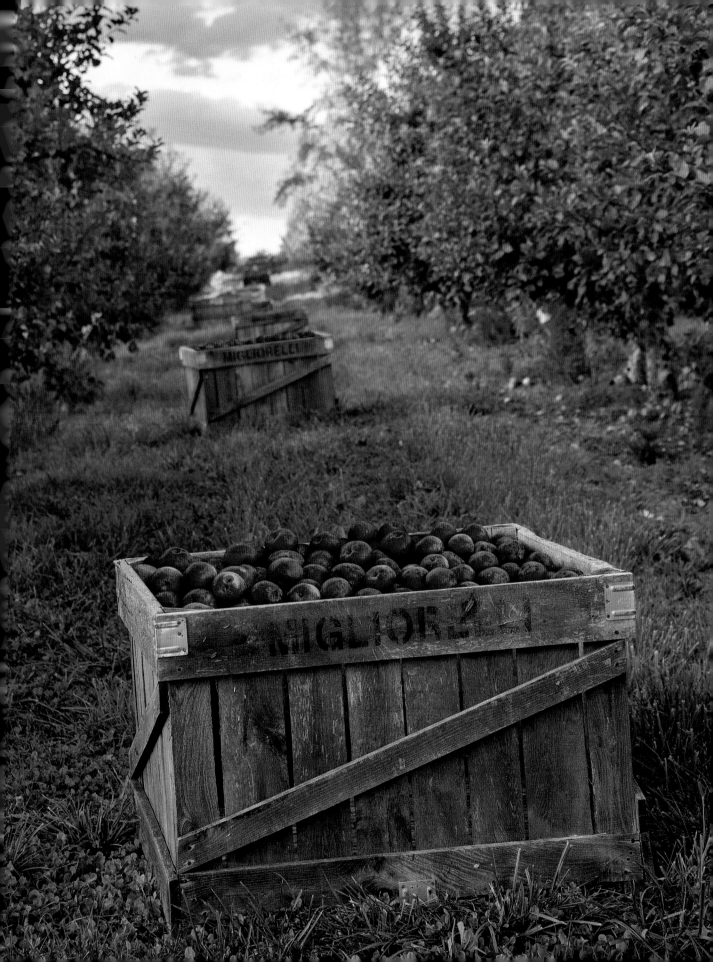

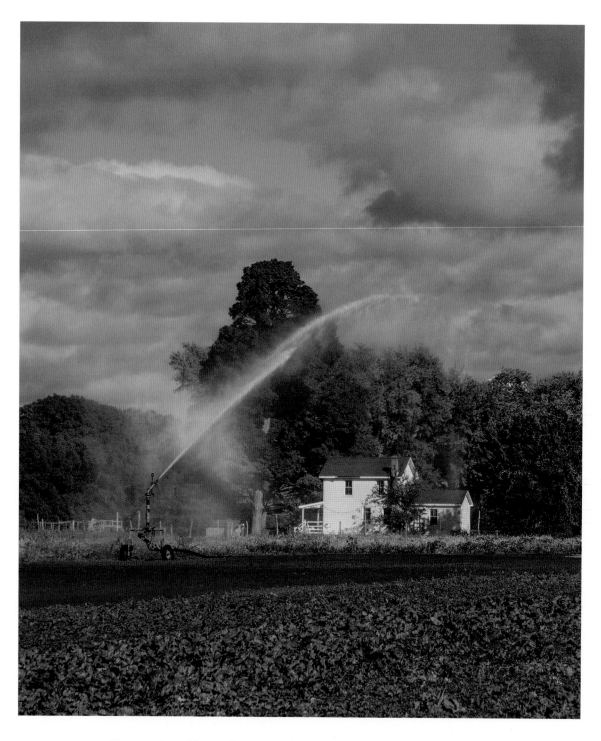

The people making policy are not farmers. We are faced with a moment when we are hiking up the hourly wages for workers. The farmers in New York State have unions and the farmworkers should as well.

—KEN MIGLIORELLI

start his own farm. The first year he collected the fertilizer and seed needed in his two-wheel pushcart. Soon after he saved enough to afford a four-wheel wagon and a horse to pull it. He used it to carry the vegetables, dandelion greens, arugula, and fennel he grew to sell at market in the city.

When his grandfather died in the 1950s, Ken's dad, Rocco, took over the farm in the Bronx. Things were becoming mechanized at this time, but his father was old school and resisted new techniques and machines. "We were one of the last farms in the Bronx," Ken said, explaining that the property is now part of Co-op City, the largest housing cooperative in the world with 44,000 residents.

In 1970 Ken drove up from the Bronx to visit his uncle, who had purchased Linden Farm in Red Hook the previous year. It was Ken's first time walking through a dairy farm, which then had around one hundred cows. This was unfamiliar territory for Ken, who was raised on a small vegetable farm. Eventually this dairy farm was folded into what has become Migliorelli Farm. Shortly thereafter, Ken and his family moved into the Second Empire farmhouse on the property, built in 1855 by Henry Staats for his son Abraham. After studying agronomy (soil and crop science) and agricultural business, he took over the accounting books of the Red Hook family farm in 1981. "We weren't making any money," Ken said. "We owed 20,000 dollars. It was time to turn that equation around."

In 1982, Chris Barrett, who then owned Staats Hall, suggested that the Migliorellis explore selling their produce at Union Square Greenmarket in New York City. This groundbreaking urban oasis offering farm-grown produce was conceived in 1976 on the northern edge of Union Square by Barry Benepe, an urban planner who grew up on a small family farm in Maryland. Architect and landscape designer Calvert Vaux, along with fellow Central Park designer, Frederick Law Olmsted, had reimagined the square in 1872 creating the Women and Children's Pavilion, which overlooks the open space now used for the market. For more than thirty years Ken departed Red Hook at 2:30 a.m. on market days, drove down to Union Square, returning to Dutchess County exhausted at the end of the day.

OPPOSITE: Water from on-site ponds being used to irrigate the vegetables on Budds Corners Road. ABOVE AND BELOW: Produce for sale at the Migliorelli Farm stand.

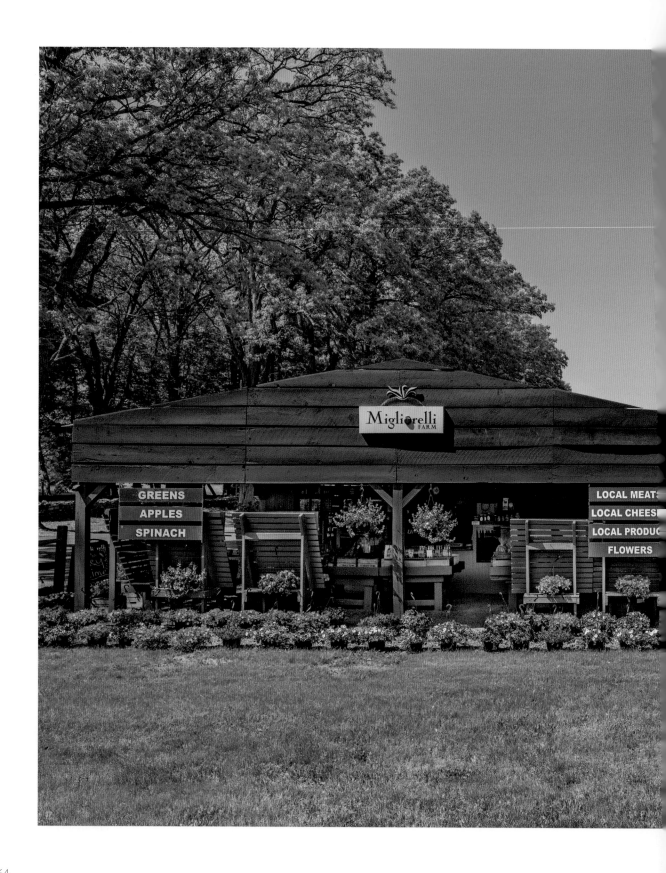

The time spent at the markets put the family in the black, as they were able to charge four times the price for produce previously sold through the wholesale market. This was the time when the city's relationship with the public, restaurants, and fresh food was blossoming. New Yorkers appreciated the accessibility of farm-fresh produce coming from upstate and not having to rely solely on supermarket produce. Chefs like Danny Meyer opened their restaurants near the market so that they could access the best produce with an immediacy previously unavailable. This was the period when ingredient sources began being provided on the menu and anecdotes delivered by the waitstaff about the origins of what the guests were ordering became ubiquitous. The restaurant Craft, located two blocks away, still has Migliorelli Farm printed on the menu as one of its purveyors.

Ken said, "Ever since I was a youngster, watching a crop go from seed to fruition was fascinating. I love the growing process, but the business is difficult, and I worry about the bottom line every day. Farmers need to be the most resilient people in the world."

Woody Klose at neighboring Echo Valley Farm called Ken in 2001 to tell him that the person renting the beautifully sited farm stand at the entrance to the Kingston-Rhinecliff Bridge in Rhinebeck was looking for another tenant. Might Ken be interested? In fact, he was, and shortly thereafter Ken signed an agreement for one of three local farm stands, this one on the grounds of an apple orchard owned by architects Calvin Tsao and Zack McKown.

Today the farm, run by third and fourth generations of the family, grows more than 130 different varieties of fruits and vegetables, including the same strain of arugula that Angelo brought with him when he immigrated to America. In 1998, Ken sold the farm's development rights to protect the land through a Scenic Hudson conservation easement, ensuring that it will remain farmland forever.

LEFT: The Migliorelli Farm stand is located at the intersection of the entrance to the Kingston-Rhinecliff Bridge and River Road in a field that was originally part of Steen Valetje, one of the historic Livingston estates built along the Hudson River.

HUDSON VALLEY HOPS & GRAINS

ANCRAMDALE

Stuart Farr was born on his family farm near London, England, and began ploughing the fields at eight years old. He graduated with a degree in Plant Science from Newcastle University and went to work in business management for a British firm specializing in agricultural consultation, so it's no surprise that when Stuart discusses his business model for growing grains in the Hudson Valley, he does so efficiently.

Moving to America following a switch to software development, Stuart met and married his wife, Sarah James, in 2001 and began yearning to return to the agricultural realm of his childhood. He began reading about classic farming books in the *London Review of Books* that discussed regenerative soil practices. This inspired him to return to farming. One refrain repeated in these books was that plants don't get attacked by pests if they have proper nutrition. Stuart said, "Most people think it takes centuries to grow a large amount of topsoil and that livestock was crucial in fertilizing the material. This went against everything that I had learned at university where I had been taught a very specific way of generating topsoil. Doubting Thomas that I was, I read a ton of books. . . . I realized that I needed to kick off my old boots and start over."

Throughout the second phase of Stuart's research, he came upon newly rediscovered traditional techniques utilizing the simple concept of crop rotations, the bedrock of every agricultural system until the middle of the twentieth century. It is during that period that synthetic fertilizers were almost exclusively used for soil preparation.

Living soil is a visceral thing. You have to see it, smell it, and watch it perform over time. There were no earthworms in the soil when I purchased this land—but now there are.

—STUART FARR

Soon Stuart was experimenting with different cover crops and mixtures. He planted rye in September, and in February or March, he used the technique of frost seeding clover in the fields. The freeze/thaw cycle moves the clover seed cover crop into the ground, negating the need to till the soil. When the soil heaves up and then contracts, the seeds will be caught in the cracks. When the soil warms in the spring, the seeds will germinate. Using this procedure allows for the clover to still be present once the rye is harvested in July.

In 2015 Stuart and Sarah moved to Columbia County after checking out the soil on different farms over a two-year period. His prerequisites included the ideal amount of acreage that was not too hilly, open land for grains, and soil that was a bit gravelly for drainage. The property that they decided upon was being farmed with conventional techniques that were not serving either the soil or the bottom-line profits. Seeing potential, Stuart started with planting sunflowers, clover, and black beans along with buckwheat, rye, and wheat.

Through trial and error, Stuart figured out what would grow well using minimal tillage, or, as with the oat fields, no tillage at all. Here we come to the subject of minimal tilling, which so many farmers are practicing as a means to replenish soils that might have become depleted over the years. This technique practiced by the early Dutch farmers in America gradually disappeared by the 1940s. Stuart has experimented with many approaches. His biggest challenge has been adapting his machines to be less invasive to the soil so that he can maintain the

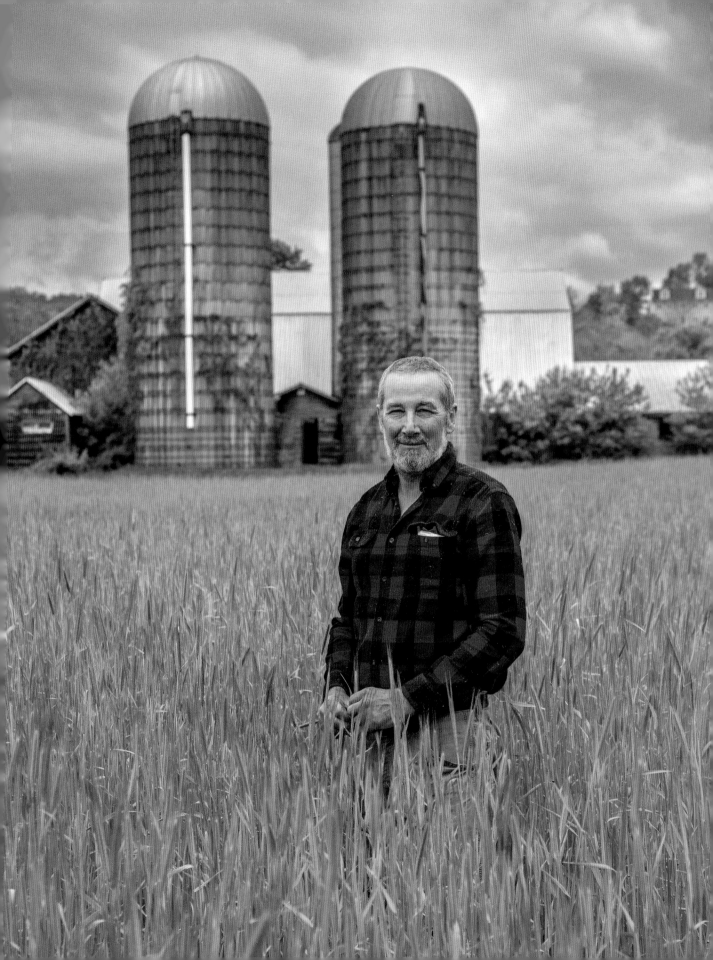

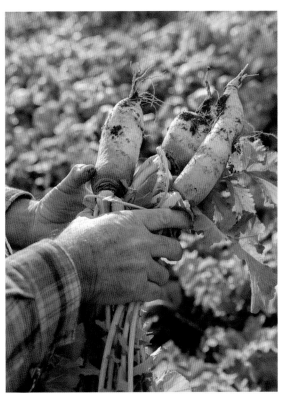

PREVIOUS PAGES: Stuart Farr of Hudson Valley Hops & Grains surrounded by a field of rye. ABOVE: Turnips are used as a cover crop during the off season. LEFT: A picturesque white fence runs through the hilly acres of hard red winter wheat.

intricate biologic microcosm found embedded in the soil. The fungi and bacteria necessary for supplying the earth with its nutritional needs are ripped apart through tilling, destroying crucial elements that support the healthiest crop growth.

Some of his fields are shallow tilled, some are strip tilled, which means that only specific rows are disturbed, leaving twenty inches of intact clover meant to maintain the root systems inherent in the soil. The cover crops used, including turnips, radish, buckwheat, and sunflowers, build organic matter, suppress weeds, and provide the nitrogen needed to grow grains and produce. They also keep the soil from eroding because of root loss.

Using a plant sap analysis, a "blood test for the soil," which measures and analyzes different excesses or deficiencies in minerals and trace elements, Stuart

has been able to achieve optimal soil for his grains. "There has been a lot of discussion regarding human degenerative diseases due to trace elements found in the soil throughout the twentieth century," he said. "Using GMOs and the devil itself, Roundup, to rid fields of weeds, perverts the soil's ability to uptake certain crucial materials like zinc and manganese. After testing the sap, we can utilize remedies like tiny quantities of fish, kelp, or molasses and other trace elements, parts per million, to jump start and then drastically improve the quality of the soil's infrastructure. Once the plants are established, the microbes are fed with root exudates, which then release compounds kick-starting the desired biological process. This is all heresy from my previous education, which relied on chemicals to option the short-sighted version I am now able to produce for the long haul.

ABOVE: A detail of an ear of hard red winter wheat (left); a single ear of rye. LEFT: A close-up view of a patch of red clover. OPPOSITE: Bagged einkorn wheat ready to sell; the press extracts oil from the seeds of sunflowers.

I spray with all organically sourced minerals, which creates an atmosphere for the most healthful grains possible. Once we have perfectly functioning soil, we shouldn't have to add anything. Earthworms are the acid test to see if you have functioning soil." Stuart dug the soil down under our feet and produced a handful worthy of Medusa's coif.

After the red wheat, rye, einkorn, oats, buckwheat, sunflowers, canola, black beans, and hops are harvested, dried, pelleted, and packed on the farm, the products are then delivered to Sparrowbush Bakery in Hudson, Kings County Distillery at the Brooklyn Navy Yard, and Blue Hill at Stone Barns in Pocantico Hills, among other venues. Stuart tells me that his business has been generated in the old-school manner, through word of mouth.

Modern science has proved important but reflecting back on what evolved over centuries of people paying strict attention to the land is now being utilized again to great benefit. Regarding not tilling the soil, Stuart said, "My father would have loved this. He would tell me, I told you so!'"

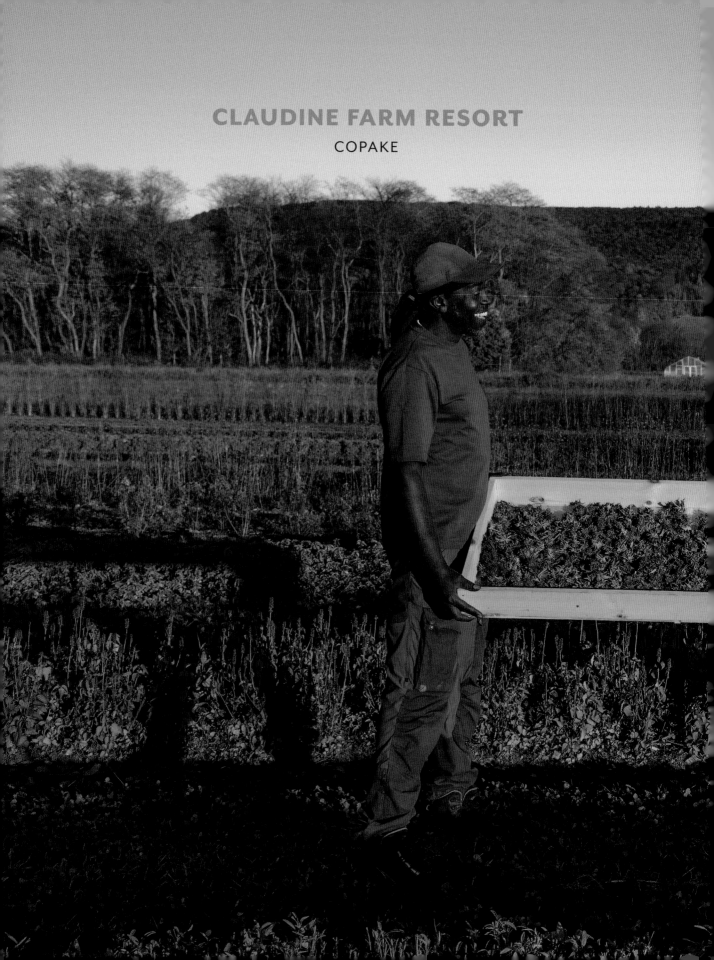

CLAUDINE FARM RESORT

COPAKE

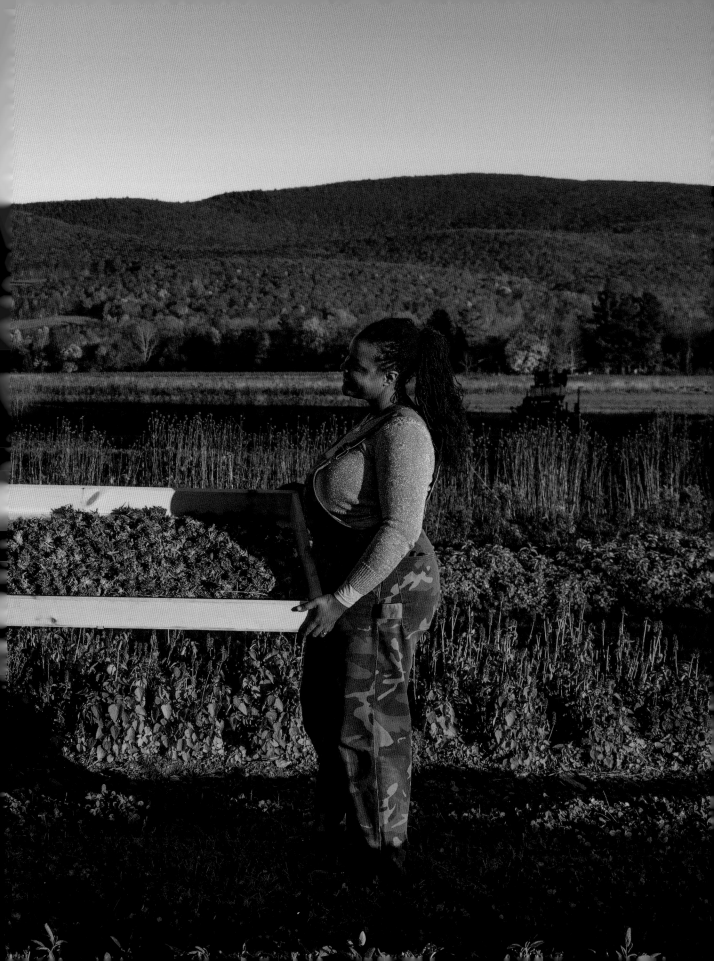

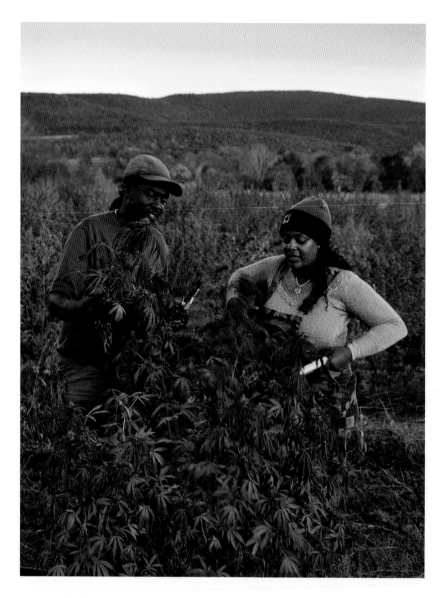

Aswad (King) Sallie told me that "farming is the new hip hop," during my visit to the farm he cultivates with his wife, Jasmine Burems, in Copake. The couple met in 2014 at a yoga class in Brooklyn that King was teaching. He noticed Jasmine singing a song by Earth, Wind & Fire and asked if he could join her on his guitar, never thinking that they would end up together. Shortly thereafter, in 2015, the couple moved upstate to Millerton with some string, a heavy rake, and a pitchfork.

The two shared an early appreciation of the healing power of plants. While King had spent time at his grandparents' farm in Cooperstown, New York, Jasmine grew up in Philadelphia observing her father, who was an herbalist. She later attended Sarah Lawrence College in Bronxville, New York. Returning to New York City after touring with the musical *Rent* as a dancer, King reflected on his experiences in urban and rural environments, with the latter resonating as where he would like to live. The couple charted their course and agreed that "there was more waiting for us outside of the city." They wanted to fulfill their dreams of raising a family close to nature. Both of their children, Nirvana and Zora-Nike, were born

here. "I want our children to experience abundance," Jasmine said, "to feel like they come from a place of plenty. There has been so much trauma in America surrounding food; I would like to recondition future generations. When you talk about farming in America, this can't be left out."

Their first efforts in farming involved the not-for-profit Claudine Farm Resort, which was named in honor of King's grandmother. Here they raised black-eyed peas in the tradition of the Gullah Geechee culture, Lenape blue corn, and Cherokee watermelons—crops that connected them to the earliest days of agriculture in America. As their business expanded, the need to diversify became apparent. Hemp and cannabis crops were slated

to become legal in New York State for the first time since 1937. "We were one of the earliest recipients in New York to receive a license to grow hemp. We spent a lot of time with politicians, locally in Columbia County as well as in Albany, the state capital, discussing how this niche agricultural product could influence urban and rural communities," King said.

In 2018, King and Jasmine founded the Institute of Afro-Futurist Ecology, with the goal of growing CBD (cannabidiol) hemp bred for high CBD and low THC (Delta-9-tetrahydrocannabinol) levels. Initially, their hemp farm focused on being a regenerative hemp incubator for participants in this region. They shared with the community the process of how to apply for licensing and once received, how to create infrastructure. The couple rented lodging nearby to provide housing for their friends from the city when they came up to help with harvesting. "We had to pull our friends onto the land so as to replicate our experience of racial equity," Jasmine said. "Our goal is to enlarge the community of Black farmers upstate.

PREVIOUS PAGES: King Aswad and Jasmine Burems at the end of a productive day in their fields in Copake. ABOVE: Separating the buds from the stalk through a bucking machine; a close-up view of a mature cannabis plant. OPPOSITE: The couple harvesting cannabis with loppers.

Cannabis doesn't come without some of the same risks inherent in other aspects of farming. We deal with nature, keeping our eyes out for a powdery mildew that can form on leaves. We have had to oxidize the leaves with peroxide, then dry them several times. The healthy plants are hand-trimmed, then slow dried and cured.

—ASWAD (KING) SALLIE

We had a feeling that CBD would evolve into legal cannabis; our desire to interface with the political entities that were legislating for this proved to be very helpful. We have seen the circle of grieving and healing that the subject of cannabis use has brought to our community and were determined to create an environment where young people were not being incarcerated for small amounts of weed. I had a lot of friends who grew up without a father for this very reason. There is trauma connected to farming in our culture. We were a people stolen to come to a stolen land. But, culturally speaking we can heal the earlier food desert." Along with cannabis, the farm is also growing vegetables and flowers.

King and Jasmine break into a complex scientific explanation of the hemp distillate from the labs that they have constructed and the live resin, which is solventless and made using ice water, heat, and pressure without harsh chemicals. "Sun grown and minimally disrupted" is how King referred to the recent crops of cannabis. He felt that their timing was wonderful and that they are now prepared for the first dispensaries in New York City.

"We get to say, 'This is ours.' We are self-sufficient. There is something very comforting for us in doing this while we face gigantic cultural issues," King said. "It's a good thing."

ABOVE: A successful day's collection of cannabis spread out on a tarp. OPPOSITE: King holding recently harvested plants from the fields while Jasmine prepares the next step of processing the cannabis in their greenhouse workspace.

PHILIP ORCHARDS

CLAVERACK

Although Philip Orchards has been farmed by the same family for sixteen generations, the Philips are trying to bring it responsibly to the twenty-first century. Leila, along with her siblings, Katherine, Tom, Bill, and John, inherited the apple orchards, outbuildings, and magnificent principal residence, Talavera, in 1992. Today, all of the Philips play crucial roles in the management of this property.

Their father, John Van Ness Philip Jr., who went by his middle name, took over the farm in 1973. "He had a great affinity for farming, especially the trees," Leila said. "I had always thought that his deep ties to the land were in some way connected to his time in World War II." In a period when men didn't commonly discuss their emotions about the ordeals of war, the natural world he found here seemed to provide solace for him.

Van Ness also had an evolved business sense, being the first in the area to transform the apple orchards into a pick-your-own operation in 1964. "There was a system in place . . . where Haitian immigrant workers were brought up here during the season, given substandard housing, and were completely disconnected from the community," Leila said. "Neither of my parents were comfortable about the social aspects of this situation, so they started placing ads in every paper imaginable, 'Pick your own, pick the best' to lure different groups up to Claverack to collect the fruit for themselves." Though the word *klaver* meant clover in Dutch and *rak* may mean meadows or pastures, depending on context, some historians say the town's name is likely not referring to clover meadows but to landmarks along the river in that area that were designated in early maps by trefoil shapes.

> *Growing local food and providing food security for the entire region has never been more important.*
> —LEILA PHILIP

After I heard the complex story of this farm, it became clear that at different moments in its history the business model had changed. The family today is finding itself at such an inflection point. Philip Orchards is not a story about massive wealth but of a middle class that, in this case, started forming in the early nineteenth century. Leila said, "When my dad passed in 1992, I realized that I didn't know very much about the history of the place." As a way of remedying this, she authored the book *A Family Place: A Hudson Valley Farm, Three Centuries, Five Wars, One Family*, published in 2009, which documents the story of the family and the farm.

Living in New York City while growing up, Leila and her siblings would spend weekends in Claverack with their grandparents. "It wasn't just the traditional city and country equation, but it was the fact that these were different worlds entirely," Leila said. "It felt like going home when we came here. We would drive a few miles to Hudson to do errands. There were no antiques shops then, only one junk store."

This tract of land had been granted in 1629 to Patroon Kiliaen Van Rensselaer, one of the founders of the Dutch West India Company. The family still possesses a half-burned sheet of paper from Admiral Aert Van Ness's logbook declaring that he was going to ". . . sweep the English from the seas." Close to a century later, William Van Ness began designing the present house, Talavera, in 1805 on the grounds of the original Dutch family's residence from 1732. When William became a United States district judge, he established his own personal branding identity. Part of this was building a home using the more fashionable English vocabulary. For a man with even greater

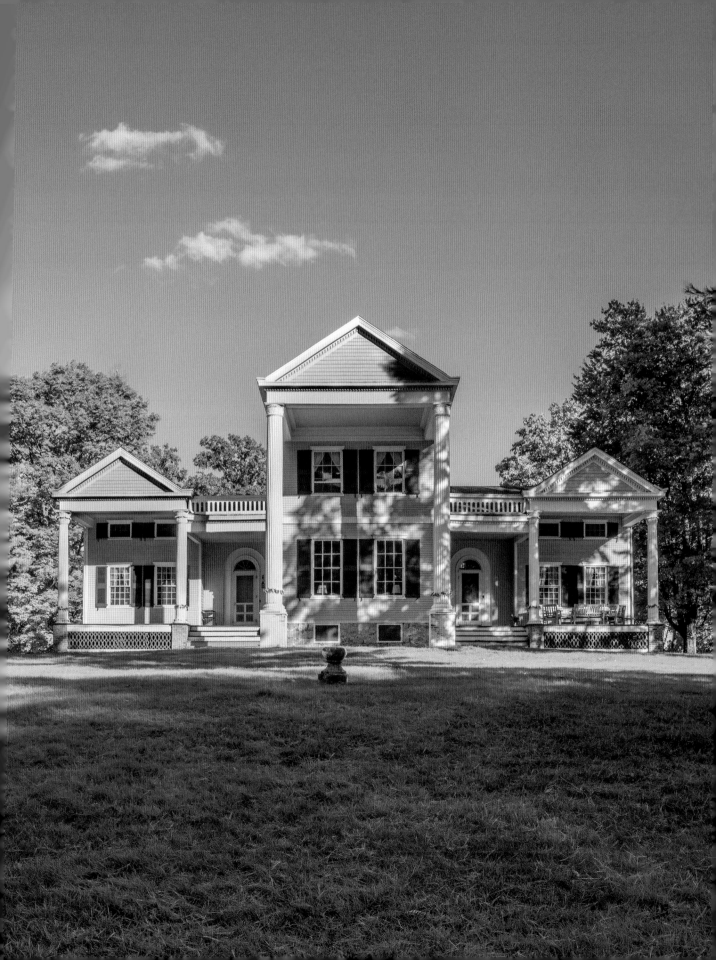

PREVIOUS PAGES: Talavera, the Federal-style home of the Philip family was built in 1805 on property that has been in the family for sixteen generations. ABOVE: A magnificent maple tree during peak apple-picking season on the approach to the principal residence. OPPOSITE: The stone gatepost at Talavera covered in fall foliage.

*My mom, who was an innovative thinker, was the first woman to run this farm,
which was unusual at the time. She slowed down the mowing so that wildflowers
could thrive, thereby creating pollinator fields that in turn hosted wild bees.
She reduced spraying . . . much to the consternation of the salesmen
repping the chemicals. She dug out the back pond to increase water supply,
creating a wetland area. She began to let the 'wild' enter the farm.*

—LEILA PHILIP

legal career aspirations, lots of columns did the trick. Although there are design references to Charles Bulfinch, the Boston classical architect, in the mantels and to architect Benjamin Latrobe in the massing, this home remains an American anomaly. Leila's mother, Julia, affectionately referred to it as "William Van Ness's foolish house." The name of the family's home references Napoleon's 1809 defeat in Talavera, Spain.

It wasn't until much later that attention to the Dutch lineage of the family resurfaced during the period that Leila's grandfather Major John Van Ness Philip was at the helm. He had a close relationship with their neighbor, Franklin Delano Roosevelt, before FDR, who was a great advocate for the region's Dutch heritage, became president. She discovered a tranche of historic documents while researching her book, including farm journals and many original A. J. Downing volumes on pomology and horticulture, all annotated by her ancestors. This has proven to be an important documentation of early American agricultural practices.

Following the opening of the Erie Canal in 1825, farming in the Hudson Valley evolved to include apple orchards. Smaller farms in the area had to change with the times or close as the massive open wheat fields in the Midwest were able to offer grains at lower prices and these farmers could now reach Manhattan's port through the canal. Later, with the introduction of the automobile, hay became less important since horses were replaced for transportation. Washington State started growing apples on a massive scale during the nineteenth century, creating further

challenges to the well-established apple-growing businesses in the valley.

Leila's recent book, *Beaverland: How One Weird Rodent Made America*, connects the dots of regional history, finance, and present-day farming. The raison d'être of the original settlers here in the early seventeenth century was the fur trade, with beavers being the holy grail. The beaver pelts were used for making fashionable hats. John Jacob Astor's trade in fur made him America's first multi-millionaire. But the cost of excessive trapping, which decimated the beaver population, eventually became clear in the loss of the complex water systems created by the beavers and their dams that had supported the spectacular agricultural land.

Generational transfers of property can often be challenging for large families. Leila said, "We need to find a new way of addressing monoculture that is both good for the earth and economically viable. . . . There are so many exciting practices that are being implemented," she said. "Here, we need to think about carbon sequestration, water, and riparian restoration [wetlands], so that we can get the best hydrol-ogy possible in the fields. The crops that we grow are no longer the only priority, but what needs to be done for soil health is emerging as something that everyone needs to think about."

The Philips are exploring different paths forward. Leila said, "To grow apples in a monoculture environment, you have to use pesticides and fungicides. I can't justify continuing that. One of the goals is to replenish the soil biome, plant trees that from the beginning can develop the ability to fight off pests. These old apple trees are beautiful but expensive to maintain, and we need to plan and invest in this transition." Hopefully the new apple trees and contemporary practices of the farm will help sustain Philip Orchards for another sixteen generations.

ABOVE: The family encourages visitors to pick their own apples using these extenders for higher access; signs on the wall with the identification of the various apples available that day for picking. OPPOSITE: Looking up into one of the older apple trees. FOLLOWING PAGES: An accumulation of colorful graffiti and signage over the years lines the walls of one of the barns on the property.

ABOVE: Leila Philip and her brother John Van Ness Philip III sitting on the southern porch of the house they share with their siblings. OPPOSITE: The interior rooms of Talavera contain ancestral portraits and collections of Federal and Classical furniture put together over many generations by the family.

LASTING JOY BREWERY

TIVOLI

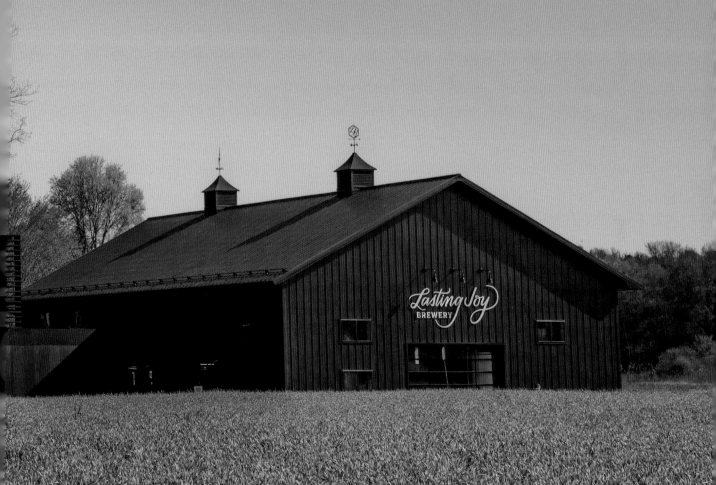

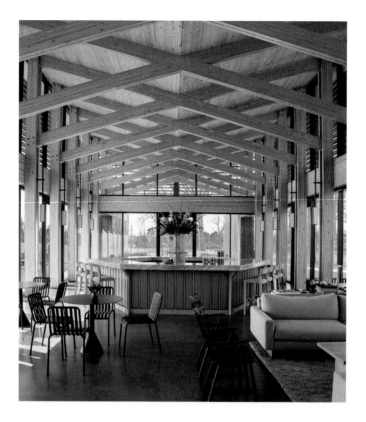

How long is joy supposed to last? I found the name of this brewery challenging because of the Buddhist teachings that my mom passed onto me. From what I had learned, joy is a fleeting emotion. These ideas circled in my head as I approached the brewery's structure that appeared to be an incongruous architectural expression in northern Dutchess County.

On a brilliant fall day, I met Emily Wenner, who, with her husband, Alex, has established a brewery that offers highly specialized craft beers. My appetite was whetted. I asked Emily why the name Lasting Joy Brewery? She responded by telling me that their goal was to create an environment that evoked enduring joy.

The duo designed the brewery as a family-friendly destination. "This is a place for locals as well as out-of-towners. We are a little tucked away, off the beaten path here," said Emily. Alex spent a lot of time in the immediate area visiting his family, who, until recently owned Teviot, an 1840s Gothic Revival-style villa on the Hudson in Tivoli. "He really loved the area, so we decided to put down roots one town

over in Milan and dedicate ourselves to celebrating New York agriculture with this place." And now, with four kids, here they are.

The couple met while at the Berkshire School in Massachusetts and have been together since. They started researching a move from New York City to upstate permanently in 2018. Plans were in place for the brewery by the winter of 2020 and the opening in the summer of 2022. They were able to receive a farm brewing license through a program started by Governor Andrew Cuomo where there were special accommodations made for businesses that exclusively use products grown in state (which fortunately was to be the case for the Wenners). The brewery got off to a strong start as word got around.

PREVIOUS PAGES: The COR-TEN steel pavilion designed by Aron Himmelfarb from Auver Architecture sits in a field of barley. ABOVE: The interior of the building has a bar in the center with drafts of the brewery's beers available behind the counter. OPPOSITE: A flight of beers in a tray made by local carpenter Keenan Farrell.

The whole [beer] industry has been traditionally made up of bearded white guys. We wanted to change the business model a bit so that we can have a more diverse customer and employee base that might not ordinarily navigate towards this area.

—EMILY WENNER

Emily said, "Beer had a me-too moment two years ago [in 2021] where it became evident that change was needed to get rid of the 'boys club' atmosphere. The days of harassment were no longer acceptable, and the fact that there was really only one demographic going into the field was tapped to evolve." To illustrate this point, Emily refers to the Brave Noise initiative they adopted for the brewery, which advocates for a safe workspace with no place for harassment.

Aron Himmelfarb's Manhattan firm Auver Architecture designed Lasting Joy, referred to as "the pavilion." He had met the couple while designing their nearby home in Milan. "Since this was going to be something built from the ground up and not an afterthought added to an existing barn," Aron said, "we had the luxury of really digging in and finding the best way to connect the tasting room to the site, which had previously been farmland. I wanted it to feel more welcoming and intentional than some of the tasting rooms I visited while doing research in the region. It is close enough to the attached actual brewery so guests can visit and experience the process in action while brewing was taking place but separated so that they are not inundated with the process if they just want to socialize. I came up with the inverted ceiling and relationship of the wood trusses with the glass so that we could have the maximum amount of light streaming into the space year-round."

I learned from Aron that his use of COR-TEN steel is a shout-out to local rustic farm equipment, but I can't help thinking that there is a reference to a Richard Serra sculpture here; perhaps a clarion call for nearby DIA Beacon museum visitors, after viewing Serra sculptures there, to head north for a beer.

Alex's degree in brewing technology from Siebel Institute of Technology in Chicago and experience working in breweries in Chicago and Coney Island prepared him for creating a brewery for himself and Emily. Now past their third season, Lasting Joy has found its footing. With the couple leading the way, they now have a manager, assistant brewer, and a staff, some from nearby Bard College, to help with serving. Alex oversees the milling of the grain, which is grown on site and nearby. Included in his selections are new

ABOVE: Some close-up views showing the fermenting and brewing process. OPPOSITE: The large beautifully crafted wooden barrels were manufactured by Foeder Crafters of America, based in Missouri, and the smaller wooden barrels are from Hillrock Estate Distillery in Ancram.

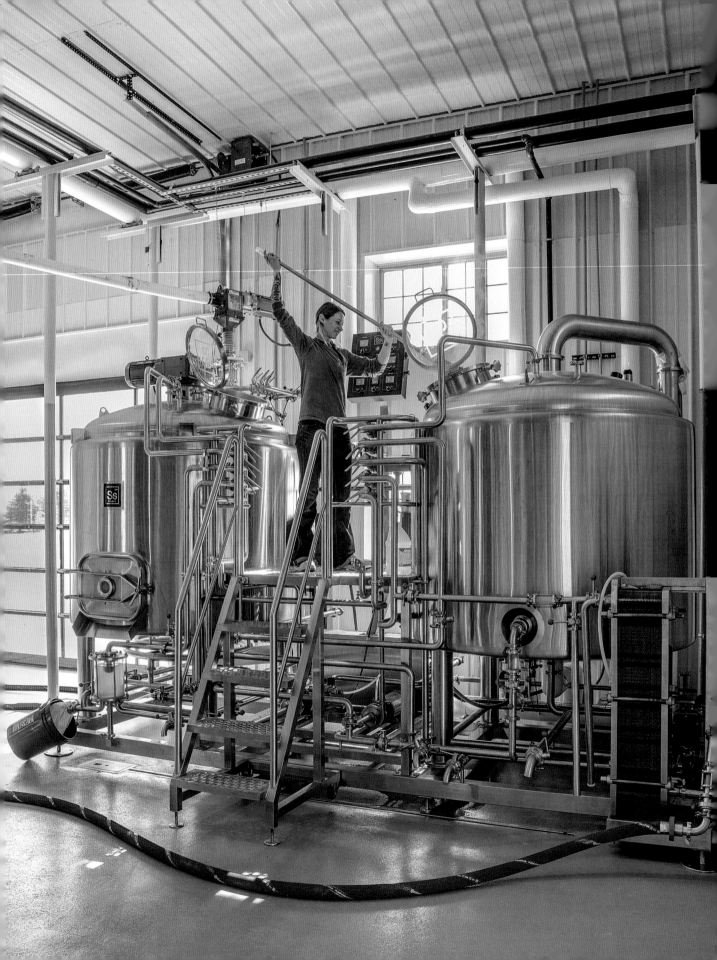

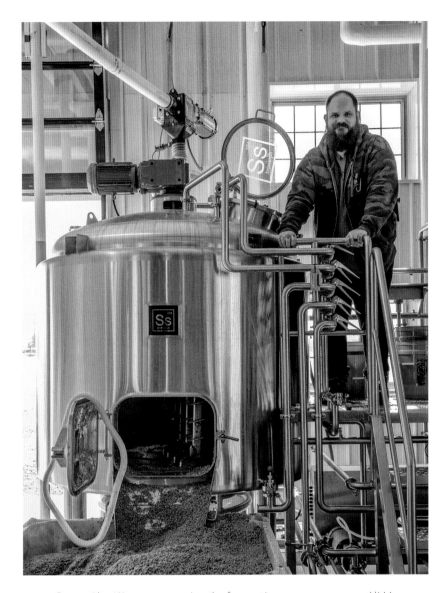

ABOVE: Owner Alex Wenner overseeing the fermenting process. **OPPOSITE:** Ali Moss, assistant brewer, stirring the mixture in the huge vats, which are controlled and monitored by the computerized panel located between them.

strains of barley that can handle wet summers. "We are not farmers, but we feel honored to be part of the awesome chain that is able to support local farms and agriculture," Emily said.

The Wenners' offerings are a blend of classic European beer styles with local ingredients. Maltster Dennis Nessel of Hudson Valley Malt is one of their suppliers. The milling and brewing spaces are state of the art, and to see the brewing process in action

paints quite a picture of the intersection between technology and nature. Steam, foam, running water, and what resembles a bubbling grain soup are all part of the process. The specific back and forth between Alex and assistant brewer Ali Moss during brew day is indicative of the tiny adjustments needed to create the desired product. In homage to their location, one of the beers has a label that reads "ILOVIT," which is Tivoli spelled backwards.

SHOVING LEOPARD FARM

BARRYTOWN

My first question to Marina Michaelles, the talented flower cultivator, who lives and runs this unusually named enterprise perched above the Hudson River in Barrytown was why the name Shoving Leopard. "This is a spoonerism for 'loving shepherd,' and Rokeby used to be a sheepfold," she said.

This all now makes sense, as Rokeby, the name of the property where the farm has located, was first referred to as La Bergerie, the sheepfold, by the original owners, John Armstrong Jr. and Alida Livingston Armstrong. While John served as US minister plenipotentiary to the court of Napoleon Bonaparte in France from 1804 to 1810, he and his wife had complimented the emperor on his beautiful Merino sheep at Rambouillet. Napoleon in return sent the couple back home to America with their own starter set. Shoving Leopard-Loving Shepherd—this play on words weaves perfectly into the cultural ethos of this family, which includes many extremely creative and successful artists and writers. Even Marina injecting "spoonerism" into the conversation reflects the eccentricities of this literary and artistic family, all of whom were raised on these four hundred acres of fields and gardens.

As Marina's uncle, Winthrop Aldrich, former deputy commissioner for historic preservation for the State Office of Parks, Recreation, and Historic Preservation (and fellow resident at Rokeby), writes in a short synopsis on the agriculture at the farm, some of the fields on the property were kept open by periodic burning by the Lenni Lenape prior to the royal patent that was granted to the family by the crown in 1688.

I have really come to understand how powerful flowers are in a person's life; they create a space for ceremony, and they change a space where a person lives or is trying to heal.

—MARINA MICHAELLES

The sacred three sisters of beans, squash, and maize were surely grown here. After becoming part of the holdings of Colonel Henry Beekman, this swathe of land was subdivided into lots of one hundred and fifty acres and leased out for three generation periods to the Palatine immigrants that had been brought over to America by the Livingston family. These settlers further cleared the land and established wheat fields that were to become the principal crop from this region in the early nineteenth century. It was Colonel Beekman's daughter, Margaret Beekman Livingston, who later passed this land onto her own daughter, Alida, and her husband, John, in 1811, following their return from Paris. General John Armstrong was a committed farmer and writer, and his revered volume *A Treatise on Agriculture* was published in 1845. At this time, the couple consolidated five adjoining farms into one 750-acre behemoth.

Marina gardens on a two-acre plot that surrounds a central labyrinth just southeast of the main house. Here, she is growing over three hundred varieties of annual, biennial, and perennial flowers, including zinnias, cosmos, amaranth, sunflowers, snapdragons, rudbeckias, dahlias, and many more. Most of the flowers are picked by Community Supported Agriculture (CSA) subscribers on a weekly basis during the summer and fall. The farm also grows hardneck garlic for local restaurants and garlic fans.

The idea for the flower business blossomed in 2001 after Marina had spent years working on other peoples' farms. She initially put down cover crops for several years to improve the soil quality. Then her initial business idea was to grow vegetables and

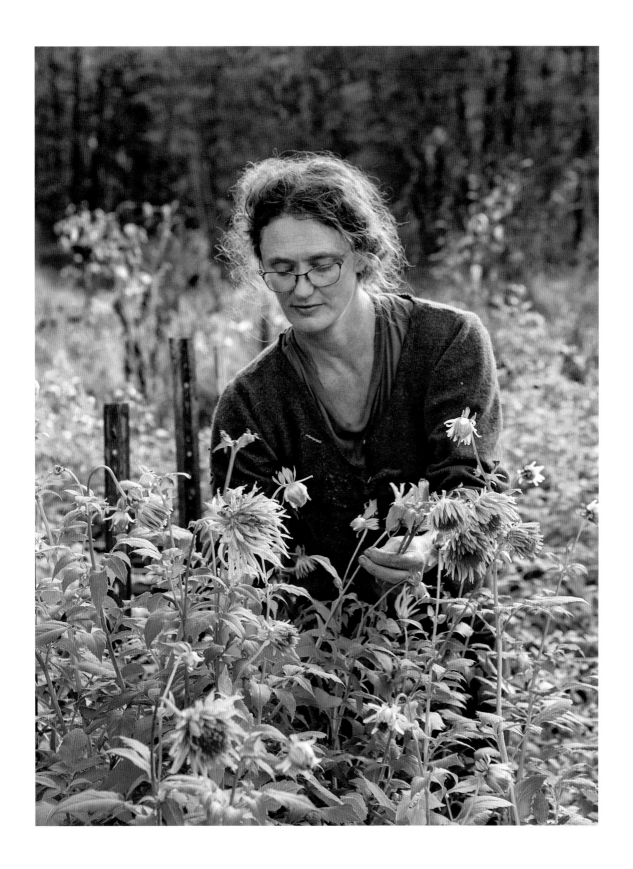

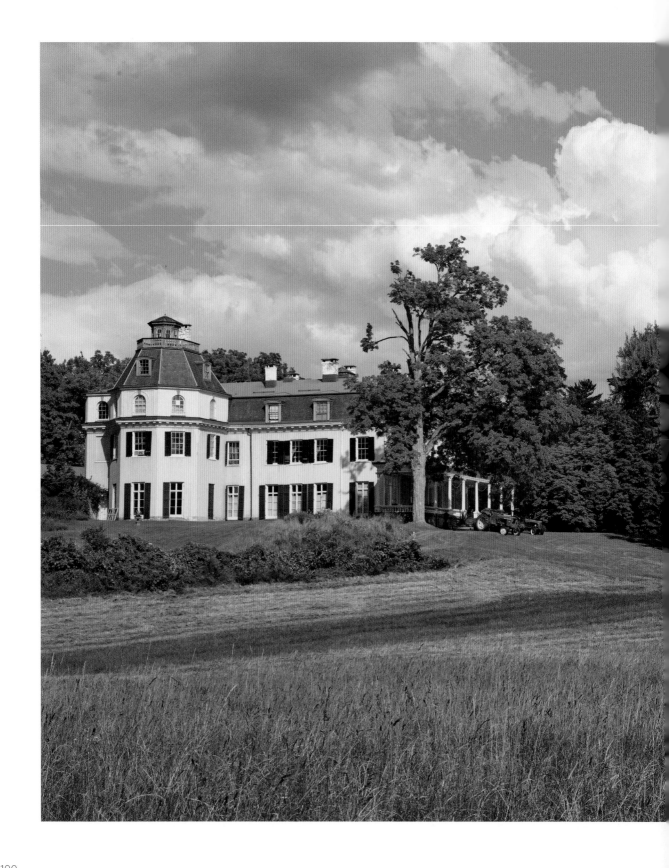

flowers and provide flower arrangements for festive occasions. But after many years of doing this, she was happy to let others do the arrangements for such events. "I much prefer having my hands in the dirt and leaving the designing to the artists," Marina said.

When I asked Marina to possibly create an arrangement to photograph for this book, she politely demurred, letting me know that her passion was the growing process and that her days of creating compositions are no more, despite all of her experience arranging flowers.

Certainly, it became obvious after spending the day with her in the garden that her passion for growing flowers was clear. "Thinking about the soil, the history of the land, both in terms of the ecology, and the human history is paramount," she said. "When I finally started the farm in 2006 and actually grew a crop for sale, I developed a CSA model for a market garden with vegetable production. I knew from the beginning that I wanted to sell only to local markets, and further connect the community to agriculture. After several years overseeing the CSA, I decided that I needed more social interaction as I am a bit of an extrovert, so I signed up for the Saugerties and Milan farmers markets, but as they already had vegetable growers, I decided to expand my flower selection so that I could bring something new to the market. That's when I got the flower bug." Amusingly, our conversation revolved around keeping pests like Japanese beetles at bay to maintain the farm's organic certification. Marina said, "I rely on the Organic Materials Review Institute (OMRI) certified fertilizers, well-finished compost, cover crops, and applications of compost tea and fish emulsion for fertility."

Today, much of this community's serious approach to regenerative soil practices takes precedence over the bottom line in their business models. This is diametrically different from the mid-twentieth century

PAGE 97: Marina Michaelles of Shoving Leopard Farm tending to the dahlias in her garden during the early fall season. PREVIOUS PAGES: Overlooking the flower garden, Marina's family's historic home, Rokeby, is seen in the background. LEFT: Haying is the main use for the western fields on the Rokeby property.

Abloom recycles flowers and delivers them to assisted living facilities, hospitals, and homeless shelters. The goal is to enliven spaces, spark feelings of compassion and dignity, and create a greater connection to nature.

—MARINA MICHAELLES

model when farmers were geared up to make corporate-level money at all costs following what they had been taught in agricultural programs. As a farmer with historic roots in these fields, Marina is a brilliant advocate for respectful stewardship. She said, "I use crop rotation, vegetative barriers, soap, garlic, and pepper sprays." She mentions on her website that she even uses "chicken detail, pheromone traps, and manual squishing for pest control."

In 2016, Marina started a collaboration with Rhinebeck interior designer Marla Walker and launched Abloom, a service that recycles flowers from weddings, funerals, and parties. Abloom creates new arrangements with the flowers and delivers them to senior housing and other locations that welcome these colorful contributions.

"In the flower and farming communities, there is a lot of interconnectedness . . . there is much idea sharing." She told me how lucky she is to be just down the road from Montgomery Place Orchards,

which has been selling tons of her flowers at their farm stand—more and more each year.

There have been many iterations of the Rokeby farm, beginning with wheat production, fruit orchards, ornamental landscapes, and a dairy with pedigreed Jersey and Holstein cows during the first half of the twentieth century, and now a flower farm. The magnificent blooms Marina produces here are part of an agricultural continuum that is a rarity in America.

But interestingly enough, despite different backgrounds and connections to the land that young farmers are working, the motives and the goals of so many farmers are similar.

ABOVE: Daffodils, statice, and lily of the valley are some of the earliest plants to emerge in the spring. OPPOSITE: The labyrinth flower garden at the peak of springtime. Marina spent several years preparing the soil before establishing the garden with the first crop.

JENNIFER SOLOW
EDIBLE HUDSON VALLEY
EAST CHATHAM

On September 11, 2001, Jennifer Solow met her future husband, Tom Jacoby. She was the creative director at the ad agency Kirshenbaum & Bond in San Francisco and was in Manhattan pitching a series of advertisements for a new brand of shampoo. The meeting started at 9:00 a.m. downtown, but, as the world learned, things then pivoted quickly. In the middle of the chaos with the Twin Towers of the World Trade Center imploding nearby, she and her coworker Lauren Schiller raced to the house of her friend's uncle, Tom Jacoby, in Soho. He was loading up his car to escape the unfolding mayhem and told his niece and Jennifer to get in his car, and then they promptly headed upstate.

They arrived at Tom's childhood home in East Chatham in Columbia County, and shortly thereafter the two began a relationship. He encouraged her to leave advertising and follow her dream of becoming a writer, so she took a writing class and became a novelist. The couple built the house where they now live in East Chatham, and she penned a bestseller, *The Booster*.

One of the risks of bucolic country living is Lyme disease, and unfortunately Jennifer contracted it while living upstate. She stopped writing fiction and turned to food blogs. She said, "I would procrastinate writing because I was so intoxicated with reading about food. Growing food was all that my Lyme-addled brain could handle." At that time her California friend Gibson Thomas, the former publisher of *Edible Marin & Wine Country*, introduced her to the idea of

becoming an *Edible* publisher. Jennifer soon began publishing *Edible Hudson Valley*, eventually adding *Edible Manhattan*, *Brooklyn*, and *Westchester* to the group's media company. She serves as the editorial director and CEO of the company, and her husband is the chairman.

Gesturing toward her vegetable garden outside the front door, Jennifer said, "The heart and soul of my work is that garden. With my magazines, my community got much bigger. I love to put farmers and chefs on pedestals. I really care about this community and food." In addition to the print and online publications honoring the regions farmers, Jennifer hosts community events in the Hudson Valley, including Dessert Disco; Food + Design; High Cuisine, a series of cannabis-inspired dinners; and Chaotic Cakes with cake influencers. Many of the events dovetail with the farmers and artisans featured on the magazine's covers.

After spending several afternoons with Jennifer, I understood her love of food. She said, "Really, it comes down to fact that I love to cook and eat. Even as a kid, sure, I drank Tab, but I also ate kibbeh nayyeh, which is a raw lamb dish, and alligator steaks." Every ingredient she selects to prepare pickled, poached, and preserved dishes comes with a story. There is a certain humor that evolved in the 1980s with my friends as we visited new restaurants and read the menus. "Why do I need to know the initials and precise geographic location of the person who collected my carrots?" I would ask my dining partner. Jennifer addressed this approach

> *This area upstate attracts a certain kind of person, and the energy of the influx is great. The person that gravitates up here wants to roll down the hill and pick daisies. The quieter life is appealing to them. People are really into the craftsmanship of their homes. Neighbors ask you how the sheep are doing.*
>
> —JENNIFER SOLOW

PREVIOUS PAGES: Jennifer Solow stirring a batch of black currant raw vinegar. ABOVE: An antique ladder doubles as a drying rack for herbs and peppers that are later crushed into teas and oils. OPPOSITE: A collection of seeds, including poppy and dill, and herbs like sage to throw in the fire on cold nights.

and said, "The chefs that I am most attracted to are the ones that are really interested in where their products come from, how it is made, where it is grown, and how it lands on the table."

Jennifer exhibits the same precision when planning her garden as the chefs that she writes about. "Cheese can be made with a freeze-dried culture," she said. "I make my cheese with local raw milk within forty-eight hours after it leaves the cow." It is the enzymes in the grass and what the cows are eating that imparts a sense of "terrior," referencing the French word that describes the complete natural environment in which a wine is produced, including climate, soil, and topography. Jennifer said, "The impact the environment has on what is being fermented is what makes really paying attention to food so interesting."

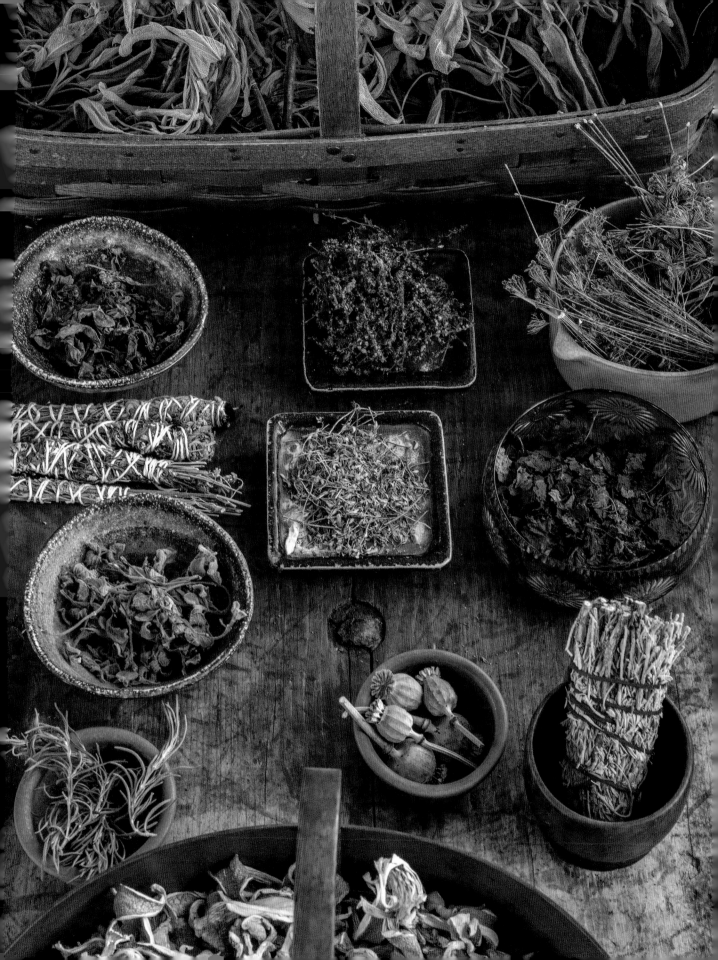

"These days I am focusing on food preservation, which I think is a culturally relevant topic," Jennifer said. "I'm experimenting with koji, which is a Japanese mold used in fermenting food. I'm also trying Calabrian methods of preserving peppers in oil. . . . Yesterday, I dried zucchinis in spirals on a broom handle." Presently, she is reading about the traditional growing methods of French farmers and trying to think about never having to go to the grocery store again. Jennifer said, "We buy so little of our food, just Fresca. I am a glutton about the garden. Blame it all on the seed catalogues. When I see pictures of ten kinds of cucumbers, I have to try them all. Then, once grown, what do you do with them? Pickles, India achar, jams, and chutneys, and so on. I then read a new book on another traditional preservation technique; and we are off to the races. My curiosity drives the process. I want to grow it, smell it, and eat it," she said. One long-term project taking place in Jennifer's kitchen is making shoyu, a Japanese-style soy sauce, which appeals to her patience because you must wait for the enzymes to break down. The same is true with miso (fermented soybean paste), which can also take a long time to break down and age. Jennifer is also spending a lot of time with honey; she is making a fermented version of charoset, a symbolic food eaten at Passover made with apples, figs, and her neighbor's honey. This is already a two-year process for her.

Jennifer said, "It is hard to see where this migration upstate is going since so many people came to live here during the pandemic, and *The Year in Provence* fantasy wears thin for some after a while. Some, maybe most, will stay, but some can't weather the reality. It is a challenge for our local farms and restaurants to survive."

I now understand why Jennifer is known as the "Voice of the Hudson Valley."

BELOW FROM LEFT: Peppers, including Mountain Longhorn (right), that have been smoked and will be used for making powders and rubs; winter squash that has been cooked in embers overnight; a bottle of oil infused with dried peppers. **OPPOSITE:** Jennifer and permaculturist Seamus Donahue in her kitchen garden under the wisteria-covered arbor, constructed using fallen black locust trees.

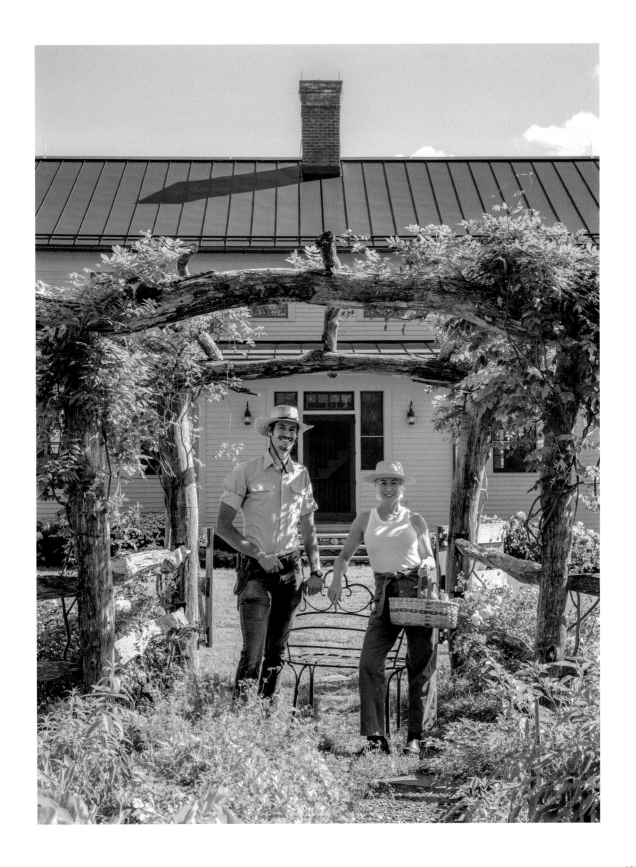

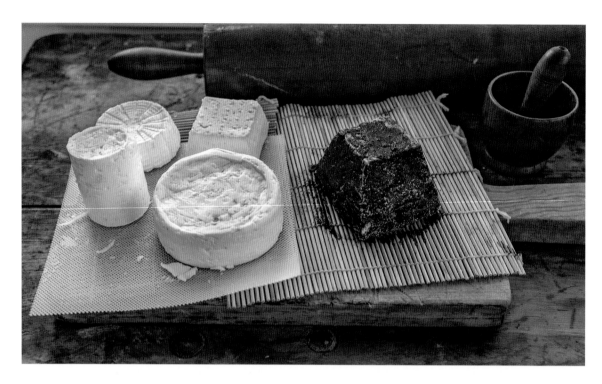

ABOVE: Several of the cheeses Jennifer prepares using local raw goat and cow's milk. All will go into her cheese cave to age and develop a snowy white Geotrichum rind. BELOW: A cast-iron pot filled with black corn that is used to make *chicha morada*, a refreshing Peruvian drink. Every year Jennifer makes a batch of Fire Water using her hottest peppers. OPPOSITE: An antique bottle found at the Brimfield Antique Flea Market with raw apple cider vinegar made from her orchard.

OBERCREEK FARM

WAPPINGER

Alex Reese's great-great grandfather built Obercreek in the 1850s, so his identity, it is safe to assume, is intertwined with this property. Obercreek Farm now sits on 240 acres on the Wappinger Creek close to the southern border of Dutchess County in Hughsonville, a hamlet of Wappinger. Alex and his wife, architect Alison Spear, started a farm stand on the property shortly after purchasing Alex's family home from his siblings in 2005, with the intention of providing the local community with fresh produce. Starting out as a dairy in the nineteenth century through the 1960s, the farm now offers a year-round selection of organic fruits, vegetables, and grains at their farm stand in nearby Wappingers Falls.

Alex said, "The soil here is different in every field, which can be frustrating, so we must be thoughtful on what we plant where and how we rotate the crops. We have mostly Knickerbocker loam, but these are all glacial soils. The fine-tuning of what goes where and when is always a learning curve." Obercreek's ability to be productive during the entire year is a result of the high (fabric-covered) tunnels covering more than six acres. The greenhouses also profit from passive solar heat through a plastic membrane. "The vegetables take twice the amount of time to grow under these conditions," Alex said, "but to produce salad greens in the winter is very satisfying."

Obercreek started out supplying local restaurants with produce, then expanded into a Community Supported Agriculture (CSA) system to further integrate the farm into the community. The amount of people shopping at the farm stand here on any given day is impressive.

The farm is managed by Alex Vaughn and Trixie Wessel, whose main office space is the old Obercreek

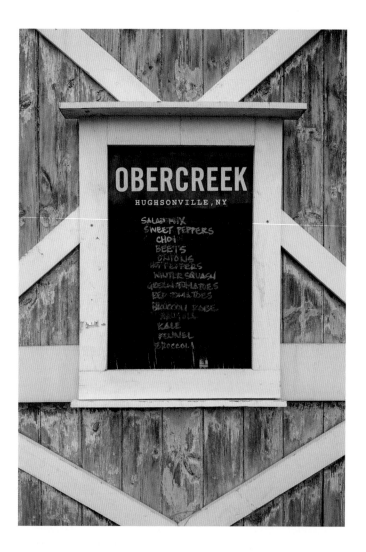

The economics of farming on a small or medium scale will always require a lot of thought. You must find your niche. We have navigated towards salad greens, but it really helps to be known for something specific.

—ALEX REESE

outhouse, which had been moved away from the house and onto the farm years ago by Alex Reese's parents. "We do our best to reach out to our community so that they consider stopping by the stand as one of their stops during their grocery errands," Alex Reese said. "We are now selling to Adams Market, which features stickers on produce grown within ten miles of the store, to signal to the customer local production. We must find new ways to incentivize

young farmers as land becomes harder and harder to purchase." The recent popularity of this region due to families moving here from urban centers has

PREVIOUS PAGES: The Obercreek farm stand is stocked with the farm's produce as well as items from neighboring farms. ABOVE: The CSA chalkboard lists items available for collection. OPPOSITE: A stone wall separates the 1850s house from a field of young paste tomatoes.

ABOVE: Margot, the farm dog, along with co-managers Alex Vaughn and Trixie Wessel in front of the Obercreek Farm office, originally the outhouse for the main residence. OPPOSITE CLOCKWISE FROM TOP LEFT: Head lettuce, trays of lettuce mix, rainbow carrots, and garlic scapes are all part of the CSA.

sent the price of agricultural acreage out of reach for many. If one is not fortunate to be part of a family with a legacy farm, the solution is to be very strategic in the leasing or purchase of farmland by partnering with such organizations as the American Farmland Trust.

"One of the biggest challenges is being able to create an efficient team every year," Alex said. "Luckily, we have housing for four or five people, which is gigantically helpful. The not-for-profit template is important, but to attract young farmers we need to develop more models that can provide appropriate profits. When I was a kid, the orchards and dairy business were the dominant agricultural enterprises, but in the last ten years there have been so many wonderful new entrepreneurial ideas being hatched and implemented."

Obercreek Brewing Company, which is located on the farm, also produces and serves beer using hops that are grown here. "Hops are some of the most beautiful vines, but it is a crop that is difficult to grow in the Hudson Valley," Alex said. "We have come up with a system of vertical growth to maximize aeration and minimize the mildew that can lead to their failing." The magnificent 1919 dairy barns, which were damaged by fire in the 1940s, are currently being transformed into the new brewery, due, in part, to a grant from the Historic Barn Rehabilitation Tax Credit from the New York's State Historic Preservation Office. With local residents and tourists now seeking out craft beer breweries, Alex has noticed a significant uptick.

On a recent balmy summer evening under a well-populated tent, pizzas were cooked in wood-fired ovens and served along with a selection of whimsically named beers: Hoppy, Simple Math, Cryptic Demands, Fall Into Place, and Violent Moon. Like Farrow & Ball's iconic paint names, their names leave me wanting to paint the sides of the brewery's bar Elephant's Breath or Manor House Gray.

LEFT: Trellised cherry and red slicer tomatoes in the high tunnel during the summer season; Michigan Copper hops are grown vertically to avoid mildew. OPPOSITE: Bacchus radishes and Hakurei turnips in the farm store.

GULDEN FARM

GERMANTOWN

This part of southwestern Columbia County in the Hudson Valley is ripe with history and classical architecture. The property that Gulden Farm occupies once belonged to Richmond Hill, a Georgian home built by the Livingston family in 1807. One passes by Teviotdale, another magnificent Georgian house, built by Walter Livingston, to get to the farm. But at Gulden Farm there is a completely different architectural aesthetic. Historically, barns in the valley were painted an almost Pompeiian red, with some green and white paint making its way into the twentieth century, but blue? And not a blue that blends into the sky but one that approaches French artist Yves Klein blue and asserts itself into the landscape.

New Yorkers Margie and Nate Thorne purchased the farm from the owners of Richmond Hill in 2016. They hired architect Hart Howerton to construct a collection of little houses. Walking past each structure, one notices a balance between these contemporary buildings that appear to have evolved over time.

Since the Thornes are not formerly trained farmers, they brought in Ben Dobson from adjacent Stone House Farm, owned by the Rockefeller family, to assist them. In 2018 they hired Kyle Dodge as lead farmer for the property and finalized Gulden's template.

Kyle hails from Elizaville in Columbia County. He studied wildlife management in Montana after high school. A lot of his friends went into feed sales, but he always wanted to be associated with one farm. Returning home, he worked on Gulden's neighboring Stone House Farm as the grass-fed beef manager. When Margie and Nate purchased the old Richmond Hill pastures, Kyle came on board. Starting with forty cows, they now have 480 head of beef cattle, with some Herefords mixed in with Red Angus. The Red Angus cows, from the Resting Ranch in Nebraska,

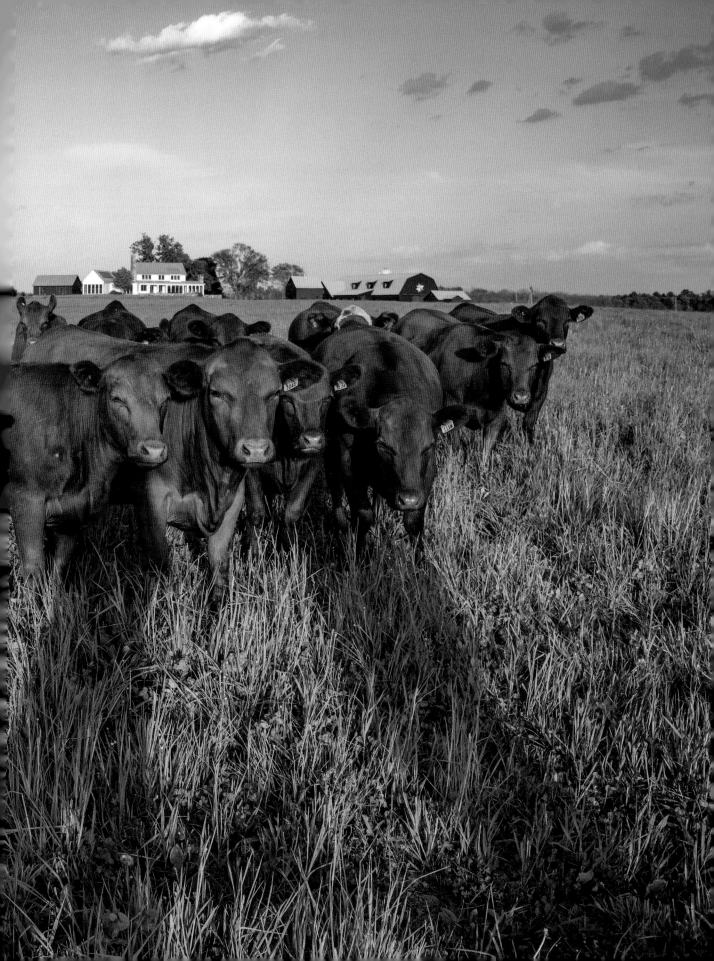

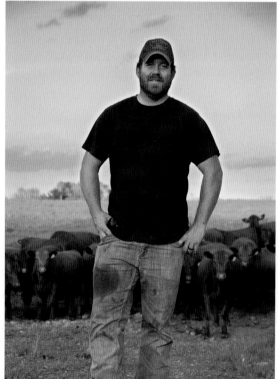

are bred with Red Angus bulls, from the Pharo Cattle Company in Nebraska. By recognizing subtle attributes inherent in each of these breeds, Kyle has been able to assemble a herd that rivals any that he's seen. Margie said, "This creates a breed that is mid-frame with slightly shorter legs; lower to the ground therefore it's easier for them to eat grass. In a no-till organic field, livestock contribute what's needed to keep the nutrients in the soil. The cows are great in maintaining the land, retaining water, and keeping fields green all year. We don't till the fields, so roots

PAGES 120–121: The collection of blue barns at Gulden Farm continuously causes drivers to stop and admire them while passing by. PREVIOUS PAGES: A herd of the farm's Red Angus cattle in the afternoon sun. CLOCKWISE FROM TOP LEFT: Another distinctive blue agricultural structure on the property; the porch of the farm store with a selection of grass-fed beef packed up in a Gulden Farm tote bag; Kyle Dodge with the cattle that he oversees. OPPOSITE: An old-fashioned windmill with the blue-hued Catskill Mountains in the background. FOLLOWING PAGES: The cattle foraging during one of the Hudson Valley's sunsets.

My life is dedicated to taking care of the cattle. They get to eat what they are meant to eat—grass, not corn, and we are extremely specific about their humane treatment.

—KYLE DODGE

have the chance to develop. On this scale, with this amount of acreage, the methane myth is dispelled. The cellulose of the grass is absorbed by the enzymes in the cows' stomachs before they expel it. The methane-eating bacteria in the soil attack what is left by the cows once it comes into contact in the ground. We encourage microbes in the soil that eat the methane produced. The land is much healthier; the question is always how to do this in an economic way. Monarch butterflies, grasshoppers, and new kinds of birds are now visible and nesting here." Kyle said, "We give them a great life here, and then they have one unfortunate one." When pushed a bit further, Kyle talked about his mentor, Temple Grandin, the animal behaviorist who is a leading proponent for the humane treatment of livestock for slaughter, and whose teachings he practices.

The beef cultivated here is grass-finished, meaning that cows eat nothing but grass and forage for their entire lives, producing a steak with a low fat content. Grass offers more nutrition than soy or corn. On nearby Dales Bridge Road, the Thornes have a farm store, run by Kyle's wife, Amanda, who also sells the beef at several farmers markets in the area.

Nate shared more history while we're sitting at their kitchen table looking out over the vast acreage framed by the magnificent Catskill Mountains across the Hudson. Sometimes through verbal or more formal agreements, Nate will swap 20 acres of fields perfect for grain for 20 acres perfect for cattle. "We own 700 acres," he said, "but we're farming 1,000. Stone House Farm was paying a fortune for chicken shit, but by lending land for our cows to graze, the soil benefits from the manure and we have a symbiotic relationship—a constant dance between farms, but a good one."

Back to blue. Nate said, "It never occurred to us that the Catskills were often referred to in historic literature as the Blue Mountains due to the specific hue they took on as the sun set behind them." Frederic Edwin Church, whose home and studio, Olana, is five miles up the road, noticed this as did many of his early Hudson River School contemporaries. So perhaps the blue structures do, after all, have a strong connection to the history and folklore of the region.

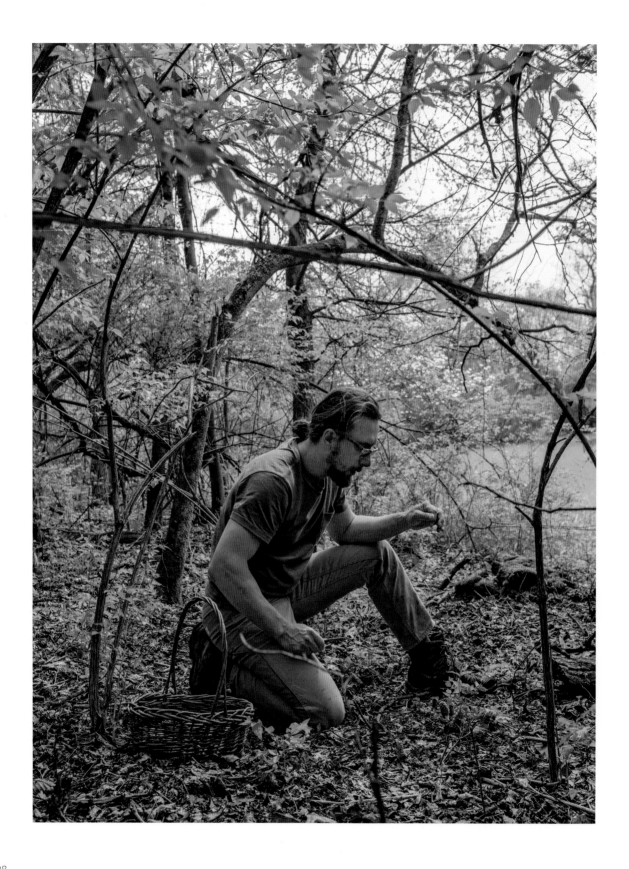

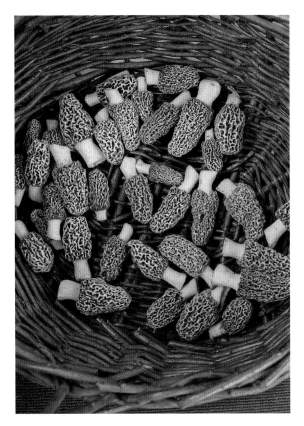

DAMIAN ABRAMS
FORAGER
HILLSDALE

After the prerequisite exchange of courtesies with Damian Abrams, I seem to have been cleared for a level of trust that I haven't been called upon to evoke since I was secreted as an unofficial guest of the Tomb of Skull and Bones at Yale, otherwise known as The Brotherhood of Death. Damian shared with me his foraging knowledge and cleared me to photograph him in action.

After driving for several miles, Damian pulled over to the side of the road where we waited for a few moments until there were no oncoming cars. Only then did he begin an ascent up the mountain in the rain that was so deft and rapid that, carrying my cameras and tripod, I worried about impending peril. After a half hour traveling straight up, we arrived in a field of the most verdant wild ramps that I could have imagined. Ramps usually are not cultivated by farmers and hence need to be foraged. Damian said, "This area is very difficult to get to. It is hidden and it has its own legacy. There is never a way to ascertain the longevity of a particular field, so the mystery is captivating." Observing him collect these leaves from the root is like watching contemporary choreography; Damian hovers almost horizontally above the ground, using his

haunches to support the entire foraging process as he progresses over the plantings, making his selections.

Damian was introduced to foraging twenty years ago while he was teaching photography at a summer camp and inadvertently fell upon a field of chanterelles. The beautiful shades of white, orange and yellow seduced him. He had only seen this kind of mushroom at the farmers markets in Woodstock where he grew up, and there was something magical about discovering chanterelles in their natural habitat. He said, "I was hooked once I realized that I could go out by myself in nature and collect them. I already had an affinity for being alone. At the time I was a mountain biker, and I loved to explore different trails and paths. But then I discovered mushrooms in the wild and figured out that I could support myself by collecting them. I made $800 a week during the season. I felt as if I had found my calling."

Foraging used to be an even more obscure, covert practice. Damian said, "As of two years ago, a rigorous two-year state certification is required from a com-munity college, which is all fair and good, I suppose." In the many years that he has been foraging, Damian hasn't misidentified a mushroom once. He said, "I stick to five or six specimens a season: Hen of the Woods, a Maitake mushroom, Black Trumpet, oyster, and Lion's Mane, to name a few. There is a poisonous mushroom called Jack O'Lantern, which can be mistaken for a chanterelle in its early formation if it is found growing from a tree stump. It is a mushroom to be extremely careful of when chanterelle season begins."

Foraging takes a certain kind of individual, who must be incredibly focused visually so that they can maintain the scanning necessary over long periods of time. While I was with Damian on the hill the first day

PREVIOUS PAGES: Damian Abrams at work in the dense underbrush of a thicket in Columbia County. A basketful of morels, collected one afternoon, and fresh ramps found in the rain. ABOVE FROM LEFT: Damian collecting ramps; a close-up view of a fiddlehead fern; Damian foraging in the forest; a morel that has just been cut.

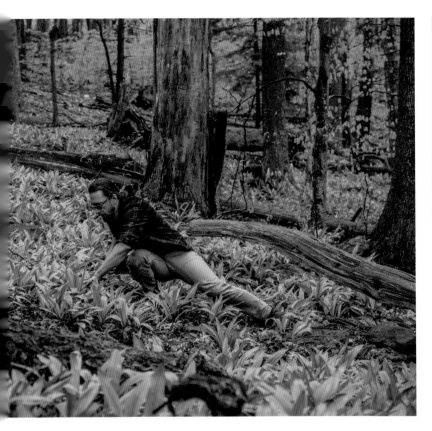

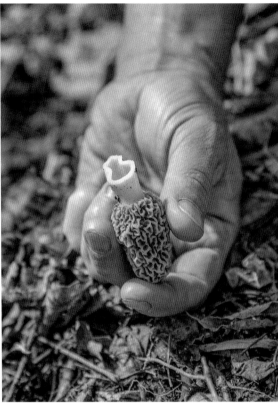

we spent together, I noticed that when he searched for a particular mushroom shape and color, he had an uncanny ability to remain immersed, which he attributes to his time spent in the photography lab.

These days Damian supplies mushrooms to several private chefs. He said, "My goal is not to supply bulk but to discover excellent specimens, such as the most perfect example of Chicken of the Woods. On a good day, I can collect sixty pounds of mushrooms."

The season begins with ramps, followed by fiddlehead ferns, then morels, and on and on throughout the year until nature's cupboard stops producing. Tracking growing patterns in different areas becomes important. Damian said, "I developed a lot of expertise on how many years to wait until I return to a particular area. I am very careful not to exploit any one area." True to form, the next week when we were out looking for morels, Damian was very selective, even to the point of passing over examples that most probably would have been acceptable to his clients. "The eternal question for me while doing this is finding the appropriate balance between the joy of doing this and not succumbing to the necessity of hitting a critical mass. The meditative benefits are huge. It is a way for me to de-program and to quiet down my mind and tap into a spiritual pursuit that connects me directly to nature. My ultimate goal is to migrate with the mushrooms, moving south as the season unfolds. I see in a different manner doing this, not by watching a clock or a calendar, but by observing nature. The seasons don't unfold as a quartet, but in an unknown rudimentary way. During the pandemic, everyone I knew was anxious about feeling isolated. My refrain was 'Welcome to being with yourself.'"

> *As a forager, I am extremely productive; the need for superlatives drops away when I am so satisfied with what I wake up to do every day. I don't need to be the 'best'.*
>
> —DAMIAN ABRAMS

ROSE HILL FARM

RED HOOK

One fall day, my conversation with Holly and Bruce Brittain in Rose Hill's Taproom began with Holly's existential question, "Rot happens, and what are you going to do about it?"

Milling about were lots of visitors, who had come to the farm to indulge in fall apple picking. "We learned quickly that every apple needs to be cleaned, and if rot is observed, throw it out immediately," Holly said. "We found a cidermaker and started a cidery, an outlet for some of the less attractive fruit. We produce a great product following a natural fermentation process." In fact, the apples that have fallen off their trees that might normally be discarded because of blemishes, are used for cider. Rose Hill now produces twenty different beverages each season. Bruce said, "For our ciders, we use a tradition closer to winemaking—a natural method that helps retain a more nuanced taste of the fruit. The cider-specific apples are tannic and chalky or sour, but when you press them, the juice is perfection."

Holly and Bruce are always surprised that their customers are willing to try some of the more unusual concoctions. Selection Suspendue, anyone? You'll discover delightful notes of toasted marshmallow and coriander.

In 2015 Holly and Bruce visited Rose Hill for the first time to pick apples. Back then the couple, who had been married in the Hudson Valley, were living in Harlem and fixing up an old townhouse. They had always romanticized the idea of living on a farm, and after their second child was born, the hunt started.

There is a lot of folklore in Red Hook about the Fraleigh family, who had owned and farmed this prop-

One of our core tenants is zero waste. Every piece of the fruit in the orchard is utilized ... We make several products that are literally recycled ... we soak second-use grapes (skins and stems) in apple water, salvages from our cryo-extract to make what we call pomquette.

—HOLLY BRITTAIN

erty, located on Fraleigh Lane, for six generations. The family had been brought to the area in 1710 as part of the Palatine immigration of indentured servants orchestrated by the Livingston family to populate the region. Founded by Peter Fraleigh in 1798 and referred to as Rose Hill since 1812, this is one the oldest continuously run apple orchards in Red Hook, a town known historically for this crop. With no family members interested in taking on the responsibility of running the farm, Dave and Karen Fraleigh, the last members of this family to own Rose Hill, contemplated the next step. In December of 2015 they sold the farm to Bruce and Holly, with Bruce's uncle, Chris Belardi, joining the partnership. The Fraleighs returned often over a two-year period as they were still committed to the longevity of the farm. How else to make sure that the honors heaped upon this farm over the centuries, including the Grand Champion of the 1973 Dutchess County Fair that memorialized the twenty first-place awards that year, continue.

In 1998 the Fraleighs had sold their development rights to the Scenic Hudson land trust, which, through conservation easements, protects farmland and helps preserve the Hudson Valley's beautiful landscape. They had also transitioned the farm from a wholesale apple orchard to a pick-your-own operation in 1994 and expanded the crops to include not only apples but also cherries, blueberries, peaches, raspberries, pumpkins, and winter squash.

In 2018, the Brittains hired a consultant to help them gain organic certification. They abruptly switched to a program where all herbicides were abol-

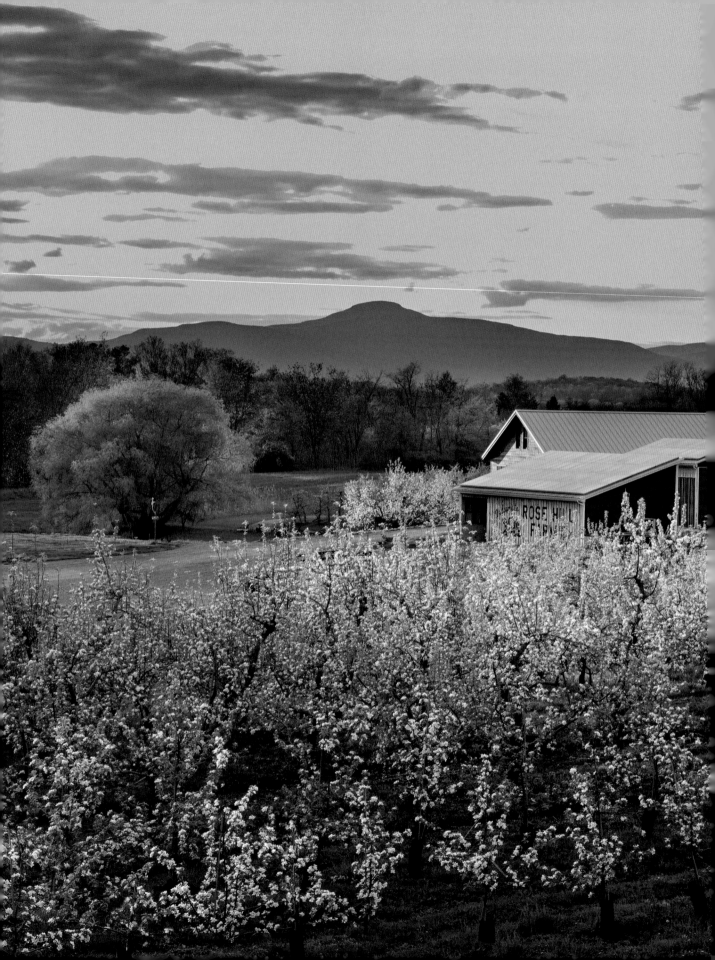

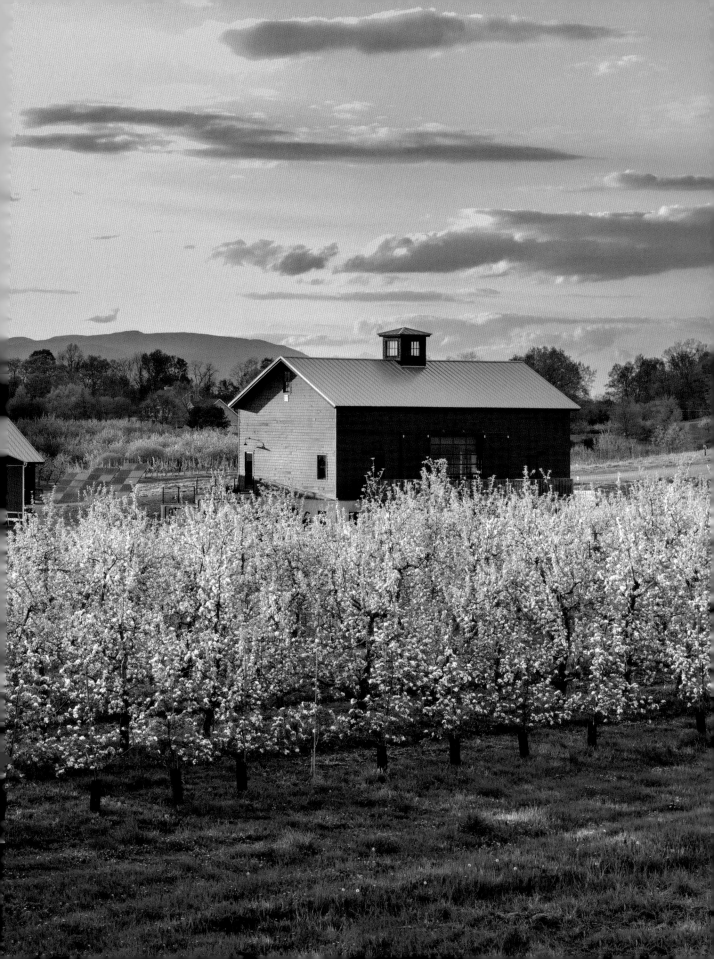

ished in an effort to create a healthier spray program. However, this effort catastrophically failed because a variety of fungi and pests not only damaged the fruit but also caused significant defoliation. The orchard no longer uses synthetic fertilizers. With the eventual removal of all synthetic inputs, the farm now has what they refer to as a "closed-loop agriculture system" where everything being used to treat the apples is generated on the property, such as beneficial inputs (mushroom, comfrey, neem oil) and cover crops.

Every single apple tree on the farm is created by a union of disease-resistant root stock paired with the desired cultivar scion portion above ground. "If you are growing Honeycrisp apples, you start with a three-foot 'whip', or branch, and that is grafted onto the healthiest root base," Bruce said.

On 114 acres of picturesque farmland, Rose Hill's fruit orchard now has 6,000 apple trees that bear many different varieties, including McIntosh, Fuji, Cortland, Macoun, Jonagold, and Red Delicious. The growing season starts in late March and ends in early November. Twenty acres are reserved for visitors to come and pick their own fruit during apple season.

"The mechanization of farming makes it incredibly hard for a farm this size to succeed," Bruce said.

PAGE 132: Sunset seen through the apple blossoms at Rose Hill Farm. PREVIOUS PAGES: The barns and taproom are set amid the 114-acre orchard with views of the Catskill Mountains in the distance. ABOVE AND BELOW: Blueberries are part of the pick-your-own harvesting experience.

"We keep entering the dialogue of how we can continue to create a healthier experience with our produce. The kids sometimes are on the cash register, but we're always thinking about how to make this into a thriving business without it becoming the family shackles." Subsequently, in 2020, the team launched a new venture—a winery brand, under the name Rose Hill that includes a range of wine, cider, and co-fermented fruit wine. Rose Hill buys their grapes from local farms. The opening of the Taproom at Rose Hill Farm followed.

Holly and Bruce love sitting in the barn and observing their visitors having such a great time. Hearing repeated requests for some food to eat while tasting Rose Hill's beverages, the couple brought in Misto, a catering service from Red Hook to serve burgers and other locally sourced dishes out of its food truck.

ABOVE: Some of the many variations of apple cider offered at the Taproom at Rose Hill Farm. RIGHT: The different types of apples are identified on signs for the public to refer to while picking their fruit in the orchard.

ABOVE AND BELOW: The Brittan children, Clara (four), George (eight), and Henry (six), often spend time after school collecting ripe strawberries during the season. OPPOSITE: The family taking a spin between the apple orchard and the fruit and vegetable fields in the children's favorite farm vehicle.

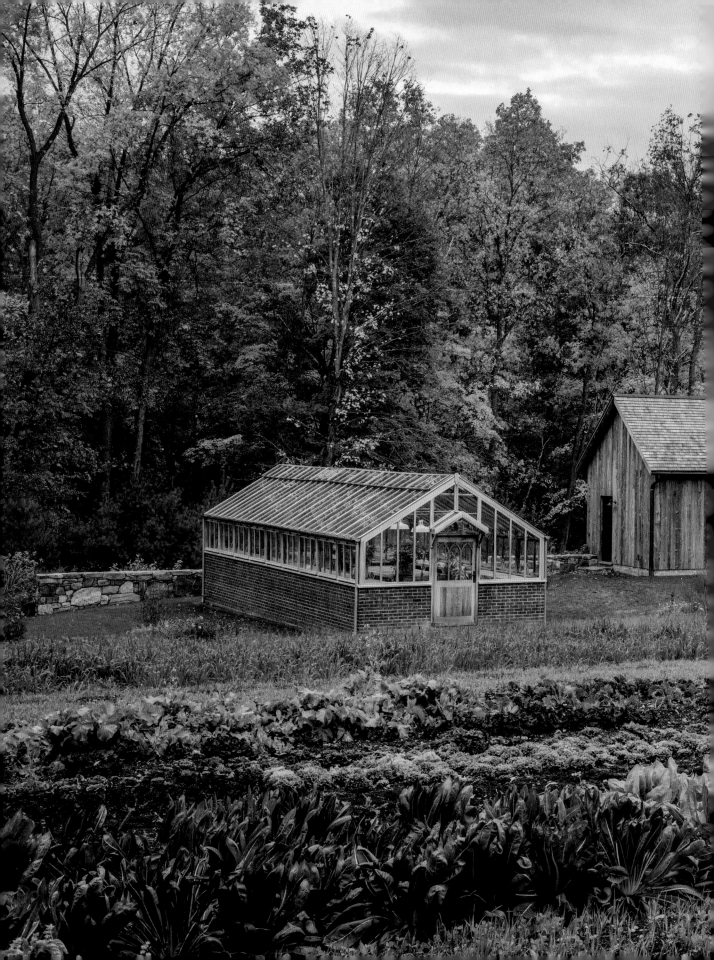

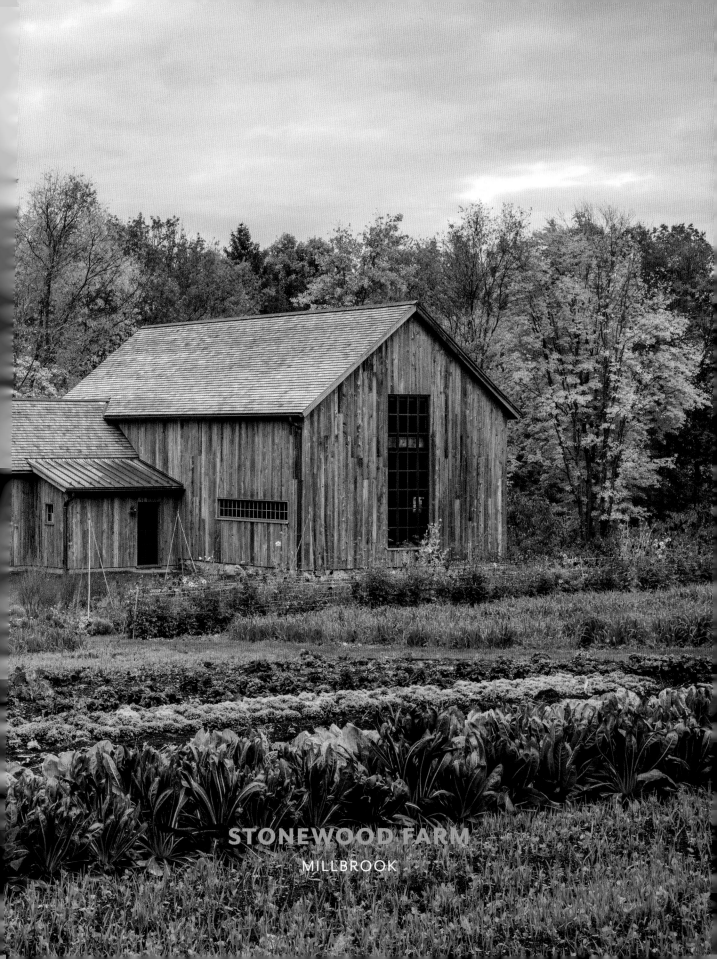

STONEWOOD FARM

MILLBROOK

Ken Holzberg rhetorically asked when discussing the genesis of the farm he shares with his partner Tom Kopfensteiner, "'What do we do if we start a farm, and no one comes?' I was very skeptical and had this fear of having to drive down to New York's Union Square Greenmarket to sell everything." I soon discovered that his concern was unnecessary.

The couple came from Boston to Millbrook in 2000 with the intention of farming. Ken said, "We always knew we wanted to create a farm that produced food for the segment of the local population that didn't normally have access to the kind of wonderful healthy food readily available in the region." Ken and Tom bought a 15-acre parcel that was densely populated with trees. Over the course of

five years, they cleared the lot with chainsaws to create their dream farm. In 2007, they moved into the vernacular farmhouse they designed and had built. Landscape architect Cynthia Rice was brought in; she pointed out the direction of the sun, the wet areas, what trees were worth saving, and the best spots for a market garden.

The land was soon brimming with vegetables, fruits, herbs, and flowers. Using vintage and recycled materials to reference historic vernacular architecture, Ken designed several barns, residential buildings, the cookhouse, and the chicken coop.

Tom gave me the background story: "I had just finished *Growing a Farmer: How I Learned to Live Off the Land* by Kurt Timmermeister, which documents

PREVIOUS PAGES: Stonewood Farm's market garden is just shy of two acres and produces over 100 varieties of organic vegetables, fruits, and flowers. The 1860s cookhouse, on the right, was reconstructed after being transported from Canada. The greenhouse is used for seedling trays and was made by Woodpecker Joinery in England. ABOVE: The vernacular farmhouse resembles those built in the nineteenth century. OPPOSITE ABOVE AND BELOW: The kitchen library is lined with gardening books and cookbooks, and is also used for small dinners. Reclaimed timbers were used for the ceilings and floors. The eleven-foot-long dining table was also made with reclaimed wood from The Hudson Company, nearby in Pine Plains.

A lot of people joke that you have to be a little crazy to become a farmer these days, but to me it's one of the only things that makes sense anymore. You should always be thinking one or two seasons ahead, and looking for ways to be more efficient, which usually means cutting out unnecessary complications.

—JEREMY LECLAIR

his efforts establishing a small farm in Seattle; I was hooked on the idea." Tom had previously worked for a nonprofit healthcare company, and Ken was an attorney, whose clients included many nonprofit real estate organizations in Boston. Noticing great numbers of young professionals leaving their jobs in urban centers, they went to work on establishing Stonewood Farm. What emerged was the proverbial three-legged stool so prevalent in nonprofit business start-ups: providing access to affordable

land for young farmers in a region, helping to feed the community, and setting up a food and farming apprenticeship program dedicated to teaching how to prepare food with what is grown in the fields.

Small-scale farming has become a recent focus in the agricultural field. Ken said, "We are farming a little less than two acres on this property. It is a tiny area, but we are able to capitalize on this by keeping the budget tight and scaled to our production. We use our hands and small equipment a lot, which is

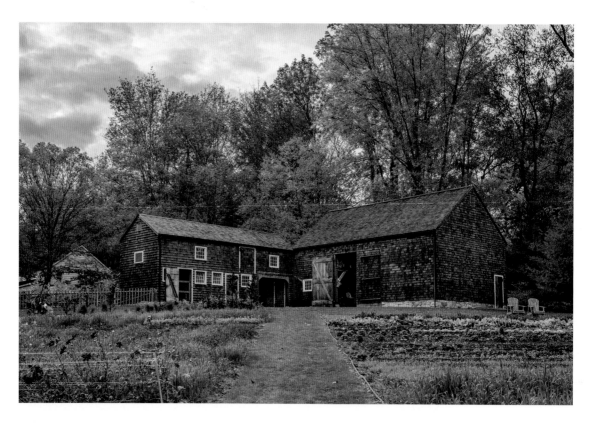

much different than what a large farm needs to do to keep up." Having farm managers Samantha Kronyak and Jeremy LeClair living in the carriage house since 2022 is extremely helpful. They arrived at Stonewood after completing a managerial program at Eliot Coleman's Four Season Farm in Maine and tend to the complex paperwork documenting the "seed-to-sale" trajectory required to maintain organic certification. Jeremy said, "At an organic farm we have to sometimes pick pests off the plants by hand. I'm noticing this year that the zucchinis are getting attacked; we have come to the conclusion that while farming organically, crops can be lost. We are always experimenting with different combinations of companion planting, which mitigates the arrival of certain pests."

Speaking to Ken and Tom's concerns that there would be no local demand for their produce, the couple found the following meaningful ways to distribute their bounty: through biweekly pop-up markets at Stonewood, donations to the local Meals-on-Wheels program, nearby senior housing facilities, and a food collection site in Dover Plains, an area that is home to many farm workers. Ironically, there isn't easy access to healthy food nor an affordable supermarket in that hamlet. The farm has initiated the Full Heart Kitchen program, which offers beautifully prepared meals and baked goods that are made from a combination of produce that might otherwise go to waste. The creator of these meals, culinary director, Kristen Essig cold-contacted Ken and Tom after read-

PREVIOUS PAGES: The 1830s tack cabinet in the potting room was salvaged from an old barn outside of Lisbon. The room serves multiple purposes from arranging flowers to potting plants and doubles as a wet bar for entertaining. The L-shaped worktable, incorporating a cast iron sink, was made with remnant pieces from other projects on the farm. ABOVE: The equipment barn includes the chicken house and was made of salvaged materials. OPPOSITE CLOCKWISE FROM TOP LEFT: Lettuce growing in the high tunnel; the interior of the greenhouse with trays of young seedlings; Tom Hopfensteiner and Ken Holzberg walking in front of the cookhouse before a Sunday Harvest dinner; guests arriving for the event.

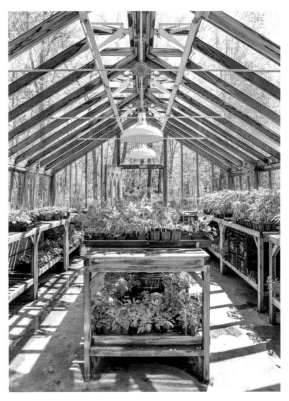

ABOVE: Culinary director Kristen Essig resting before the dinner preparation begins. RIGHT: The interior of the cookhouse has vintage English and French tables with a set of chairs found in the Netherlands. The room is used for Sunday Harvest dinners, garden-to-plate cooking classes, and pop-up markets.

ing a mention online about what they were up to. She said to them, "Take my offer seriously" to come join the team. While still the executive chef at Dauphine's in Washington, D.C., she's now spending the majority of her time at the farm. Five times a season, Stonewood hosts Sunday Harvest fundraising dinners. I attended one of the dinners and was impressed; Kristen came out during the meal to share the subtleties of the ingredients used in the dishes served that evening to a mesmerized group of twenty-six guests. Clearly the magnificent setting is also the star here.

"The aesthetics of the place are essential to the whole experience," Ken said. In the spring of 2023, guest chef Melissa Martin of New Orleans's Mosquito Supper Club prepared a feast inspired by that region. Afterwards, she spoke about growing up on the bayou and the ingredients included in that evening's meal. "These dinners involve our guests in a more engaging

manner than CSAs," Tom said. "They want to get into the nitty-gritty of what they're eating."

Kristen also prepares lunch for small groups of volunteers, who show up to work in the garden for three-hour shifts. Throughout the growing season, Stonewood offers cooking classes using garden-fresh produce from the farm.

Stonewood Farm receives financial support from such organizations as Berkshire Taconic Community Foundation, Community Foundations of the Hudson Valley, and Field Hall Foundation. Tom said, "The cycle created by being able to generate funding from the local community and return it, through great food, back into the same area fulfills our mission."

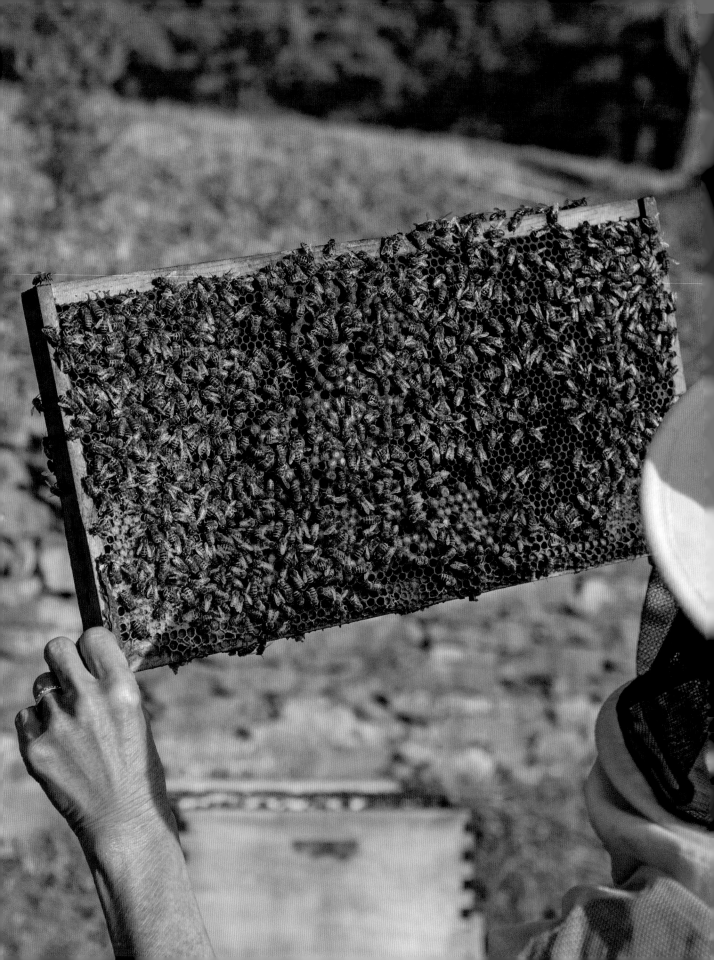

TIVOLI

There is mystery surrounding the expression "the bee's knees," but in the 1920s it did refer to being top-notch. The honey produced by master beekeeper Nancy Wu Houk, the owner of NYBUZZ, is, indeed, top-notch.

Nancy said, "I won't drone on . . ." before she shared with me a wealth of fascinating information about bees. For starters, these creatures have three body parts: a head, thorax, and abdomen, two sets of wings and two antennae, and a proboscis for collecting nectar. Bees smell and communicate with their feet, tapping the honeycomb with a sort of Morse code to advise where the queen is. A "waggle dance" is performed by honeybees where they move themselves in a figure-eight pattern while inside their hive to indicate to one another the exact direction and location of pollen, nectar, or potential new sites to build hives. "Karl von Frisch coined the term in 1927, referring to an algorithm that directs them based on the direction of the sun," she said.

What started with a gift from a house guest of 10,000 honeybees (*apis mellifera*) in a balsam box has turned into a business that fully occupies Nancy's day. Her husband, gallerist Edwynn Houk, "nearly croaked when the bees were presented to us, so I took them over," she said. Now there are thirty bee colonies, consisting of a hybrid of Carniolan, Russian, and feral (local), on the property.

While working in art conservation in Manhattan, Nancy met Edwynn at a Metropolitan Museum of Art exhibition opening. Two years later he proposed to her, following an appointment with Nancy about a Berenice Abbott photograph. Once married, they decided to look for a place upstate and came across The Pynes, an eighteenth-century home on 13 acres along the Hudson River that had belonged to Lydia and Roland Livingston Redmond, a former president of the Metropolitan Museum of Art.

With two children in tow, they closed on the house in the village of Tivoli in 1994. Nancy said, "I thought it would be a nice thing to bring to the kids' teachers honey as gifts and then slowly I was overcome by the whole subject of beekeeping. I took class upon class to acquire more knowledge. They're not just cute little things. The complexity of the communities fascinated me." With a master's degree in organic chemistry from Yale, she later earned a degree from the University of Montana as a master beekeeper.

Nancy took me into the processing area and opened a bucket of crystallized honey. I stuck my head down to inhale. It was the most heavenly perfume. "All honey crystallizes except for tupelo, sage, and acacia. Crystallization is contingent upon the honey's amount of pollen and fructose," Nancy said. "Most honey in the grocery store is fraudulent honey. It's boiled to death by commercial operators and is mixed with cheap sugars to bring the price down."

Reflecting on the development of the species, Nancy said, "The first bee accidentally moved some pollen around from an early flower, probably more like a fern, and received protein. Then 140 million years of evolution occurred and here we are." In fact, today one-third of the world's food supply is pollinated by

> *Don't ever remove dandelions from your lawn. Bees need strong nutrition to make strong queens. Dandelions provide seasonal nectar and protein for at least 100 species of insects, while their seeds and lion-tooth leaves feed over thirty species of birds and other small wildlife.*
>
> —NANCY WU HOUK

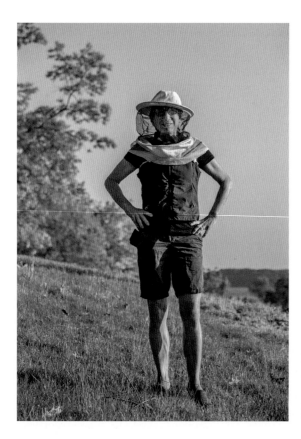

PREVIOUS PAGES: A robust Russian bee colony cares for newly laid eggs in hexagonal wax cells. These nurse bees feed royal jelly and beebread (honey, nectar, pollen) to the developing brood, which they check on around 1,300 times a day. ABOVE: Nancy Wu Houk kitted up in her beekeeper veil. RIGHT: Fall honeybee colonies nestle in hives next to the weeping beech trees that protect them from the harsh winter winds from the Hudson River.

bees. Nancy shares with me a series of images that use a filtration with subtle gradations of tone invisible to the human eye, which approximate what the bee sees. These filters lead a bee towards pay dirt, or the nectary.

Nancy said, "Let me tell you about the police bees. When the queen is alive, she sends out pheromones that basically render the female worker bees infertile; they cease ovulation and if they do produce eggs by chance, they are unfertilized. The police bees are there to curtail any possible reproduction from the obstreperous worker bees. But when the queen dies, the female worker bees instantly begin to ovulate and become confused. The whole system is very Machia-vellian in that there may be several potential queens growing inside these rather stalactite-looking queen cells in the hive. During this process they are 'piping' to one another. It sounds like they are quacking, but they are making sounds with their nascent wing muscles. The first one eats her way out of her stalactite and basically declares that she has won the 'queen of the hive' award as she emerges. She is assisted by the

police bees who do a lot of her dirty work." In other words, the police bees kill off her less efficient competitors as they emerge. Nancy showed me a video of this process. I'm used to the buzz sounds when bees hover or fly, but the queen "emitting a pipe" was something otherworldly.

Today, there are new challenges facing honeybees. Nancy said, "In 1987 the *Varroa destructor* mite arrived and began decimating the American population of honeybees. The Asian giant hornets have arrived on American soil. They are carnivores, five times the size of the bees, and attack them." In 2022 America's bees suffered colony losses close to forty percent. She shared another video with me that showed thousands of honeybees surrounding a hornet that had made its way into the hive. They turn

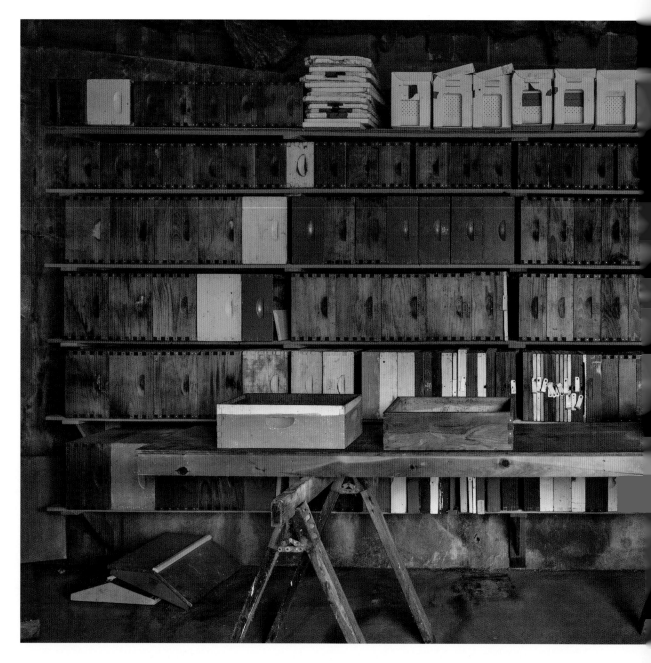

their backs and vibrate their bodies, raising the temperature in the hive to 117 degrees F. The hornet cannot survive at this temperature and in an instant a signal is given, and the bees devour it. Another foe is the praying mantis, who posts itself at the edge of the colony and grabs the bees as they enter the hive.

Dandelions and different kinds of clover, which have great amounts of proteins, were brought over by the Europeans in the 1600s along with specific strains of honeybees. To produce great honey, the varietals made available to the bees, such as black locust, clover, and chestnut, become important. Nancy said, "Every flower gives different qualities of nectar." She brings out several colored honeys, each with their distinct perfume. NYBUZZ harvest includes Horse Chestnut honey, aubergine in color with aro-

Whether it be a work of art or a honeybee makes no difference. I once worked on an André Kertész photograph of Mondrian's eyeglasses, and there were areas of silver mirror oxidation, which I addressed without rendering the image looking new. One proceeds slowly and with complete focus. It is the same thing with bees and honey. It's about the art of the process and how it fits in with the whole system, whether that is an important photograph or a series of hives. If I have made the bees' lives easier and created an environment with diverse nutrient-rich food, my job is almost done. Bees are about connection, how life evolved, and how it never stops."

matic caramel notes and a slightly nutty aftertaste. She also makes comb honey, raw honey, and hybrid products like pâte de fruits. These products are sold at such places as the Culinary Institute of America in Hyde Park, Otto's Market in Germantown, and Bread Alone in Rhinebeck.

Nancy said, "Stewardship is what remains of the beautiful past, in the present, and for the future.

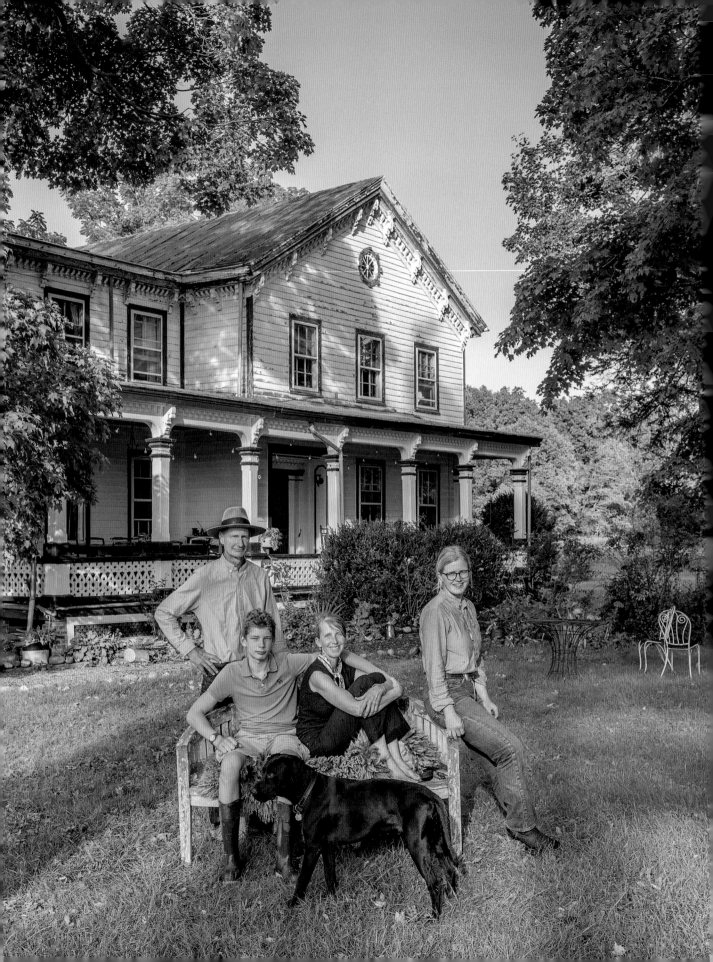

LEIFER HOMESTEAD

LIVINGSTON

On Saturdays between ten and noon during the summer you can get one of the best pains au chocolat in America at a small farm stand in the hamlet of Livingston in the front yard of Chad Wisser, a friend of the Leifer family. I often drive fifteen minutes from my home nearby to sample one . . . or three. This is a delicious weekly product coming from the kitchen of Dorothee and Eric Leifer, a jeweler from Cologne, Germany, and a Kansas-born former Columbia University professor of sociology, respectively. The Leifers' homestead is just down the road, "a spot" where they have lived with their kids since 1998 after purchasing an 1808 farmhouse, which had been owned by the Finger family since 1858. Back then, they arrived at the house on Eric's motorcycle after lunch at the nearby Elizaville Diner and fell in love with this place. Their children were brought up understanding that everyone has a role in keeping the household running. In fact, the Leifers do everything for themselves. Everything.

After meeting at a dance at Columbia University's International House in 1994, they became a couple. Early on in their relationship, they clearly decided that they wanted to raise their family outside of the city and its suburbs. While still in Manhattan, the couple had grown tomatoes on the roof of their brownstone on West Eightieth Street and planted green beans covertly in Central Park's Ramble, which had been designed by Calvert Vaux in the 1850s. The plan included " . . . learning how to live by problem solving," Eric said.

I was up here for ten years before I heard the word 'homestead'. We wanted to create a model for the children where we would all work hard in the summer and learn to put things away for the winter, as a metaphor, but also pragmatically. When one gets out of a cash economy, it's the labor that has value.

—ERIC LEIFER

The total amount of money expended for the restoration of the exterior of the house was a mere ninety dollars because the Leifers traded with neighbors for assistance and oftentimes it was just offered. In the nineteenth century, this bartering system was called "changing work," as both money and labor were scarce. During the first year, due to the house's state of disrepair, they rebuilt five chimneys, which required jacking up the house five inches. The couple had no water for three months and needed to repair the plumbing. "I got sick of working and taking so much out for taxes," Eric said, "and I loved figuring out what to do and how to do it. I was fascinated with learning [how to restore an old house]."

Dorothee said, "My parents grew up with very little during two wars. I feel ashamed when I have to throw something out. There is much more of a mentality in Germany not to waste." This sentiment explains the Leifers' ethos regarding their farming practices. Very little is thrown out.

The Leifers' farming plan emerged shortly after they moved upstate. The farm produces chestnuts, persimmons, potatoes, squash, figs, grains, heirloom tomatoes, sunflowers, onions, and corn that works well for popcorn, among other crops. Also, hens are raised for eggs, and chickens for meat. They now have their own cow; initially Dorothee borrowed one for milk in exchange for some hay. The bartering system continues to serve them well. The Leifers are also beekeepers.

The family sells their produce at the farm stand in Livingston. Once the family's nutritional needs are

satisfied, the surplus is offered at the farm stand on their property. A sign was designed by their daughter, Emma, and placed on the winding country road, indicating the location. Dorothee began catering and producing farm-to-table dinners for paying guests that includes fresh pizzas produced in the outdoor wood-fired oven. In this case, the table is on the farm. There is never any garbage left after a gathering of eighty guests. All is used or repurposed. Dorothee said, "I have plenty of forks, and I can wash them." So, there is no need to buy garbage bags.

The kids have begun moving on. During an afternoon on the farm, I learned about their eldest daughter Emma's burgeoning pizza business. A few weeks later, I ran into her at Churchtown Dairy, where she is

the herd manager, and I sampled one of her delicious pizzas that she produced there for an informal dinner. Previously she did a six-month stint cattle wrangling in Wyoming. Their son, Heinrich, returned in the afternoon after working nearby at Bartlett House, a historic railroad hotel that now houses a cafe and

PREVIOUS PAGES: The Leifer family taking a rare break from busy farm work in front of their nineteenth-century house. From left are Eric, Heinrich, Dorothee, Emma, and their dog, Lasko. THESE PAGES: Hanging on the wall is a painting of Eric (age 12) and his grandfather, painted by Eric's mother. The dining room table is used to lay out the season's bounty with cheese and the many vegetables collected from the fields, such as tomatoes, peppers, garlic, sweet potatoes, onions, and corn.

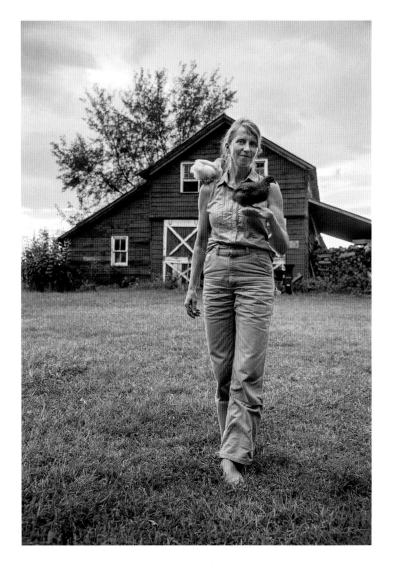

ABOVE: Dorothee posing with two of her hens. OPPOSITE CLOCKWISE FROM TOP LEFT: Dorothee milking her cow, Millie, by the barn; a bucket containing the fresh milk; Emma updating the sign for the garden stand on their property; the selection of pains au chocolat and croissants that the Leifers bring to the Livingston market on Saturday mornings.

bakery. He arrived home with some baguettes, a gift from the owners of Bartlett House, that we all devoured with butter and jams from their kitchen—exemplifying the local culture of sharing their homemade items.

The gathering in front of Chad's home on Saturday morning has become something of a local get-together. He posts what will be offered on Instagram (@livingston_living), and the group that assembles discusses local events as well as the produce and baked offerings. Eric's vintage hat is not the only thing that harkens back to another period in the region's history. If you could retouch some of the discordant elements, it would be easy to imagine one was still in the nineteenth century, eating pretzels and drinking rhubarb beer.

RISE & RUN PERMACULTURE

STUYVESANT FALLS

Permaculture is the practice of observing occurrences in nature and diverse ecosystems, then developing solutions to duplicate these findings. This holistic approach to agriculture is a response to the industrialized practices that preceded it. The term permaculture, which refers to a sustainable farming system, was proposed in 1978 by Bill Mollison and David Holmgren, who had studied in depth the aboriginal and indigenous agrarian cultures around the world. The theory behind it goes back even further to 1924 and the teachings of the philosopher, Rudolf Steiner, who founded the Waldorf School.

If one were to travel back to this period, to the time when John Singer Sargent was still painting, one might invite Seamus Donahue, the co-owner of Rise & Run Permaculture, which assists clients to achieve a holistic approach to their vegetable and fruit gardens, to the artist's studio. Seamus personifies so many of the physical attributes Sargent sought in his models. Except he is a teacher who wakes up every day wanting to share with his clients the wisdom of permaculture practices. Seamus said, "I often use the flower alyssum to attract lacewings and hover flies to eat aphids and help with pollination. I plant marigolds with tomatoes and basil to keep certain nematodes [roundworms] away and to confuse the Japanese beetles. I also like to have tender aromatic herbs like dill and cilantro blooming around my cabbages to keep the cabbage moth away. Bush beans are great to keep the potato beetle away from eggplants and potatoes." One of the premises of permaculture is that placement is every-

Some tips for new gardener's: start small, grow what you know and love, expect loses, stay present and consistent, and leave some room for the wild and let the wild help you grow too.

—SEAMUS DONAHUE

thing. By paying attention to the success of each vegetable, a planting template emerges that can be used going forward. In keeping with permaculture, farms are divided into zones, with delicate plants closer to one's home or barn, with the more robust plants farther away.

Located in Stuyvesant Falls in Columbia County, Rise & Run Permaculture was founded in 2018 by Seamus and John Mulligan. In 2021 Seamus launched Rise & Run Gardens as a separate consultancy business. The Rise & Run Permaculture team offers complete ecologic and economic assessments for their commercial and residential clients. Through the Rise & Run Gardens, Seamus provides consultation in planning ecological, aesthetically pleasing kitchen garden designs. He helps to inform his clients about the natural conditions of their landscape and what can be done to create harmonious and abundant environments. His advice includes the following: by leaving native shrubs and trees near the garden, you will allow protected perch space for beneficial birds that can help you keep pesky bug pests in check. By letting some plants stay in the ground past harvest and go to seed, you can ensure your own home-grown seed supply that may be even better adapted for your own soil. Other services include maintaining gardens, including pruning, weeding, mulching, fertilization, and pest management.

After receiving his permaculture design certificate in Australia, Seamus returned to where he had been raised, in Stuyvesant Falls. His mother, an artist, and father, a photographer, had moved there from

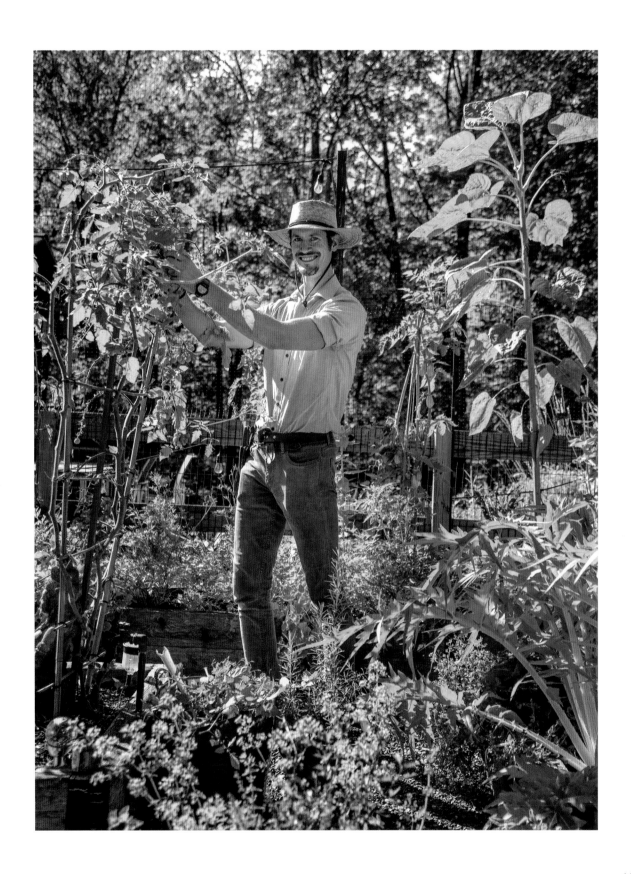

Brooklyn when he was young. He attended the Ichabod Crane Central School District, named after the fictitious Washington Irving character. After graduating from Emerson College, Seamus worked in several areas associated with farming and landscape: he was a forager for City Grocer in Brooklyn, spent time at an ornamental nursery where he installed vegetable gardens, and worked for several upstate fruit growers before taking a farm business planning course at a local community college. This all led up to him enrolling in the permaculture program he matriculated from in Australia.

Upon reflection, Seamus decided to determine how to best integrate human activity with the nat-

ural world. He wanted to turn back to the agrarian community, with its abundance of natural wealth and rich history, that he had loved so much when growing up in the Hudson Valley. Seamus noticed that the region was ripe for his permaculture teachings after observing so many new people moving to this region and wanting to farm here.

Seamus has been coaching gardeners, both new and seasoned, for over a decade, providing the practical know-how to ensure a successful garden season after season. After imparting what he has learned about permaculture, he hopes to pass on planting methods to give his clients the ability to take over much of the work that he initiates. He said, "As

Planting a variety of flowers, especially native varieties, alongside your vegetables can invite more pollinators to keep your garden flowering and fruiting more abundantly than without. As you receive their benefit, you are also offering these creatures habitat in an age when all wildlife are becoming refugees.

—SEAMUS DONAHUE

permaculturists, we have the mindset to educate, to solve some of the social problems of the world by getting people into their gardens."

In 2020 many people left urban centers due to the pandemic. The valley's grocery shelves were often empty, and Seamus found himself working double time addressing the requests of local residents about permaculture, as well as those from new arrivals, who now had time on their hands and entertained thoughts of becoming self-sufficient. Given the important discussions about climate control and the fact that people don't always have access to the foods that they once took for granted, some people are addressing this issue by creating an environment at home where they are able sustain themselves and not cause further damage to the environment.

Seamus's observation of Rise & Run's current residential clientele is that most of them are second homeowners, retirees, and people who can afford to have his services on a weekly basis. However, his ultimate goal is to provide a downloadable course through the local community college in his hometown that will be accessible to a much broader demographic, creating an army of stewards trained in the teachings of permaculture to reinvigorate the land and produce abundance.

———

PAGE 165: Seamus Donahue of Rise & Run Permaculture in Spencertown training cherry tomatoes on a trellis, with a sunflower to his right and a cardoon in the foreground. PREVIOUS PAGES: In a Pine Plains rock-walled garden that Seamus oversees are winter squash vining on the ground and a Brussels sprout stalk on the left. ABOVE: A basket of freshly picked tomatoes; ripening eggplants. Seamus plants bush beans next to both plants to keep the potato beetles away. OPPOSITE: Tomatoes on a bamboo trellis with basil to the left and salvia flowering to the right.

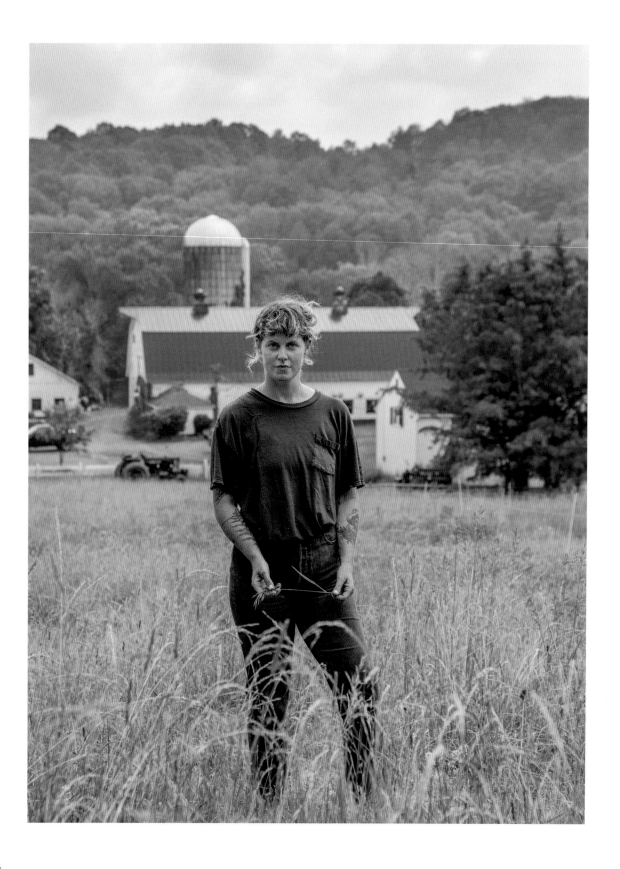

CHASEHOLM FARM

PINE PLAINS

Sarah Chase was someone I met following the screening of the documentary film *Our Farm, Our Farmers*, produced by L. Parker Stephenson. The film covers the story of Chaseholm Farm's dairy and creamery, as well as several neighboring dairies. Currently, there is a momentum of support for the local dairy industry, which has been woven into the fabric of this region since the early nineteenth century. Rick Osofsky of Ronnybrook Farm Dairy offered the following US statistic: "In 1980 there were 650,000 family dairy farms. Today there are 21,000. We've lost 629,000 farms, but the number of cows remained the same. They've been absorbed by the big agricultural farms."

Sarah's family is the fourth generation to live in Pine Plains and the third to run the dairy. Her grandfather, Ken, was born here and became a local dentist. Historically, the Holstein genetics have been impressive in this region. So, when Ken decided to buy a farm in 1937, he stocked it with fifty of these cows due to their higher volume of milk per cow. Sarah's dad, Barry, fell in love with

> *Everything that we are doing these days revolves around taking this business that we grew up with and bringing it forward in a way that resonates with our values and priorities.*
>
> —SARAH CHASE

the dairy as he came of age here. "Growing up, I was most interested in the cows," Sarah said. "I started milking them when I was twelve but also loved the haying in the summertime."

After graduation from Oberlin College with a degree in gender and feminist studies, Sarah realized how invested she was in the farm. Sarah took the reins in 2013 following her father's retirement. She now lives with her wife, Jordan Schmidt, in the farmhand's house, which is directly across from the milking barn and the farm shop. Sarah's brother, Rory, moved back East in 2008. He had become interested in cheesemaking while at the University of California at Davis. Rory heads the cheesemaking division at the farm, producing cheeses like tome-style Stella, the triple-cream Nimbus, and Moonlight, with its log shape and ash rind.

"My dad was a great breeder. . . . I was given his last fourteen cows. He taught me to have an eye for this. My work here has produced cows that are a little smaller, with a wide muzzle and heart girth. They

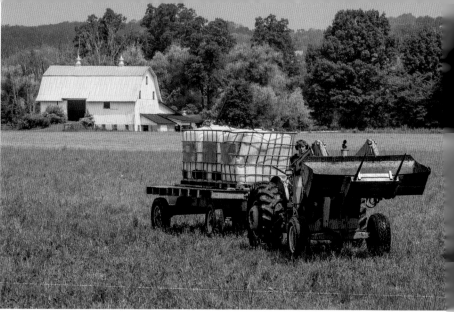

are closer to the ground, not spindly." Today, the thirty-three milking cows at Chaseholm are Holsteins crossed with Jerseys, who contribute the high butterfat content in the dairy's milk.

Sarah has made adjustments to the farm, including weaning the cows off of grain to being grass fed. She also began the process of having the farm certified organic. "I did this to have access to certain markets; it is part of my ethics," she said. "The subject of 'organic' is so confusing to the consumer. There are four different certifications: 100-percent organic, organic, 'made with' organic ingredients, and includes specific organic ingredients. When shopping, who is taking the time to read all the fine print? Ultimately, I had to build a customer base that trusts us because so many people have become disconnected to their food." To do this, Sarah created a website and a CSA program, and Rory delivers the milk and cheese personally to farmers markets in the Hudson River Valley and New York City.

PREVIOUS PAGES: Sarah Chase of Chaseholm Farms in front of the barn complex. The farm's milk is bottled in simple glass jars. TOP ROW FROM LEFT: "Beware of attack cow" is humorously posted on the entrance to the milking barn; Sarah at work in the fields; her home was built in the 1770s; some of the wonderful cheeses produced on the farm by Rory Chase; the farm store sells raw milk, cheese, and meat, as well as products from nearby farms. BOTTOM ROW FROM LEFT: The milking barn; the morning's milk is combined in this glass container before being bottled; the cows line up each morning after locating their respective stalls; a vintage sign at the entrance; the cows foraging and grazing in the more than 300 acres of fields.

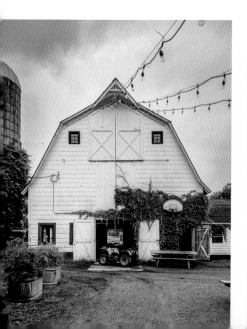

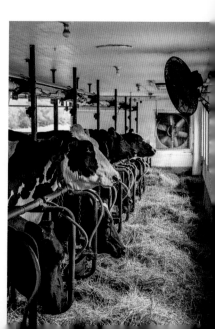

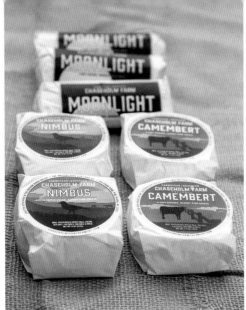

"I am trying to provide the most 'cowlike' existence for them," Sarah said of the herd. "We leave the calves with their mothers for six months. They would be separated immediately on a conventional farm so that the milk produced by the mothers continues to be part of that farm's saleable product." Watching the cows enter the milking barn one morning, I was impressed that each one walks directly to the stall that has her name on a sign above it.

Sarah and Rory own about 330 acres but are farming about seven hundred acres, the remainder on leased land. Sarah said, "I like to leave the cows to graze on about one third of the grass blade and then move them on to another pasture so that the grass can still photosynthesize and continue a healthy path for itself. When the cows are left to decimate the field, you can get into trouble." If a drought comes along, the fields are still able to supply nutrition since they haven't become void of forage.

The electric fences that surround several fields are latched with a battery that is solar powered. When the gates open, the cows can move on to the next field throughout the day. Growing organic vegetables taught Sarah about rotational grazing.

Knowing that she must create a thriving work balance for her employees made Sarah think about herself. "I could totally lose myself working twenty-four seven on the farm. . . . After putting so much time into the actual evolution of the farm as well as advocating on the subject, I now feel entitled to a little grace and spend a bit more time with friends and family. There are so many queer farmers; especially women-run dairy farms. We meet up twice a month in Vermont or on Zoom to share anecdotes, tips, etcetera."

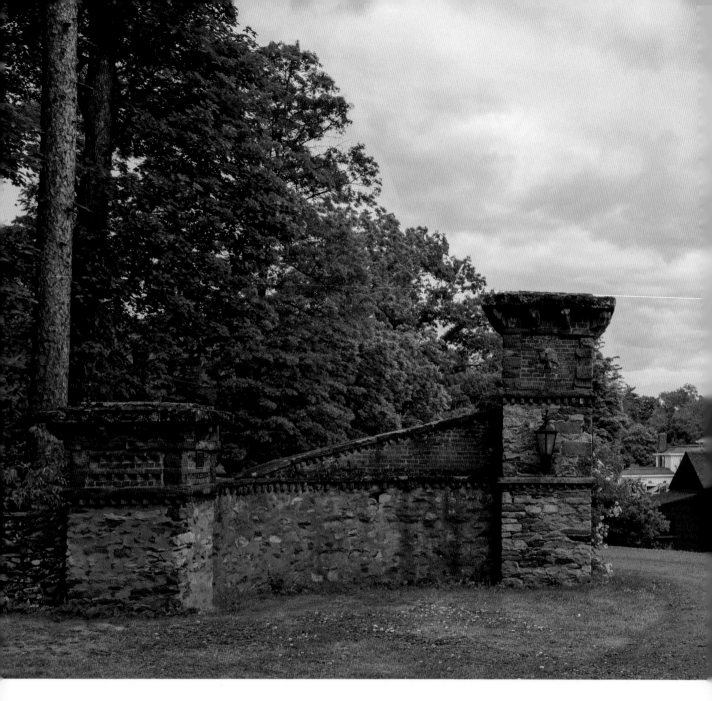

Stonegate Farm, the home of Jill Rowe and Matthew Benson, is in the hamlet of Balmville, which is amusing since one of the products of their skincare line Cultivate Apothecary is named Evening Cleansing Balm. Their beauty and wellness products include whole-plant oil-based serums, elixirs, and balms, which are made using botanicals grown on the farm.

Matthew said, "There is a terroir quality to the products coming off this farm. The calendula and echinacea are already communicating in their mycorrhizal underworld while growing and continue their harmonic relationship once processed into Jill's preparations. Our goal is to provide experiences, where what is produced here on the farm can be eaten, smelled, and put on your skin. If you are interested in the senses, this is the place." Guests dine in fields of anise hyssop while eating food made with the same plant. The farm grows many items not readily available in the area: black currants, gooseber-

STONEGATE FARM

BALMVILLE

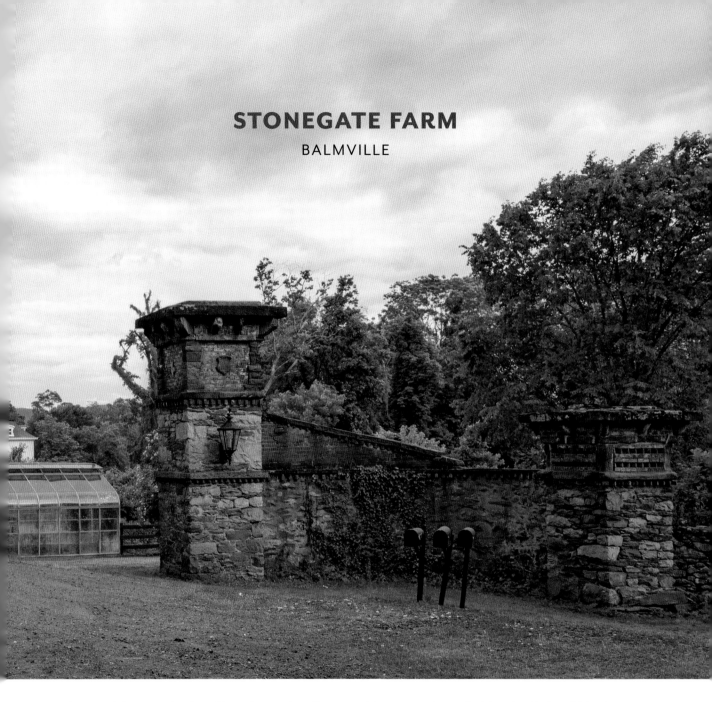

ries, aronia berry, and quince. They also produce Baco Noir grapes, which were brought over to the region by the Huguenots in the early seventeenth century.

After journalism school at Columbia University, Matthew traveled around Europe, sometimes picking grapes in France, before settling down in Manhattan's photo district and opening his own studio. "I was photographing gardens and food, documenting people's wonderful lives in books like *Growing Beautiful Food* and *The Photographic Garden*, but living

without a garden and with a tiny kitchen," Matthew said. Enamored with his clients' lifestyle, he decided to move to the country.

The name Balmville is derived from the Balm of Gilead tree, whose trunk is still preserved there. Since 2000 Matthew has resided in a collection of mid-nineteenth-century outbuildings that are located on the grounds of Echo Lawn, an estate built in 1848. Natalie Knowlton, a collector of American antiques, lived here in the early twentieth century and

*A property takes maintenance and so does a relationship. You have
to allow time for things to emerge. D. H. Lawrence said,
'You always seem to think you can force the flowers to come out.'*

—MATTHEW BENSON

was one of the founders of the American Wing at the Metropolitan Museum of Art, where her impressive collection was given.

The board-and-batten siding that was so much a part of this region's architectural heritage unifies Matthew and Jill's rural retreat, which reflects the tenets of the Picturesque Movement popularized in America by Andrew Jackson Downing, whose own home and nursery, Highland Gardens, was just down the road. Across the street is Morningside, the 1859 home built by Downing associate Frederick Clarke Withers, whose Gothic-Revival library was removed and installed in the Metropolitan Museum of Art's American Wing.

Algonac, the ancestral home of Sara Delano Roosevelt, President Franklin Delano Roosevelt's mother, was connected by a rustic bridge to Echo Lawn.

As a child Matthew had lived all over Europe while his dad was working as a cultural attaché; hence he was well accustomed to historic buildings. "This place reminded me of some of the houses in the

PREVIOUS PAGES: The early twentieth-century gates were a later addition to Echo Lawn, which was built around 1860. ABOVE: Jill Rowe and Matthew Benson, the owners of Stonegate Farm. OPPOSITE: The Autumn Damask roses are used in essential oil for their rich and aromatic perfume.

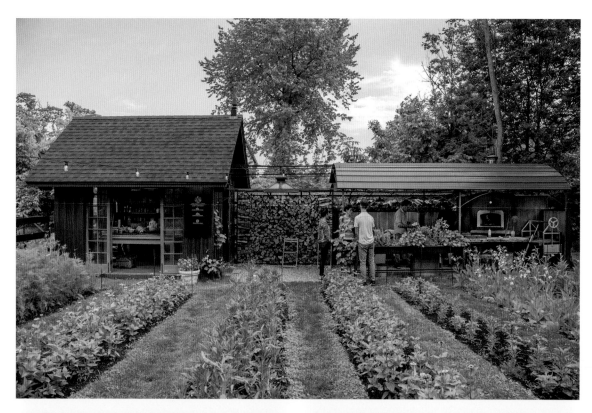

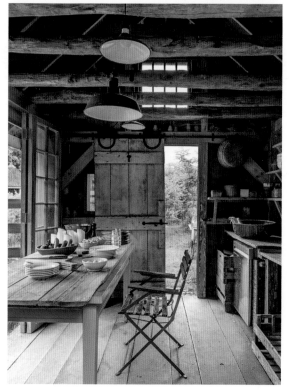

OPPOSITE CLOCKWISE FROM TOP LEFT: The outdoor production space with a wood-fired oven is used to host seasonal dinners called Dirt Kitchen Suppers; the prep kitchen; chilled Hakurei and basil pesto soup with borage blossoms being served. ABOVE: Guests in the garden at one of the summer events; the greenhouse is also used for intimate dinners. BELOW: Freshly baked focaccia, made with tomatoes, basil, and leeks, cooked in the wood-fired oven.

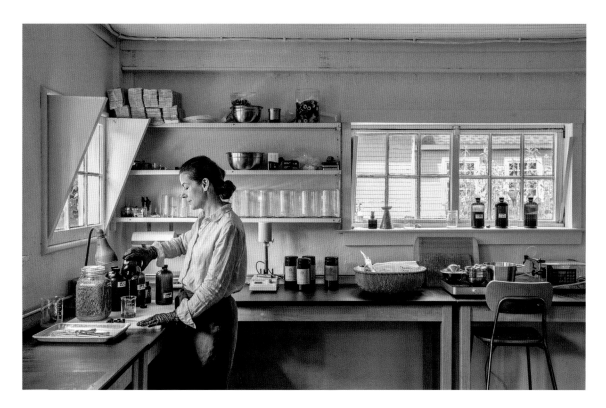

Swedish countryside I experienced while growing up. What they don't have in Sweden are entrance gates like this," referring to the monumental early twentieth-century Arts and Crafts entrance, rendered in stone and brick and lending the farm its name.

Still standing are the carriage house, icehouse, a stable, and the cow manger, which now serves as Jill's laboratory. Matthew said, "Almost all the trees here are cultivars mentioned by A. J. Downing, whose grave is very close by. I found a guy in Michigan who creates fields for Civil War battlefield reenactments using all these heritage trees. I asked him if he had Esopus Spitzenberg and Pink Sparkle apples and was blown away when he said, 'Yes' and sent us 'whips' to get started in the orchard."

After modeling with Wilhelmina and Elite in New York, Jill worked at Christie's before taking on

positions at Tony Shafrazi and Sperone Westwater galleries. Jill said, "The arc of looking at artists, what they're influenced by, and how they get to their own expression of what they have to offer was helpful."

In 1995 she met decorator and real estate agent Randy Florke while looking for a home in Sullivan County. They ended up opening The Kitchen, a restaurant in Jeffersonville together. For three years she was the chef and sommelier there until she sold him her share and moved back to New York. Soon thereafter she landed a managerial position at Danny Meyer's Union Square Cafe. All of these experiences paved the way for her arrival at Stonegate. Living a few miles down the road in Newburgh, she met Matthew, and they became a couple.

Matthew quotes author Martha Beck to explain the couple's thought process, "'How you do one thing, is how you do everything.' This encapsulates so much of what we're doing here on the farm. We have no playbook . . . We are self-sufficient, completing everything needed here: the packaging, photography, and processing of the fruits and botanicals. For this enterprise to move the needle forward, we are

ABOVE: Jill working in the formulation lab of the apothecary that was originally the cow manger of the Echo Lawn estate. OPPOSITE: Jill and Matthew display the bottles and jars of their skincare products in the apothecary, which is adjacent to the flower fields.

ABOVE: Matthew's collection of musical instruments in the barn that was once part of an 1860s agricultural complex, which included a carriage house, stable, icehouse, manger, and gatehouse. Twenty years ago, the barn was converted to domestic quarters and now serves as a gathering and entertaining space. OPPOSITE: Autumn Damask rose petals that will be used by Jill for skincare products in a basket on the dining table.

reflecting on our aesthetics, values, and priorities. Most of the cosmetics today are produced by very few laboratories. The brands are thirsty for actual meaning. We have the eye for detail to produce a very special product within the walls of this garden."

The farm cultivates an abundance of medicinal and culinary herbs, botanicals for topical and ingestible beauty and wellness, as well as fruit, vegetables, cut flowers.

Stonegate also hosts Thursday suppers where all the food served is from the garden. Matthew said, "We are big on fully immersive experiences.

The herbs that guests are sitting next to are incorporated in the sorbets. The calendula across the field is in the salad dressing." While I was attending a dinner recently the heavens opened, followed by a deluge. Everyone moved rapidly into the greenhouse to finish eating. Then a magnificent rainbow appeared to punctuate the end of the meal.

Matthew said, "A small farm is like a stretched canvas. All the black fencing is like the borders that surrounds full frame printing; it visually isolates different areas for the eye to take in. The confinement of space can lead to great creativity."

GLYNWOOD CENTER FOR REGIONAL FOOD AND FARMING

COLD SPRING

The evolution of Glynwood becoming the much-revered powerhouse that continues the agricultural identity of the Hudson Valley is as organic as the produce that it is now certified to distribute. The property, once a vast swath of farmland in Cold Spring in Putnam County, consisted of 2,600 acres when it was purchased by financier George Perkins Jr., his wife, Linn, and his mother, Evelina, in 1924 from the Jordan family. They named the farm Glynwood, referencing their three names.

At the farm, the Perkins carried on the deep conservation ethic inspired by George's father, George Perkins Sr., who paved the way for the creation of the Palisades Interstate Park Commission. At that time Glynwood was the epitome of a gentleman's farm,

while Wave Hill in Riverdale was the family's more formal primary residence.

Anne Perkins Cabot, the daughter of George and Linn, grew up at Glynwood. Later, she married Frank Cabot, and the couple divided their time between Stonecrop, just up the hill from Glynwood, and Les Quatre Vents in Quebec. Frank was a financier, gardener, and horticulturist who founded The Garden Conservancy, based in Garrison, New York, in 1989. Both of these properties are open to the public on the Conservancy's Open Days program. In 1960, the farm took a turn when Evelina and George Jr. both died. Sadly, the golden age of the farm had passed. It wasn't until 1992 that the family sold over one thousand acres to the Open Space Institute, annex-

PREVIOUS PAGES: A close-up of a mural of the Perkins House and the Hudson River in the living room. Looking west over the old barn to the Perkins House. CLOCKWISE FROM TOP LEFT: The agricultural library is housed in this wing of the house; looking east toward the fields; peonies with dry-stacked stone walls seen in the distance; one of the original farmhouses on the property. OPPOSITE: Guests at one of the Farm Dinners used for fundraising.

ing the rest of the property to the Clarence Fahne-stock Memorial State Park. The remaining 957 acres was used as the base for a not-for-profit center that took a leading role in encouraging regional country-side stewardship. In 1995, another 900 acres were sold to the Open Space Institute, with 700 added to Fahnestock State Park. Eventually, the 230-acre farm became the Glynwood Center for Regional Food and Farming, with the "Inc." added in 1997.

Two things became clear during the following years: small and mid-size agricultural farms were imperative to the preservation of rural farmland, and the agricultural businesses in the area were in serious trouble. Glynwood compiled a paper, "Smart Agriculture: Selected Tools and Techniques for Pre-serving Farmland," which outlined options for zon-ing, the transfer of development rights, conservation easements, and leasing options for farmers. It also

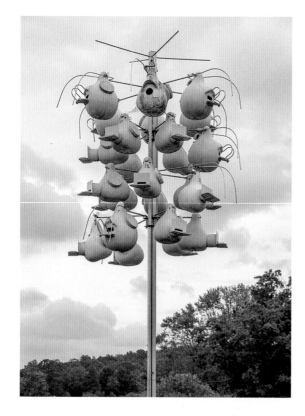
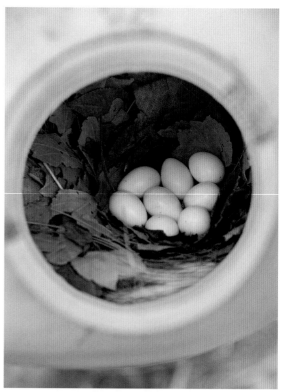

Farming can be a slightly lonely existence. We can often be a fragmented industry, looking at our fellow farmers as competitors instead of allies. But we face so many of the same challenges, that how we can collaborate is important. The old networks are fading away— and Glynwood is establishing new ones.

—ALEX REESE, FORMER CHAIRMAN OF THE BOARD

addressed Community Supported Agriculture (CSA), agritourism, and branding, creating an important template that continues to serve the community.

Glynwood's program "Keep Farming: Connecting Communities, Farmers, and Food" is the backbone of its efforts to pass on resources to the region. Their leadership group, the Community Agricultural Partnership, was formed to work with volunteer teams and experts to collect data on what is being produced in the area, how much land is being farmed, and the success rate of marketing. This database offered an unprecedented snapshot through a macro lens of the state of the industry in the area.

The initiatives at Glynwood are impressive. Addressing topics dealing with the long haul, using hands-on experience and resources not ordinarily available to young farmers, fills a crucial void in the region where many people have not had access to this kind of knowledge.

Associate Director of Vegetable Production Jarret Nelson, whom I spent a bumpy afternoon with driving around the farm in his ATV, showed me the impressive fields of USDA Certified Organic vegetables. This means that the farm adheres to strict organic standards set by the US Department of Agriculture, which prohibits the use of synthetic pesticides, herbicides, and fertilizers. The farm also produces pasture-raised meat and eggs. Their livestock is cared for in ethical and healthy ways and are raised under Animal Welfare Approved standards. "Few academic programs include sustainable agriculture," Jarret said. "The kind of diversified vegeta-

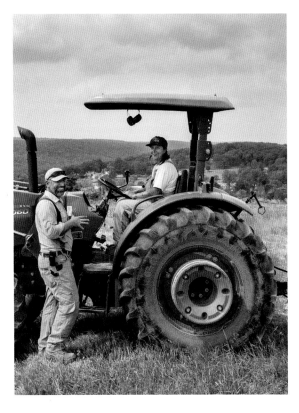

ble production that we practice here is unlike what's existed before. Glynwood is teaching it hands-on." Apprentices help grow the food Glynwood sells through their CSA and Farm Store.

In an era when the practice of passing one's farm onto one's children cannot be taken for granted, Glynwood is producing waves of young people into the field. For the apprentices, this is a laboratory where they get to observe and practice farm management techniques and how to address inevitable challenges, such as how to reduce greenhouse gas emissions and deal with changing weather patterns. The Farm Business Incubator program, co-partnered with the Open Space Institute, is held across the Hudson River in New Paltz in Ulster County. Farmers who have completed the Apprentice program move up to the next step, which provides the opportunity to begin their own businesses in a low-risk, supportive atmosphere.

Kathleen Finlay offered a reevaluation of the mission statement when she came on as president in 2012. Programming has grown to include The Cider Project, which fourteen years ago jump-started the reimagining of what had been a historic regional tradition. Looking toward the future, it is possible to imagine a Hudson River Valley that is home to a wide array of farms that use regenerative practices, led by farmers who have trained with the best teachers and who keep on learning from one another. Who can argue with educating 600 food and farming professionals, significant donations to local hunger relief programs, apprentice graduates, and an increase of New York State's cideries by 600 percent? The values that Glynwood presents and advocates for speak to the many threads running through the community at large. The intention is to produce healthy, nutritious food over the long haul. Please sign me up.

OPPOSITE: The gourd-shaped birdhouses are constructed for purple martins and can be raised or lowered using a pulley system; a close-up view of their eggs inside. ABOVE: Jarret Nelson giving instructions to a farm apprentice on maneuvering a tractor; hens' eggs being collected at the end of the day by another apprentice.

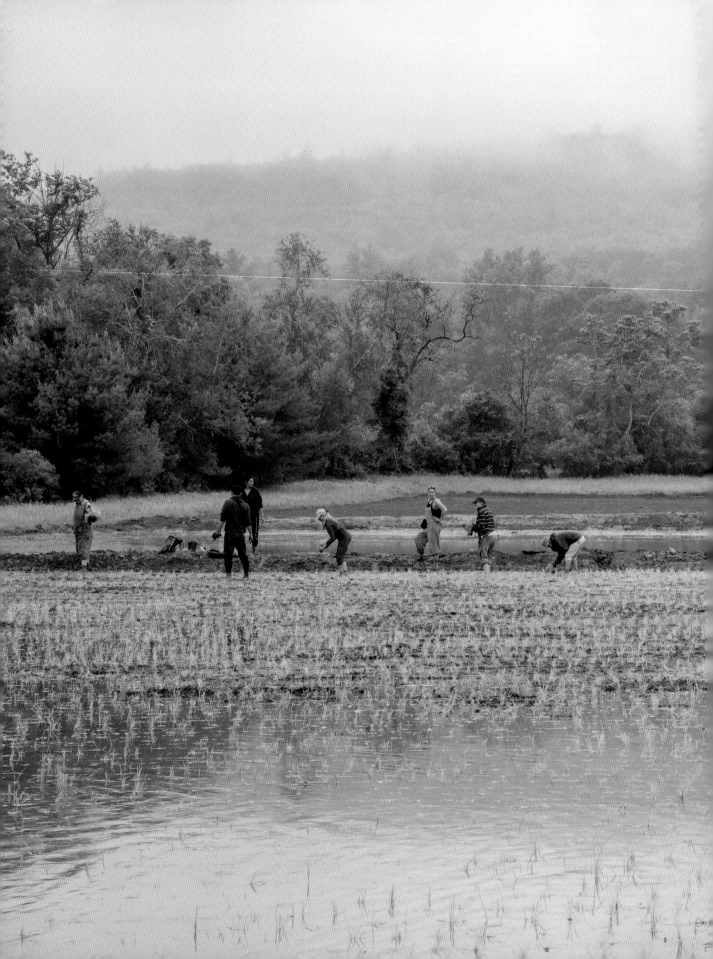

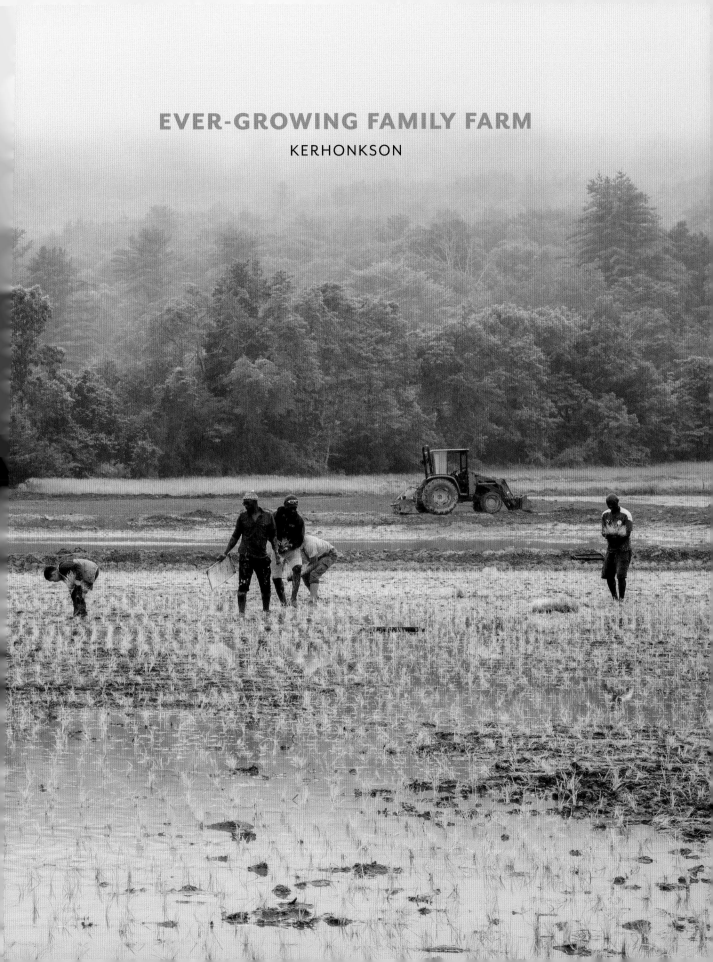

EVER-GROWING FAMILY FARM

KERHONKSON

riving across the Hudson River enroute to Kerhonkson in the rain did not bode well for a successful day of photography. But as I rounded the corner on the dirt road and got out the car, the visual I was confronted with stopped me in my tracks. It was a magical moment, made even more so after meeting Nfamara Badjie, his son Malick, and co-founder of the farm, Moustapha Diedhiou, all knee-deep in mud. Jennifer Petit, who purchased the land in 2021, soon joined us and shared the history of the property.

When I sat down with the three men—Nfamara and Malick are from Gambia and Moustapha is from Casamance in Senegal—it became clear that their

venture growing rice is a bit of an outlier in the region, but one that is representative of the many diverse ways that agricultural businesses can get momentum and find their niche. Rice is indeed a unique crop along the Hudson, with Ever-Growing Family Farm one of the only commercial rice farms in the region. The first time I heard about the farm, I was incredulous but after I learned their story, it all makes sense.

Nfamara, a member of the Djola tribe, was living in Sitta, Gambia, where he is a renowned drummer, playing Bougarabou, traditional ancestral drums. In 2000, Todd Casata, a musicologist at the University of Southern California in San Diego (USCSD), was traveling in the region and heard him playing. They

PREVIOUS PAGES: The inaugural day of rice planting at Ever-Growing Family Farm. ABOVE: Nfamara, Malick, and Moustapha wearing traditional African batik clothing with ceremonial headdresses. OPPOSITE: The rice seeds are germinated in Nfamara's greenhouse at his home in Ulster Park before being transferred to the fields; One of the burlap bags used for the rice; Jennifer Petit at work in the rice fields in Kerhonkson.

forged such a strong connection based on their shared appreciation of music that Nfamara invited Todd to live with his family for two months. When it was time to leave, Nfamara presented Todd with a set of hand-carved drums. Five years passed before Nfamara received a message that there was a call for him at the local police station. It was Todd, telling him that the faculty at USCSD wanted to meet his teacher.

Following months of paperwork, Nfamara became the first person from Sitta to come to America. He stayed three months in San Diego, then moved to the Bronx where he lived with a cousin. It turned out that the cousin had a Senegalese friend from the same tribe as Nfamara, who resided in New Paltz and was also a drummer. The two men got together to play Bougarabou. At a dance class in New Paltz, Nfamara met Dawn Hoyte. Soon after, he brought her to Gambia for a traditional Djola wedding, and there she met his children. The family eventually moved, along with his son Malick, to Ulster County and lived in a house owned by Dawn that became too small once the ever-growing family expanded. They looked for a larger place, hoping to discover property that could support the growing of rice. Nfamara said, "Dawn told me that 'No one grows rice here; you're crazy,' but when I found our current house, I was confident that the wetlands

Due to the absence of chemicals used in the cultivation, we are constantly getting feedback that people feel healthier eating this rice. We dry it in the sun, polish it twice, and it's ready to go.

— MOUSTAPHA DIEDHIOU

in the back could work. Our family in Gambia has always grown rice and millet for coucous as well as peanuts. We located two trays of organic rice seed in Vermont and got to work. Eventually we started growing black, red, Loto arborio, and Koshi rices."

Helping them achieve their dreams was Dave Llewellyn, director of Farm Stewardship at Glynwood Center for Regional Food and Farming. He also works for the American Farmland Trust, which helps facilitate loans. Dave introduced the men to Jennifer Petit, who had recently purchased one hundred acres in Kerhonkson that had been farmed for the last century. She was looking for someone to continue the tradition.

"The first time I came to this land," Nfamara said, "I dug into the soil very deep. I saw that it was clay at the bottom, which is perfect for growing rice as it keeps the water from draining. The topsoil was black and full of nutrients. I was convinced at that moment that we could make this work."

"It took us awhile to come to terms with the weather, Moustapha said. "The first time I saw snow, I asked, 'What is that?' In this area, there is rain throughout the year; in Gambia, only for one to three months. Last year we produced one thousand pounds of rice. I knew we could grow rice here. And this is coming true."

ALL FOR ONE
ONE FOR ALL
GOSHEN

Sitting with me under a shady tree, Alix Daguin said, "My family has been obsessed with food for eight generations." In 2021 she and her mother, Ariane, opened All For One One For All farm (AOOA), referencing the famous motto of the three musketeers in the novel by Alexander Dumas. Alix explains that the quote spoke to their hope to create a farm that stands up for what is right and that would also enrich the local community.

Alix's grandfather ran the Michelin-starred Hotel de France in Gascogny that he had inherited from his parents. Here, he invented magret de canard, which became a French staple served throughout France. Since palmipeds, or web-footed birds, were considered dirty at the time, her grandfather discovered a way to serve duck in a manner that provided confidence for his guests. This part of France was known in the 1950s for its bull arenas. Alix explained in as delicate a manner as possible that the insemination for breeding was achieved via the use of liquid nitrogen; it was her grandfather's idea to implement this same technique in creating the frozen ice-cream dessert he became famous for. Alix said, "El Bulli chef Ferran Adrià is often quoted as attributing this process to one Monsieur André Daguin."

Although Alix's mother, Ariane, is André's eldest child, her brother inherited the business. For thirty-five years she ran her own enterprise, D'Artagnan, which specialized in Hudson Valley foie gras. Ariane sold the business in 2021 and decided that she and her daughter should set up shop with a new endeavor.

Alix grew up in Manhattan with her mother. While attending Cornell University's Hospitality Management program, she started a series of group dinners. These were held in a nearby forest among other inviting environments. "I wanted to design spaces for

people to eat and converse. I needed the tools to be able to build spaces for eating enjoyment, so I got an architectural degree at the California College of the Arts. Following an internship with French architect Jean Nouvel, I started my own firm."

While hiking together one summer in Spain, Alix's mother asked her if she was going to work for D'Artagnan. They had toyed around with the idea of opening a grocery store and an academy for kids centered on farm-grown food. After Alix started her design firm, Duck Duck Design, both women realized

that it was now or never to realize their dream. Alix remembered the constant refrains of "Are we really going to jump head-first into starting a farm in New York State?"

Araine's best friend lived in Goshen in Orange County, where AOOA is now located. "There is amazing soil and serious agrarian roots here," Alix said. While driving to Goshen, about an hour from Manhattan, they saw a 'for sale' sign on a horse farm with fifteen acres that seemed manageable. They bought the property, and it took several years to get

AOOA up and running. Alix said, "We both agree that good food shouldn't just be for people that can pay more. Our mission here is to connect people to a productive biodiverse environment that produces nutritious food at fair prices. I want to introduce young people to the benefits of healthy eating. To engage them, we created sheep milk chocolate popsicles and organize food scavenger hunts." The superstar of the farm, Bilou, the Toulouse goose that sat by my side and nuzzled against my leg for an hour while I was interviewing Alix, helps create a surreal-like welcoming environment.

PREVIOUS PAGES: The raised beds behind the barn at All For One One For All farm are planted with salad greens and herbs. TOP ROW FROM LEFT: Bilou, the Toulouse goose; Alix with a flock of her Karakul sheep; her dog, Paul, in a pollinator patch; a sign indicating the sturdy grape varietal grown on the farm. BOTTOM ROW FROM LEFT: A soldier beetle pollinating a fruit tree blossom; an edible squash blossom; AOOA implements the silvopasture practice; a close-up of Nanking cherries.

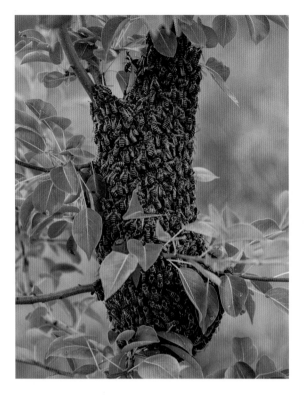
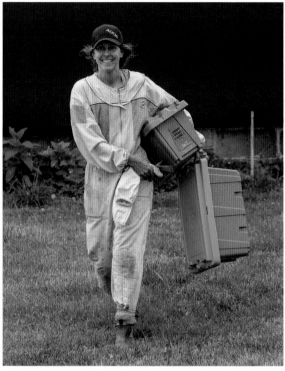

AOOA is a silvopasture farm, which means there is an integration of trees, forage, and grazing of animals that is mutually beneficial. The trees host birds and necessary insects that assist in cross-pollination to help to create the optimum environment for healthy produce. A micro-environment is created where spraying can be omitted entirely. The trees provide shade when needed for the animals as well as a root system that replenishes the aquifer and prevents erosion to the topsoil. Alix has the tops of the trees cut, and the animals are fed with the leaves when droughts occur. The birds eat the unwanted insects that would otherwise attack the fruit. "Once the animals eat the leaves on the branches, we take the voided branches and create a brush pile," Alix said. "This is a biocontrol tool where snakes, insects, and diverse birds and bugs can live. What a small farm needs is a complex diversity of animal life, starting with the sheep, chickens, bees, and insects. We need this environment to create as resilient an atmosphere as possible on the farm. Even-

> *Don't rake up leaves. Once broken down, fallen leaves improve soil health and add carbon into the ground.*
> —ALIX DAGUIN

tually this all filters down into the soil and is regenerative. In America we have altered ninety-nine percent of our soil and it is very much time to start to reverse the practice. We had enough capital to start the process of creating a farm that is sustainable, but obviously it needs to become self-sufficient in a short amount of time. Today, we have 120 new baby hens, 250 laying hens, 120 meat birds, sixty turkeys, thirteen sheep, and six geese." For the last three years Alix and Ariane have employed a great team: Danielle Caldwell is in charge of marketing and graphic design, Matt Celona is the farm manager, and Luke Segota oversees the market gardens. Menus using their produce are being created for the farm's soon-to-open restaurant.

ABOVE: An impromptu swarm of bees; Alix preparing to catch the swarm and bring it to a new hive. OPPOSITE: The farm has many laying hens, which include Golden Penciled Hamburgs, Salmon Faverolles, and Spangled Russian Orloffs. The Hen Mobile was retrofitted from a two-horse trailer with roosts and nests added inside.

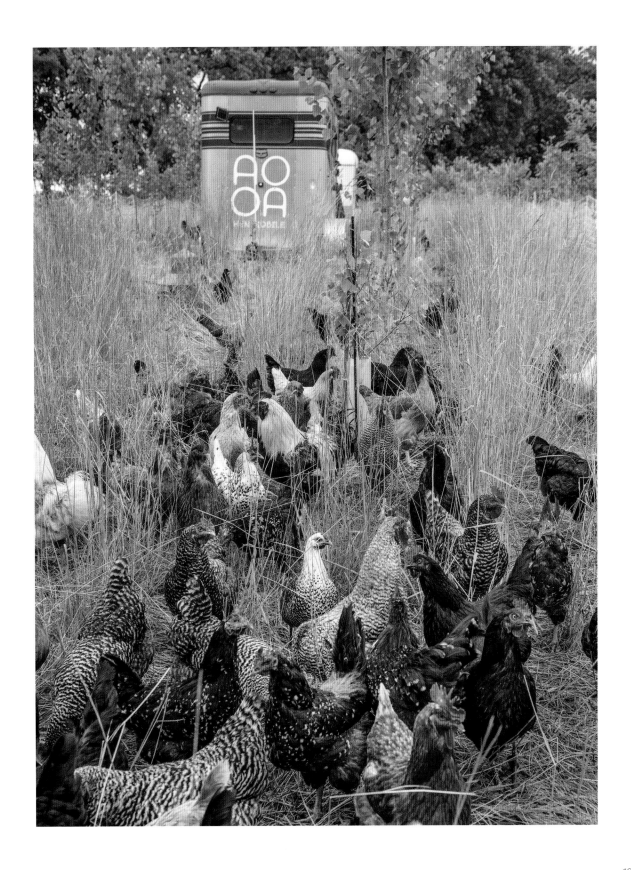

SPARROWBUSH BAKERY

HUDSON

Grayling Bauer got a phone call in August 2021 from his employers Antoine Guerlain and Ashley Loehr, who were looking to sell their bakery to him. Antoine and Ashley had started Sparrowbush Farm, an organic vegetable operation, in 2013, and then Antoine, a master mason, had built Sparrowbush Bakery's oven in 2018 to start a new operation. Now they wanted to move to Vermont, and the proverbial question of "How do we find the next steward of our business?" was on the table. After receiving the offer, Grayling said, "No way." Despite having only worked there for several months, he soon reflected on his decision and changed course. Running his own bakery seemed too good an opportunity to turn down.

Grayling knew the area well, having gone to Bard College, which is a few miles south of the bakery. After school he moved to Manhattan for several years, working for interiors stylist Michael Reynolds and then at The Standard Hotel as marketing manager. "I just presented myself to Antoine after I moved back to the area," he said. "His bakery was focused on wholesale and farmers market businesses, and the idea of working in a wood-fired environment with locally sourced grains was appealing."

Continuing in the original bakery's tradition, Sparrowbush is a small-production bakery and stone mill, specializing in naturally leavened bread and fresh milled flour. Grayling said, "Being a 'boss' was a big personal step for me when I took over." Spending time with Grayling and his dedicated team, starting

Every day we repeat the same process and yet every day we learn something new; we create the right conditions, and the dough does the rest; there are infinite variables that can impact the outcome of our loaves, so why fixate on them all. The best bread comes out of the oven when we let those false hopes die.

—GRAYLING BAUER

at the crack of dawn, I encountered a very efficient and impressive operation. Minutes count, and there is a definite rhythm to the bread-making process.

As part of Grayling's desire to only use local ingredients, the bakery sources most of their grains from Stuart Farr of Hudson Valley Hops & Grains, which plays an integral role in Sparrowbush's breads. Lang-MN is a hard red wheat that is high in protein, and Rouge de Bordeaux is another grain that Grayling is fond of. He found that milling the Lang-MN with Renan, a lower-protein wheat, produces the best result. The two grains are run through millstones, then through a sifter. "With stone milling you get bigger chunks, which adds to the character of the loaf. We sell the milled flour at farmers markets as well. I inherited many recipes but am always tweaking them. The quality of the bread is directly linked to the fact that we mill the ingredients ourselves." For pastries, Sparrowbush often uses the fruits from Montgomery Place Orchards and berries from Whistle Down Farm.

Grayling found a new space for the bakery in Hudson, the Columbia County city a few miles north of the original location, "I'm thinking several years into the future," he said. "The new bakery has a big yard, a place where people can gather, and I like the idea of an expanded workspace." The idea behind this expansion is echoed in the name of the bread that I devoured during my visit, The Neighborhood Loaf. This sliced bread is made with organic wheat grown in the region that is milled and sifted at the bakery, fermented, and then baked in a Dante's Inferno-like

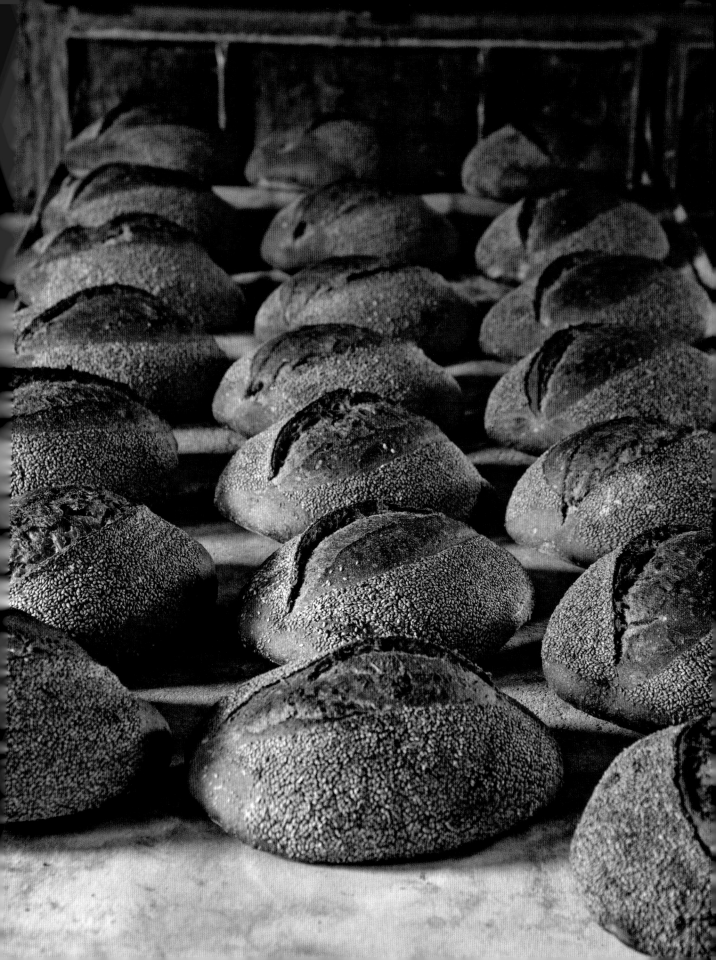

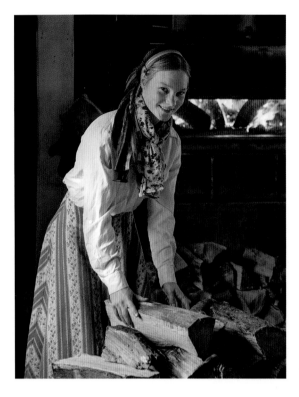

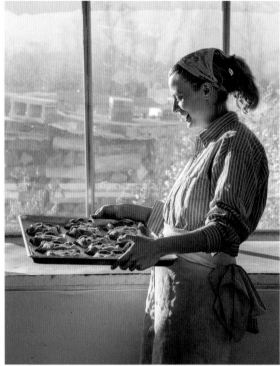

oven, which proved to be a challenge to move as it weighs ten tons. Grayling said, "Baking wood-fired bread forces us to sequence the different breads through the oven because we are slowly losing heat over the course of the bake. We start with small breads that can take high heat like Companion, then the hearth loaves, followed pan loaves that need a longer baking time. We don't really keep track of temperature because we can't control it. The fire that we make the day before determines everything."

The list of what the team is producing is comprehensive. The naturally leavened breads include rye, raisin oat, brioche, table bread, and sesame. Sparrowbush also sells organic flour and polenta. Other caloric offerings are galettes, Red Fife round wheat miches, and morning buns made from brioche dough. And then there are the irresistible walnut and chocolate chip cookies.

During a Saturday morning visit with Grayling, I was mesmerized by the choreography inherent in the bread-baking process; the raising of the mechanized loading table that delivers the loaves of bread into the oven, the timer then going off, and the

removal of the piping hot bread. I tried all of the varieties as they exited the oven and was overwhelmed with the deliciously different tastes and the rugged and handsome loaves. Hot bread is comforting and can trigger Proustian memories. It seems simple to make, but herein lie the nuances. Texture, resistance to the tooth, and the relationship of the crust to the center of the loaf are all qualities that the connoisseur of good bread looks for.

Sparrowbush's baked goods are served at Gaskins in Germantown and Stissing House in Pine Plains, among other local venues. At the Hudson Farmers Market, bread appreciation is apparent. Once Sparrowbush's loaves are out of the oven, they are trucked over to the market while still warm and then sold to a line of weekly customers, who make a point of being there at that exact moment.

PREVIOUS PAGES: Freshly baked sesame loaves on the loader after coming out of Sparrowbush Bakery's oven. ABOVE: Baker Eleanor Kress loading wood into the ovens; fellow baker Mary Campbell transporting a tray of tarts. OPPOSITE: Owner Grayling Bauer in his grain room.

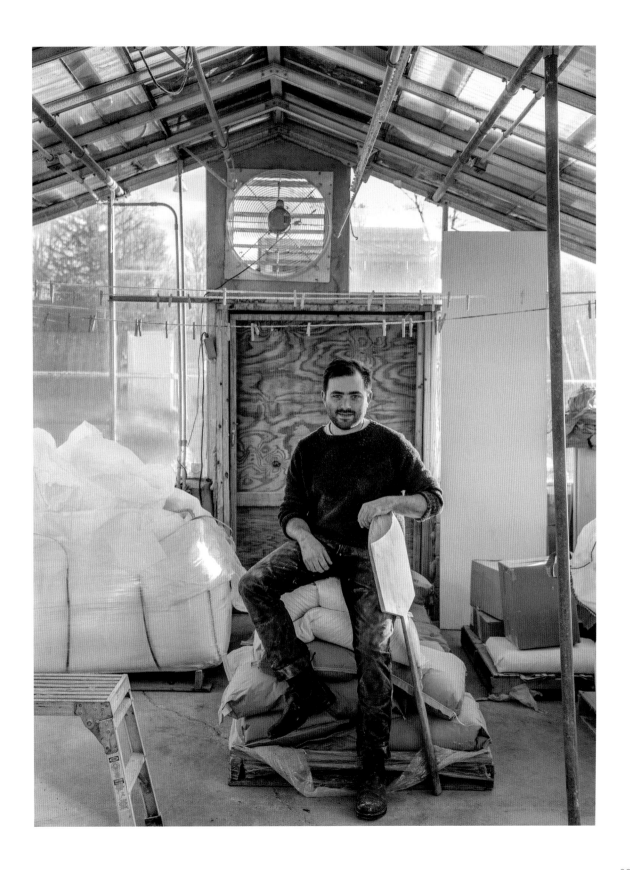

ABOVE: A crispy Companion loaf. OPPOSITE CLOCKWISE FROM TOP LEFT: Bialys at the farmers market in Hudson; Grayling teaching Living Food, a beginner's bread workshop, at Churchtown Dairy; spelt bread being sliced to sample; bread proofing in bannetons.

FOUR CORNERS COMMUNITY FARM

RED HOOK

One of the threads running through my exploration of agricultural practices today is that of contribution. Sam Rose started Four Corners Community Farm, which is an expression of his own history and experience. Launched in 2021, the farm set a mission of "mitigating food insecurity, building a more inclusive community by provid-ing the tools, resources, and network to help people grow their own food, and sharing produce with food distribution programs," and it has been fulfilled.

Sam studied soil and plant science at Cornell University College of Agriculture and Life Sciences. While in college, he often volunteered on agricultural projects in Latin America before settling in Mexico

for ten years where he taught urban farming to high school students. During a semester in the Galapagos Islands with the Ecology Project International, he coached students on how to collect data to document ecological hot spots, regions with a high level of endangered species. The students were propelled forward by their enthusiasm resulting from the research. With his wife, Cecilia, Sam founded Raíz de Fondo, a community garden in La Paz in the Mexican state of Baja California. They also had a kitchen there, where classes in nutrition were held.

The donation of a plot of land and the funding for seeds spearheaded a special project for Sam there, helping him to introduce the local population to per-

maculture and bio-intensive gardening. The sunken beds needed in this part of Mexico to keep the crops cool (in contrast to the Hudson Valley where raised beds work well) were filled with soil fertilized with organic material.

When drug lord Joaquín "El Chapo" Guzmán who was removed from power, the order of the region disintegrated. Due to the increased violence, Sam and Cecilia returned to America. Sam said, "The young guns were duking it out, and our house was destroyed shortly after we left. I was friends with Dan Colen and Josh Bardfield, who were starting the not-for-profit Sky High Farm nearby. We moved to Red Hook while I was working there managing the livestock and vegetables. When I started looking for my own place, the Farmland Trust put me in contact with Frank and Liza Migliorelli, who had a field that they thought might work for what I had in mind."

Sam has always been interested in teaching, which is being put to good use at Four Corners in Red Hook. Using aspects of the educational/business template he had initiated in Mexico, he started to compile thoughts on how this farm might best serve the community. Sam planted ten varieties of small-batch wheat, spelt, rye, and heirloom grains. "A small farm can deal with fifty pounds of a certain seed just to see how it will do in this particular soil at first," he said. "Old-world varieties do well here. They grow tall and snuff out the weeds, which can pop up as I don't use any pesticides. Off season I plant red clover to sequester carbon back into the soil. It is a privilege to farm here. The soil is prime, and the fields are flat and well drained. This is considered the best soil in the region. I have a fiscal sponsor here but became a 501(c)(3) [a not-for-profit classification] so that the farm could become an all-volunteer endeavor and open the land to the community. I wanted to create an environment where people that might not ordinarily have access to soil to grow food on would have their own parcel to work with. There are great tangible rewards when there is food donated to people in need, many who have family members working in the fields of other

> *Modern plants have become shorter and shorter, so they don't fall over in the rain and wind, but the older seeds are better at getting the nutrients needed and to help keep the weeds down.*
>
> —SAM ROSE

PREVIOUS PAGES: The fog-covered fields at Four Corners Community Farm. OPPOSITE FROM TOP LEFT: Sam Rose at work in the corn fields; a logo detail on the gate at the entrance to the farm; Sam's son, Noam, proudly showing a bunch of radishes. ABOVE: Sam in front of one of the old barns.

nearby farms. There are people growing their food on the farm that I might not run into on the street in town. We offer childcare, gas money, and stipends to level the playing field and empower the group that we want to profit. Many of the people coming here are from rural backgrounds but not familiar with productive farming practices. It is hard for certain groups to become involved in the community, but this gives them an opportunity to do so, all the while enriching this environment by bringing their culture here. We do a gigantic event for The Day of the Dead, the Mexican celebration in October memorializing family members who have passed. It is a festive day, one that also memorializes the end of the growing season, and it facilitates cross-cultural exchanges. The women who make the food are proud to share it with the group. It makes me happy to break barriers."

THIS PAGE AND OPPOSITE: The celebration of The Day of the Dead in October at the farm includes concerts, plant sales and *ofrendas* (offerings) that honor the memory of deceased friends and family.

TURKANA FARMS

GERMANTOWN

Past a white picket fence and down a long tree-lined path is the storybook eighteenth-century Georgian house that anchors Turkana Farms in Germantown. What began as the weekend farming project of Mark Scherzer and Peter Davies in 2000 quickly turned full time when their apartment across from the World Trade Center in downtown Manhattan was uninhabitable following the destruction of the Twin Towers in 2001.

The couple was previously living in an A. J. Downing-esque home in Sag Harbor on Long Island's East End, an area routinely used to express what upstaters define themselves in contrast to. After redefining their priorities, they scouted the Hudson Valley for a farm where they could have a decent growing season and some great soil at an affordable price.

This region is significantly less costly than the Hamptons, and it was familiar to Peter, who had

attended Bard College at Simon's Rock in nearby Great Barrington, Massachusetts.

The property Mark and Peter decided to buy included a mid-eighteenth-century house with additions made in the 1820s on thirty-nine acres. It was once part of a vast 300-acre farm with orchards, and seemed like a perfect fit. "The upstairs kitchen was built in 1926," Mark said. "Before that everything was prepared in the basement, which has several small windows and a door for easy access." As I later found out, the original kitchen fireplace still works, and takes me back to an earlier life of the home.

While at the annual Dutchess County sheep and wool show in 2000 at the nearby fairgrounds, the couple were captivated by a breed of Central Asian Karakul sheep. Peter wanted a flock of heritage sheep and these hearty contenders fit the bill. They purchased four sheep and some chickens and began their farming venture. The Karakul breed was brought here from Central Asia in the beginning of the twentieth century as part of the then popular Astrakhan fur industry.

Peter, who had received a PhD in theater from Yale, had previously taught both English and theater in Turkey. With Peter and Mark's strong connections to Turkey, the couple named their property Turkana Farms. This small-scale producer of heritage breed livestock, chickens, turkeys, and a wide array of vegetables and fruits, continues to keep Mark and his partner Eric Rouleau busy.

Looking back, Mark said, "I had fantasies as a kid of living on a hippie commune. Peter wanted to live in a Roman villa when he grew up. So, we compromised. Turkana Gallery was started because of our time spent in Istanbul. We sold Turkish kilims, and we had over four hundred rugs in our loft on September 11." Many of the rugs eventually made their

PREVIOUS PAGES: Mark Scherzer hugging one of the Karakul sheep from his farm, Turkana Farms. His Georgian home as seen from the road. LEFT: Part of the extensive collection of Turkish antiques found in Asia Minor over the years. OPPOSITE: The home's original kitchen located in the raised basement. FOLLOWING PAGES: The flock of the inquisitive and resilient Karakul sheep with their winter coats on.

The F2T app is wonderful. It bypasses the need for us spending the day at a farmers market. We can sell small quantities of food without worrying about the shipping minutiae in order to get our produce delivered direct from our doors to yours.

—MARK SCHERZER

way upstate; some are now rolled up against the walls, and several have been laid out on the wood plank floors. Turkana Gallery was absorbed into Turkana Farms once the pair fully accepted that they were in this whole hog. In fact, the hogs that they were breeding early on were Ossabaw Island hogs, direct descendants of the pigs that were released on Ossabaw Island, Georgia, in the sixteenth century by Spanish explorers.

Mark continued to practice law in Manhattan while Peter lived full-time up in the country. Mark said, "The gardens were impeccable then, but there is a much different vibe now." Peter passed away suddenly in 2018, and Mark said, "I contemplated the time needed to take care of the farm and realized that I couldn't handle all the labor. I very much like doing some of the chores. Additionally, as a farmer, one is always figuring out what the way forward is."

Mark pens the weekly *Green E-Market Bulletin* that goes out to local customers, weaving together philosophical, economic, and pragmatic aspects of a farmer's life as well as what vegetables are ready for pick-up that week. One of his musings concerned the psychological ramifications for Doodle, the Karakul lamb that bonded with Mark after being rejected by its mother. A second is his observation about the winter and summer solstices, and how they affect the activities of the farm.

I was one of those customers when I moved up to Staats Hall in 2010. As a single dad with my seven-year-old son, Elio, I needed things to do with him. One of our outings was to visit the sheep, col-

lect some produce, and place our payment in the crockery pineapple Mark leaves as a symbol of hospitality and the honor system.

"Do you use the F2T app?" Mark said when I reminded him of how we originally met at Turkana Farms. This app delivery service, developed by Farms2you, LLC., connects consumers to fresh farm produce. "Patricia Wind and Clifford Platt, who started the app, are the Jeff Bezos of agriculture," Mark said. "It is amazing that technology is coming to the rescue."

I take in this news while sitting in their cozy 1790s kitchen warming myself by the fire while ordering my week's produce on the phone.

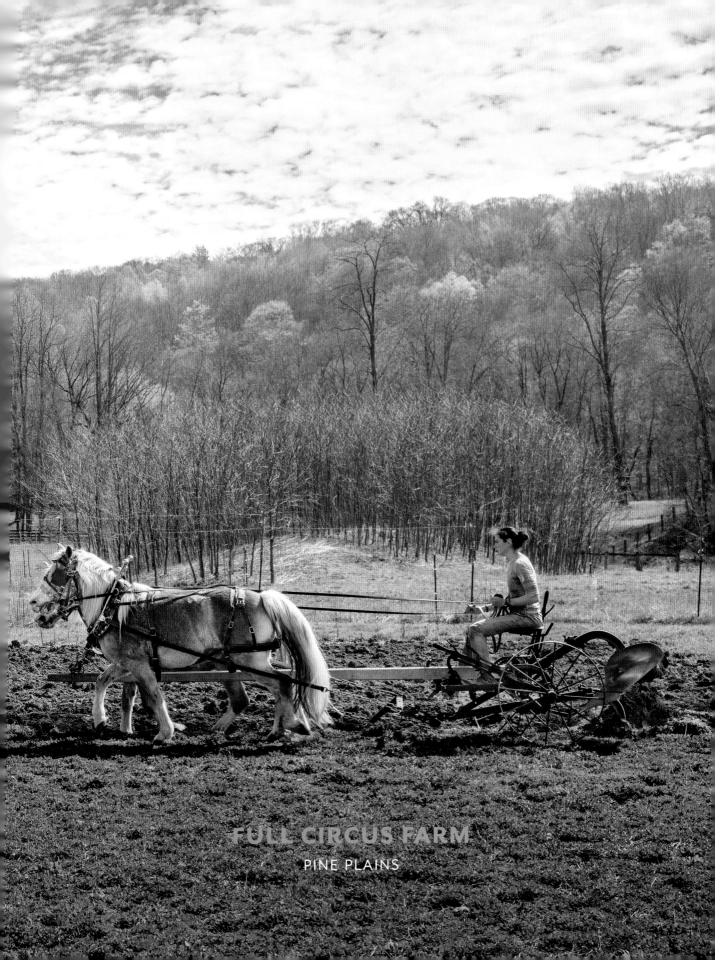

FULL CIRCUS FARM

PINE PLAINS

Mark Stonehill, who runs Full Circus Farm with his wife, Miriam Goler, said, "We were just brainstorming. The name sounded totally silly and improbable; it was an evolution from Full Circle. I noticed that Marina Michahelles had named her farm Shoving Leopard [in Barrytown] and thought if she can go there, so can we." Full Circus is a fruit and vegetable farm, whose speciality is grafting fruit trees. They have a popular CSA program and sell at farmers markets.

Thinking out of the box can lead farmers to some interesting problem-solving conclusions. Like how do you farm when the smell of the diesel fuel necessary to run tractors makes you sick? The solution for Miriam and Mark was to move to horse power, and not the kind that measures engine efficiency.

Enter Sandy and Sunshine, the two eight-year-old Haflinger mares that live on the farm with the couple and their two young children. Mark and Miriam started looking for draft horses, finding these two at an Amish farm in Utica. Mark said, "We easily located great equipment to use. There has been a move-ment away from using draft horses for over a century, so equipment abounds, but finding the right team proved more difficult." The modern plow was perfected in 1814 in New York by Jethro Wood. "These guys are not afraid of the equipment rattling and don't get spooked. They are prepared for anything that might occur on the field. We watched them carefully before taking them back to the farm and saw how beautifully they worked together," said Mark.

The couple had met at Stuyvesant High School in Manhattan. Mark said, "We grew up city kids and never would have thought that we'd be doing this. Miriam wanted to live in the woods and focus on environmental conservation work; she had worked on trail crews with horses during high school summers. I'm from a family of scientists." Mark started farming

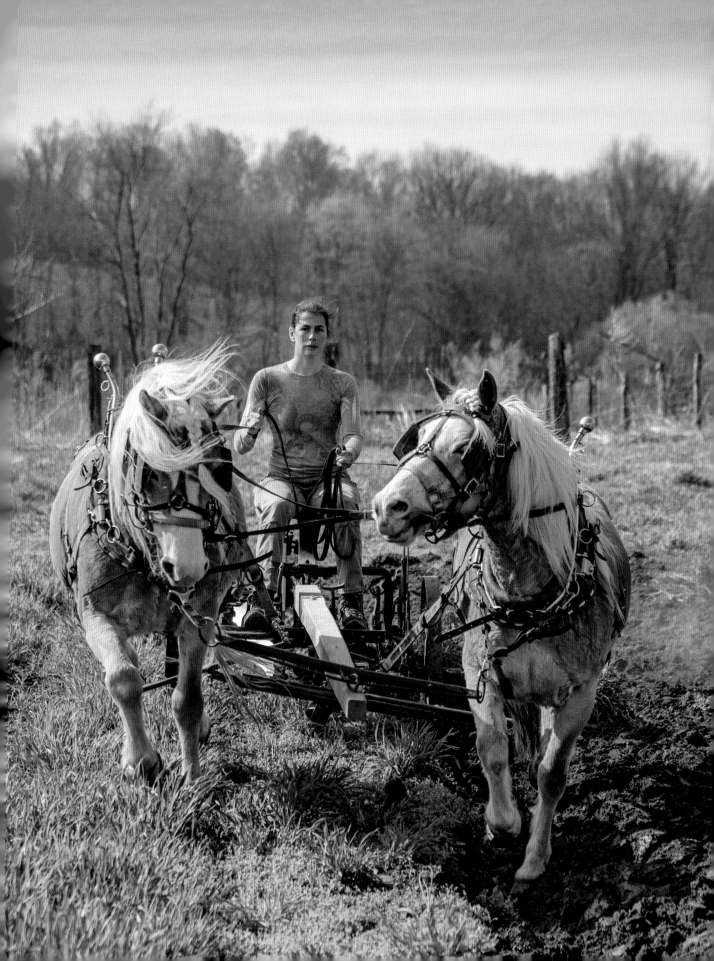

one summer on Randall's Island and shortly thereafter began volunteering at the Brooklyn Botanic Garden and with the New York Parks Department Environmental Education Program. Miriam studied agriculture at Cornell, then worked in Minnesota on a farm while Mark attended Macalester College in St. Paul. After returning East, Mark worked pruning in New York's Central Park.

The next step for Mark and Miriam to gain more experience farming was finding a farm accessible by train, which they located in Amagansett, Long Island. They could take a train with their bikes on board, then bike the rest of the way to work. After a season at Quail Hill Farm, Miriam came to the conclusion that she could farm long term but not with tractors. After spending the next year working and learning tree grafting at a friend's farm that maintained nineteen ponies near Acadia National Park in Maine, it became clear that draft horses were the answer.

The couple finally agreed that they were done with minimum-wage employment, and that it was time to leave New York City and start their own farm upstate. Miriam's previous experience working on the trails had trained her well to work with draft horses, and she really loved taking care of them. Miriam said, "We found the Columbia Land Conservancy's Farmer and Landowner match program, a sort of online dating for farmers. We got lucky and within two months we had found this property. We have a great symbiotic relationship with the owners; they receive an agricultural tax exemption, and we get to fulfill our dreams." They made a general business plan with a projected budget after participating in a program in Maine that focused on young farmers entering the field. Their original lease was for five years, but they keep on extending it as the relationship has been mutually beneficial. Miriam said, "It is important that landowners make some investments in the prop-

LEFT: Mark Stonehill in the orchard cutting fruit tree branches that will be used for whip grafting; Miriam joining the rootstock to the scion wood, which have both been cut at an angle to heal together most efficiently. OPPOSITE: A selection of grafted apple branches, which will be nurtured into apple trees.

Grafting is totally magical. The tissue of two trees literally fuses together to become one; the key to success is to line up the cambium layers as closely as possible. . . . both plants create callus tissue—a mass of cells at the wound site—that heals them together.

—MARK STONEHILL

erty they are leasing. The barns need to be structurally sound, and coolers are helpful for the produce to remain viable. All these details are helpful because the ongoing question with farmers and lessors is what happens to our investments if we were to leave or not have our lease renewed?"

The biggest challenge for Miriam and Mark is the balance of farming and parenting. Miriam said,

"Making it work for the long haul is our goal. We'd like to expand the fruit tree grafting niche of the business. There is a reason that farmers do a lot of the work themselves; the bills are gigantic. Without a certain degree of grit and perseverance, small operations like ours wither and die. We are so proud that we have made this work, and it supports us in a way that's true to our vision."

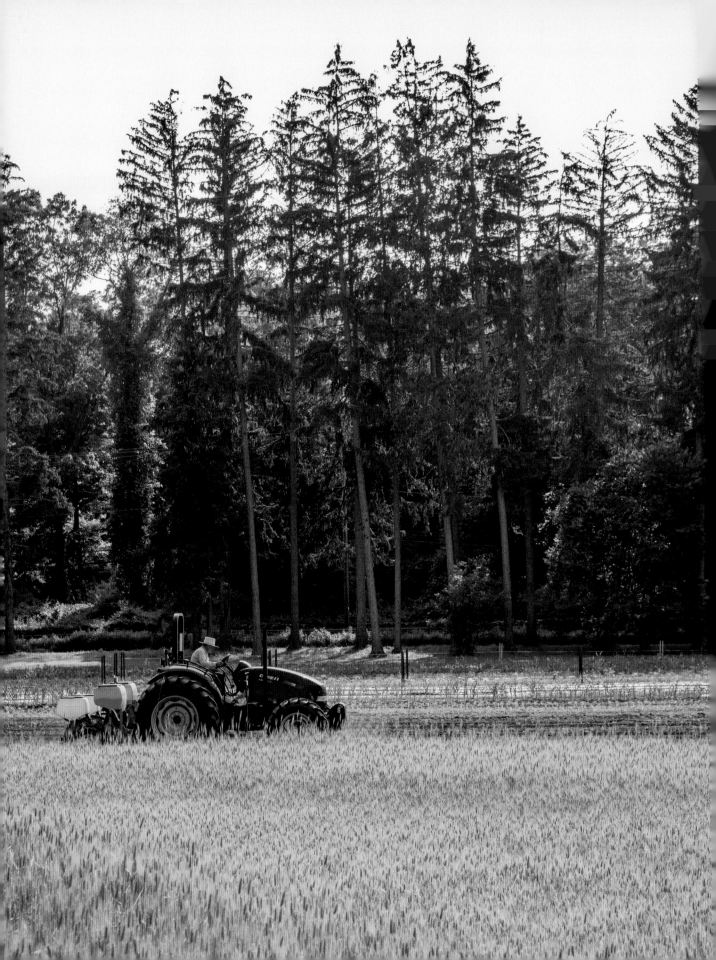

DAVOREN FARM

GARRISON

For nine years Stacey Farley, an artist who works with ceramic tiles, and her husband, Peter Davoren, who is the CEO of Turner Construction Company in New York City, have leased a magnificent ten-acre field that had run amok over the years directly across from Boscobel, the historic house museum on the Hudson in Garrison, which had been reconstructed in the mid-1950s. While I was sitting with Stacey in the shade at a picnic table (there is no house here, just a barn) one steaming hot summer day, she said, "This is the one-thing-led-to-another farm."

The story begins with her husband, Peter, a lover of old tractors. He started collecting examples dating from before 1952 so that he could tinker and put them together for use. He became popular with the neighbors by haying their fields. The couple decided to ". . . capitalize on the time spent in the fields and start growing some food," Stacey said. It became increasingly clear to Peter that working in the fields offered him peace and solitude.

Stacey and Peter began producing crops that they sold at local farmers markets, to restaurants, and at the pop-up farm stands they would set up on site, all the while looking for "the big idea," how they could create a sustainable business model and at the same time carve out an identity that was specific to their farm. Every year they experimented with different seeds and planting practices to see what the best combination of ingredients for success would be. This is how things go with a new farm; you can have all the best academic training, but, really, it comes down to being present with the conditions: the soil and microclimate at hand and particularly the prevailing food culture in the surrounding area.

Farming is a soulful, individualistic, by-myself cleanse that feels extremely productive. On days I'm in the field by myself, I can be very effective.

—PETER DAVOREN

Crunching the numbers after several years, the couple came to the conclusion that theirs was not the winning business plan and that the economic equation was not going to be financially feasible over the long haul.

Stacey said, "We had other jobs as most farmers need to do. It would be great if there were a template for success, but due to the variables in this area, there is not. You have to really think about who you are, and the community that you want to serve; it can be an arduous exercise of inquiry. My thought was that if we could get a great crew of young people here every season, maybe it would work in a different way. We are growing farmers. If we train and set four young farmers into the field every year, we will have done our job. I could never have enrolled so many volunteers if this farm venture had not been a not-for-profit organization that it evolved into. Jennifer Carlquist, who is the executive director of Boscobel, is gigantically helpful with pointing people our way to help out." Thankfully, many people in the area are looking for a way to contribute to the production of healthy food. The equation that seems to be the most successful is that the volunteers work for a minimum of two and a half hours, in teams of twenty or so.

The big idea, it also turned out, included feeding people. Despite the fact that Garrison is an affluent community, the food pantries in the neighboring towns were consistently running out of healthy food for the significant population dependent upon them. Davoren Farm is now focused on delivering fresh produce to these pantries, located in the community as well as in the local churches. They farm also supplies food banks and spaces that can store food for a while.

Stacey said, "Nearby in Peekskill, the pantry serves over 400 families a week. Our daily goal is to get food on their tables within forty-eight hours."

Today, Davoren Farm's mission of producing nutritious, flavorful food to feed people and mentor young farmers is being fulfilled. The farm grows wheat, sunflowers, and a wide variety of vegetables, including sweet corn, arugula, peppers, potatoes, edamame, watermelons, all sorts of tomatoes, and more. In the fall when pumpkins mature, Stacey said, "If, due to poor timing, you miss Halloween, you're done." In other words, get your pumpkin seeds planted in May to ensure that your crop is magnificently robust by Halloween.

PREVIOUS PAGES: Peter Davoren on his Case 90 tractor planting sweet corn next to a wheat field. ABOVE: Wooden markers identifying some of the crops grown on the farm. LEFT: Many of the seeds that the couple use are from Johnny's Selected Seeds, a company based in Maine. OPPOSITE: Peter and his wife, Stacey Farley, on their prized antique restored Massey Ferguson 165 tractor.

SKY HIGH FARM

ANCRAMDALE

We produce a lot of food that is donated, but we know we are not going to solve the problem of feeding communities in need with healthy nutritious fresh food by just donating. The problem that we are trying to solve is systemic.

—JOSH BARDFIELD

What do artists Elizabeth Peyton, Takashi Murakami, Jeff Koons, and Jenny Holzer have to do with agriculture? They are all friends with painter and sculptor Dan Colen, who is the owner of Sky High Farm in the hamlet of Ancramdale, a not-for-profit organization committed to addressing food security and nutrition by improving access to fresh healthy food to people in need. Sky High Farm Universe is a brand that includes the apparel line Sky High Farm Workwear, beverages, and wellness products. These artists and others donate designs for Sky High Farm Workwear, the line of clothing that the farm produces to support its efforts in donating all the produce generated here to food insecure communities upstate as well as in New York City. The farm and the brand are distinct entities that work hand in hand to fulfill the farm's mission.

Sky High Farm Workwear was launched by Dan in collaboration with Daphne Seybold, former communications director of Comme des Garçons and Dover Street Market. A significant amount of the proceeds generated from Workwear sales at Dover Street Market and other shops around the world support Sky High Farm's programs. Workwear has partnered with photographer Quil Lemons and with mega brands Supreme, Converse, and Balenciaga, among others. The merchandise includes repurposed baseball hats, sweatshirts, and button-down shirts, some with playful corn and eggplant embroidery referencing the farm's produce. Many of the garments include the farm's whimsical logo, designed by illustrator Joana Avillez, of a strawberry and a crescent moon. Ben Gilberg oversees the tie-dye process for some of the garments on-site at the farm. Dan and his colleagues have created an ingenious business model that not only financially supports but builds awareness for Sky High Farm.

A decade ago, Dan purchased forty acres of verdant land to create a sculpture studio for himself in

PREVIOUS PAGES: Sky High Farm Workwear employee Ben Gilberg hanging tie-dyed T-shirts out to dry. OPPOSITE: The poured concrete structure designed by Berman Horn Studio was originally Dan Colen's sculpture studio. RIGHT: Executive Director Josh Bardfield in his office; the industrious Sky High Farm team.

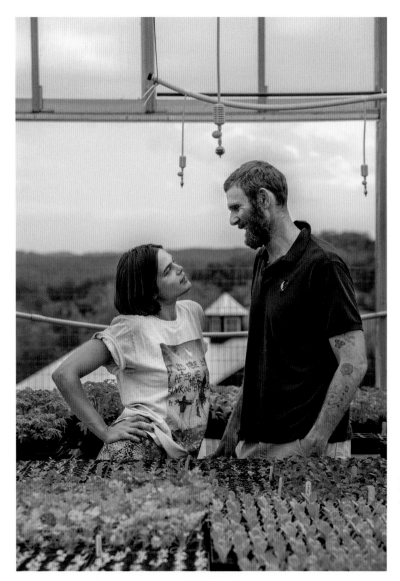

Ancramdale. The hamlet is named after Ancrum, Scotland, the birthplace of Robert Livingston, whose family owned this land from the late seventeenth through the early nineteenth centuries. Eventually, his vision for the land—to be of service to a larger community—emerged. Sky High Farm has evolved into an integrated vegetable and livestock farm.

Dan and the team, including Sky High board member and Executive Director Josh Bardfield, learned that a lot of food banks received donations of packaged, canned, and processed foods. The farm could fill the gap with fresh and healthy produce. Josh

told me about the history of their endeavor during one of my visits to the farm. "I bring a background in public health, and Dan brings his take on art and popular culture, two potentially discordant areas," he said. "Our work here is definitely part of an evolution, and we are building a decade-long runway so that the farm can eventually develop to its full potential."

In 2022 Sky High Farms collaborated with the Judd Foundation for the symposium "Who is we? Where is there? What is it?" on art, land, and community. It was held at the Judd Foundation's Spring Street location in New York City's Soho. The forum

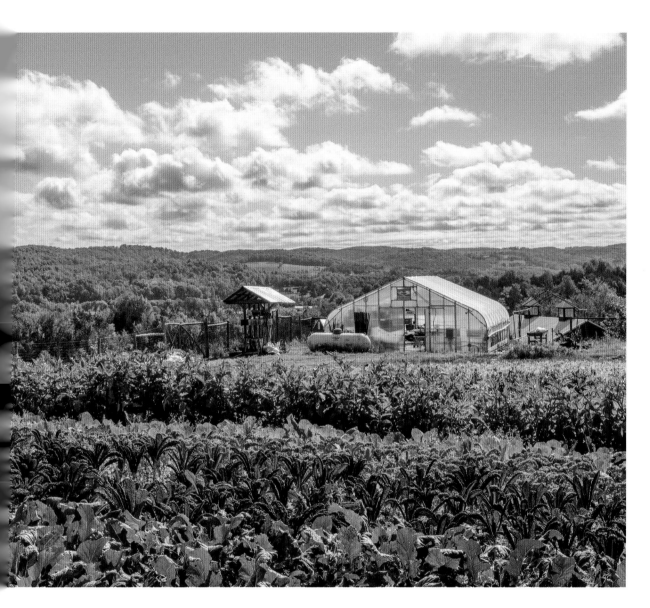

provided and opportunity to explore the vision that Josh hopes will resonate with the farm's extended community. Josh said, "Art resonates with people, and this generation is tuned into platforms that art previously had a monopoly on. Art, land, community. These are the components that as we continue

ABOVE: Dan with his partner, artist and baker Lexie Smith, in the greenhouse; a fall view over the vegetable garden with the Ancramdale hills in the background. Everything grown at Sky High Farms is donated to food-insecure communities in the Hudson Valley and New York City.

to refine our vision continue to stick out as defining our priorities. We live in an area upstate that is rich in agricultural bounty, but there are food deserts that persist, communities that don't have access to fresh produce. There are so many households that have sugar-filled shelves with no vegetables." We continue our conversation on the subject of industrial-scale agriculture. "All over, the detrimental evidence of this is becoming more and more apparent," Josh said. "If we can generate interest, even in a small way, hopefully we can contribute to the overall health of the region because the Hudson Valley feeds New York."

Josh is good at seeing the macro. He worked for years at the AIDS Institute, the state-run agency that oversaw HIV services in New York State, and his specialty was implementing the systems that arranged quality of care for its clients. Spending cuts on global HIV programs resulted in his transition out of this field. "The pandemic catalyzed the [farm's] board to grab the moment to raise funds, develop a workable budget, and to build a base of support that would match their ambitions," Josh said.

There are currently ten employees on the farm and an impressive fellowship program, now composed of four young people with little or no previous experience in the fields. They train in soil health and pasture management. The fellowship participants arrive in May and stay through October. Living on-site, two fellows work with the livestock, and two tend the vegetable gardens.

Josh said, "We are also giving grants to other farms. If we're going to move the needle forward with agriculture, we need to try to forward resources to people that might not be able to get grants. The idea is to take the success that we have experienced and achieved and to spread it in an intelligent way." I focus on this last sentence, a leitmotif that I am hearing from so many people that I have visited during my exploration of farming upstate. These farmers all want to share accumulated wisdom and successful and innovative business models. "We're supporting a foraging project in nearby Ancram that has an outdoor teaching kitchen, workshops in seed-saving and fermenting and on the history of agriculture in the area," Josh said. What makes Sky High unique is their outreach to a broad audience. The farm team is thinking creatively on how to do that. The intersection of art, public health, and agriculture is a great place to be, and their goal is to continue to leverage the resources they have to serve the community at large.

––––––––––

ABOVE: Major Dude in his element; the chicken house is often moved around in the fields to offer fresh forage. OPPOSITE: A picturesque moment in the pasture reminiscent of the work of French artist Camille Corot and the Barbizon School.

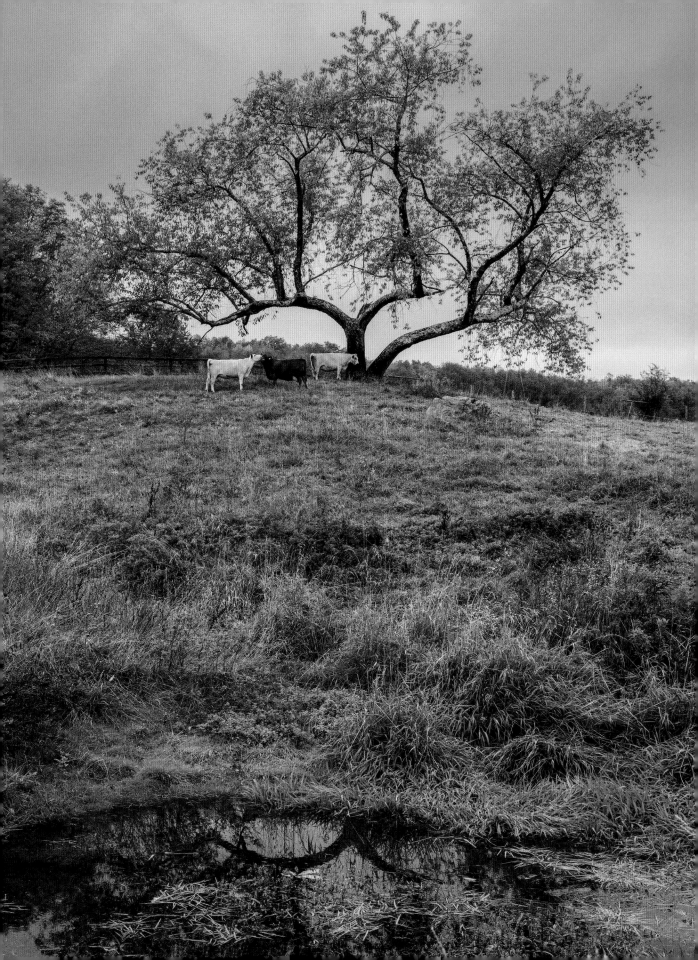

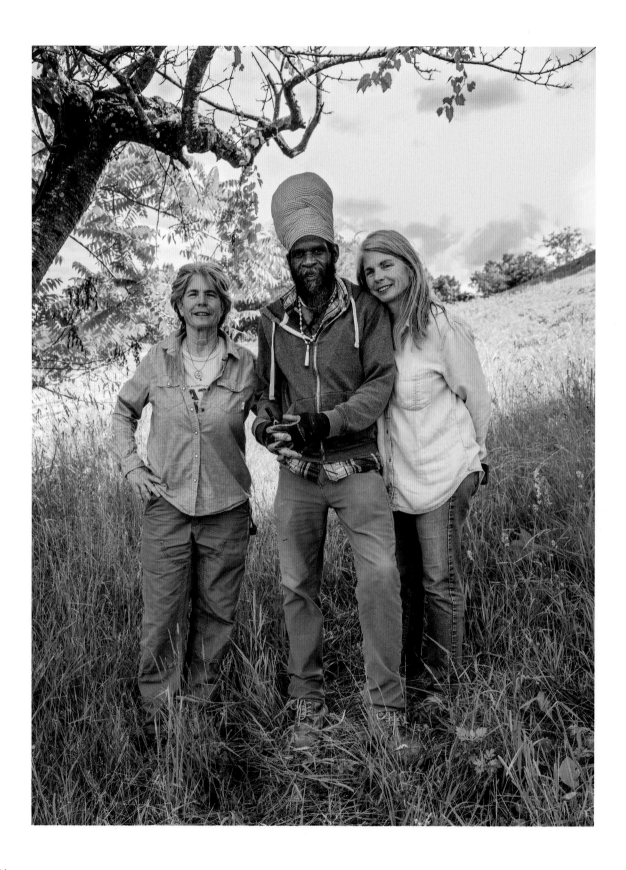

HEPWORTH FARMS

MILTON

riving with Amy Hepworth through the 500 acres of fields that make up the farm bearing the name she shares with her twin sister, Gail, threw me off balance. It is not only that she rapidly attacks the steep hills that lead to the Hudson River with abandon but trying to follow her history of the farm can be hard due to her rapid-fire delivery. I soon became accustomed to it. We careened around fields that were established in 1818 and are now being managed by the sisters, the seventh generation of their family to take on the responsibility. The farm specializes in vegetables and many varieties of greens. Cannabis, one of these greens, is the women's path forward to adapt the farm to the twentieth-first century. "You could say we were betting the farm on this next crop," Gail said.

After graduating from Cornell in 1982, Amy assumed leadership of the farm and began removing the toxic chemicals from fertilizer and pesticides from the soil. In 2008 Gail joined her after a career in biomedical engineering. "If you want control, farming is not for you," Gail said, "but if you want every day to present challenges, farming will align with you." Alignment is a theme that is part of the ethos of the farm's team. Morning circles that include stretching were developed by Amy to add an esprit de corps as well as create the mindfulness necessary to support long days outside. As Amy said, "This can be harsh work, and I don't want anyone here to get bent over. . . . This was not part of the workers' previous training, but little by little they began to see the benefits of the circles. Now they go out to work with a skip in their step. Mindfulness operates on many levels. If someone throws a zucchini in a box and it snaps, it negates all the work that preceded that moment. . . . The graphic design that is used for packaging represents the Native American Twelve Cycles of Truth, which we have incorporated into our philosophy through encouraging strength of character, donating millions of pounds of produce to food

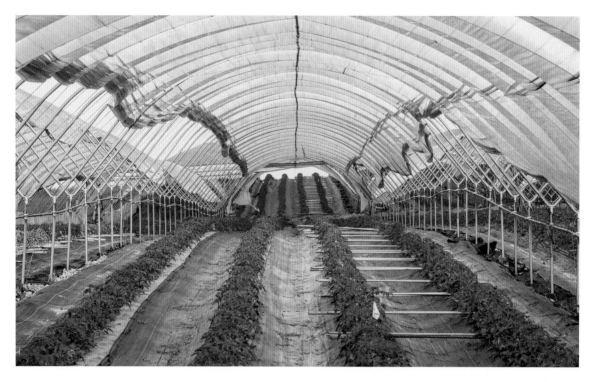

PREVIOUS PAGES: Sisters Amy and Gail Hepworth with cannabis specialist Michael Hart on a hill above the Hudson River. Pre-rolls in their distinctive packaging. ABOVE: The high tunnels are used to house heirloom tomatoes. BELOW: Fields of kale and collard greens laid out with precision. OPPOSITE: Planting cannabis seedlings along the Hudson River.

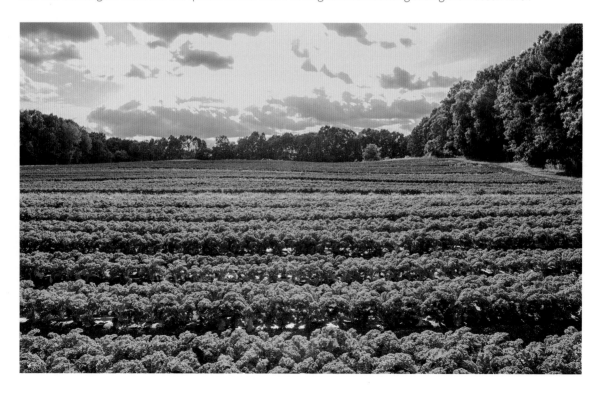

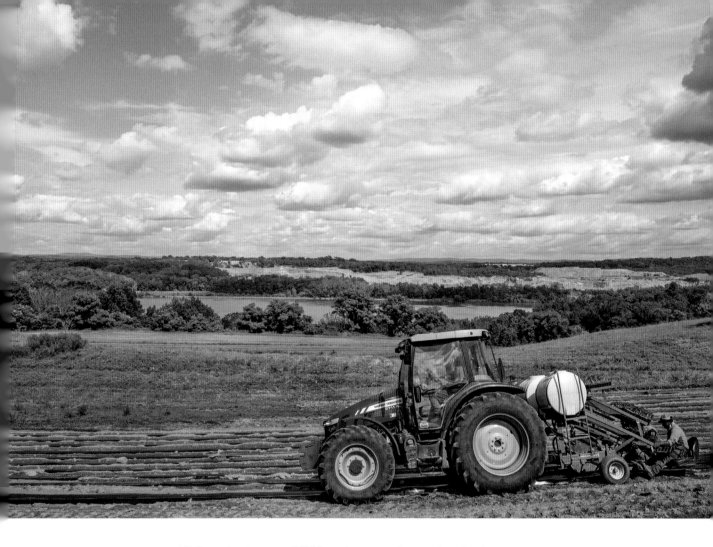

*We have had our prohibition glasses on for one hundred years.
Cannabis has always been around, but it was the special interests that
finally got it off the table legally. This is now an eight-billion-dollar
industry spread between New York and Massachusetts.*

—AMY HEPWORTH

banks, and most importantly, taking into consideration leaving the earth and soil more productive than when we inherited it." Observing Amy and her employees, I noticed a respect and kindness that is genuine. There are 150 people working here, and the quality of communication apparent across the board is palpable.

The Labyrinth Xtracts company leases out the million-dollar mobile facility for obtaining cannabis extract. Once the processing license is secured from New York State, technician Jeff Kofilschmidt begins the process of extracting "trim" (leaves and heads of the plant) from the cannabis. Using a cryo-ethanol extraction method, the cannabinoids are stripped out, leaving behind the fats and lipids of the plant. The main cannabinoids are delta-9-tetrahydrocannabinol (THC, the primary psychoactive compound in cannabis) and cannabidiol (CBD, an ingredient that is used for medical purposes and does not cause a high). This solution is then passed through a falling film evaporation system to collect a crude type of cannabis oil, which subsequently goes through three passes to purify the product into the final distillate. In New York, distillate sells for eight thousand to eighteen thousand dollars a liter. A dedicated staff is needed to oversee the compliance requirements. Referencing the iconic diamond evaluating metric of cut, clarity, color,

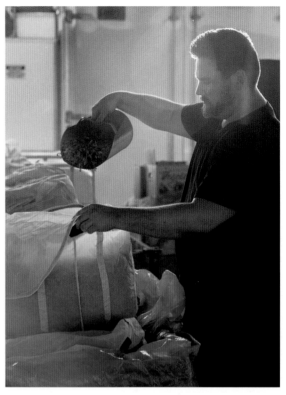

ABOVE: An ethanol extraction system filters cannabis distillate; Jeff Kofilschmidt preparing to make the distillate. LEFT: A finished bottle of THC concentrate can make up to 90,000 edibles.

and carat, the equation used for distillate is color, clarity, and concentration. The liter contains 900 milligrams of THC, which can produce 90,000 edibles. CBD is used in beauty products and oils that address arthritis and muscle pain.

I also learned from Jeff the precautions necessary for optimum cannabis plant health, such as how to avoid powdery mildew and bud rot by checking the plants every three days, and how and when to prune this labor-intensive plant. The cannabis produced here has distinct terroir qualities due to the specific soil and weather on these hills. Amy is adamant about growing her crop outside to take in the terroir in contrast to most farmers who grow cannabis in a controlled indoor environment.

The farm includes three hundred acres of vegetables—half farmed organically, and the second half

ABOVE: Bottles of distillate awaiting the production of edibles and topicals; the accelerant pre-roll machine can produce 1,200 products an hour. RIGHT: The Hepworth logo represents the Native American Twelve Cycles of Truth.

farmed with a hybrid of ecological and conventional techniques. In the 1980s the farm initiated an experiment over the course of five years where it measured the environmental impact quotient (EIQ) to analyze how certain chemicals affect the environment. Amy said, "The sulphur and copper had profoundly bad effects on the fields. Following that, we became the region's largest organic apple distributor with over 900 acres in production."

Amy and Gail are also farming many of the surrounding fields that they lease. After being an intrinsic part of the agricultural community for centuries, when someone is looking to close shop or just down-size, Hepworth is the go-to place to explore a sale or collaboration. At the end of time our together, Amy said, "I have a deep sense of pride and satisfaction, and I've earned it."

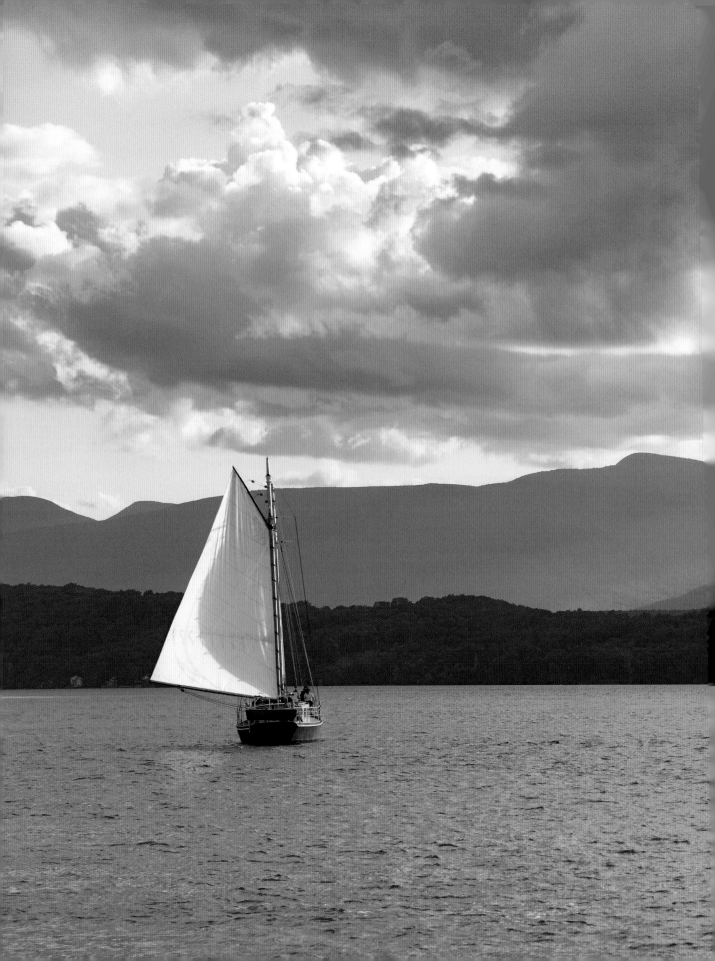

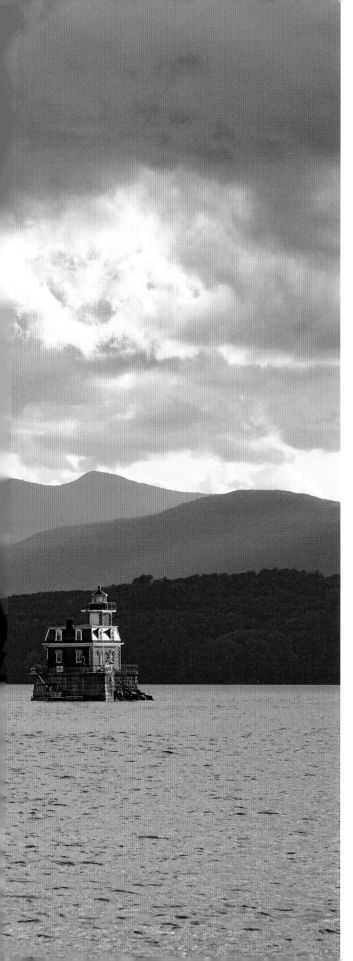

SCHOONER APOLLONIA

HUDSON

Watching the *Apollonia* sail into the distance can be a sublime experience. Knowing that it is transporting produce and cargo to Manhattan after stopping at towns and villages on both sides of the Hudson River is a mind-boggling notion in 2024.

Sam Merrett, the captain of Schooner Apollonia, was born in the area, but it wasn't until he returned from Oberlin College in Ohio that the ideas that led to this endeavor started to percolate. After immersing himself in environmental studies, Sam observed that all of the teachings were ". . . about the future. I was impatient and wanted solutions now." To that end he opened a fueling station in Ohio that sold alternate fuels like waste-product vegetable oils. The business was called Full Circle Fuels, and when he moved to Hudson in 2011, he opened a satellite shop there by the same name.

The City of Hudson's early history was predicated on the processing and shipping of whale oil, and the Hudson River had historically been the country's first superhighway. These two facts triggered Sam, along with several friends, to found the Hudson Sloop Club. The goal of the club is to nurture a strong relationship for the city's citizens with the waterfront. One day in 2013, he noticed a plywood boat entering the harbor. Later when he discovered that it had been built by the Vermont Sail Freight Project, he experienced a transformative moment. "I hadn't thought of this as a modern solution," he said, "and it aggregated all of my interests into one package."

Sam put together a team in 2015 after locating the *Apollonia* in a backyard outside of Boston where it had been laying derelict without its sailing rig and with only the steel hull remaining. It had been built in 1946 by a naval architect, and Sam eventually

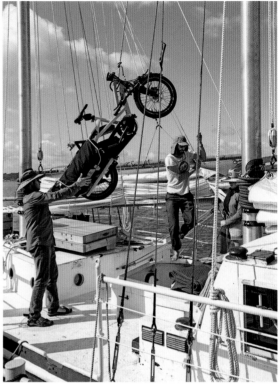

PREVIOUS PAGES: *Apollonia* passing the Hudson-Athens Lighthouse before arriving at the Hudson riverfront. ABOVE: The informative banner is posted at stops of call along the Hudson River; the yellow bike that is used for delivering merchandise to recipients along the river and in New York City is hoisted onto the boat. OPPOSITE CLOCKWISE FROM TOP LEFT: The boat's wheel is wrapped with rope to protect the sailors' hands; bottles of sunflower oil are part of the week's cargo manifest; the interior is an exercise in organization as the space is used for sleeping and storing merchandise.

sleuthed out the plans that were fortunately located in a vault in Mystic Seaport. By 2019, the schooner was fitted out as a seaworthy sailing vessel. The next step was to figure out the template of what a modern sailing freight and cargo ship might become. Sam developed three tenets that spoke to his goals: to initiate a method of transport that was low on emissions, to increase activity on the Hudson's many riverfront ports, and to train future crew members.

The waterfronts lining the Hudson had begun as bucolic stopping points for sloop transport by the Dutch in the seventeenth century. After 1807 and the introduction of Robert Fulton's steamship, traffic increased exponentially, with a trip from Manhattan to Albany taking thirty hours and costing five dollars. Industrialization began creeping in during the nineteenth century, creating unsustainable environmental conditions that begged to be remedied. Following the environmental cleanup fought for by groups such as Scenic Hudson, Riverkeeper, the Hudson River Foundation, and many others, the Hudson began its arduous process of becoming closer to its primordial condition. With much work left, this effort continues today. It is now safe to swim in many parts of the river.

In 2021 *Apollonia* had its first season, making five runs down the Hudson, delivering local products. The cargo manifest these days includes sunflower oil, malt, North River Rye, and Flotsam beer brewed by Newburgh Brewery. Sam also started putting together boat boxes that offer subscribers selections of Hudson Valley products, and he sets up boxes of

Creating a modern sailing freight and cargo ship like Schooner Apollonia—what a totally elegant way of transporting stuff with zero-carbon footprint while connecting people with the river.

—SAM MERRETT

curated selections of natural hard cider for Cider Club of Brooklyn's Greenpoint Cidery.

"The goal is to slowly expand into a fleet, either under my aegis, or with others launching their own boats. *Apollonia* is a magnificent historic vessel, but I am also exploring the possibility of purpose-built boats." Brad Vogel from the Center for Post Carbon Logistics has spent time on the schooner with Sam evaluating possible areas for expanding its network while focusing on a zero-carbon footprint.

OPPOSITE: Captain Sam Merrett setting sail early in the morning enroute to Manhattan to deliver cargo.
ABOVE: The schooner brings groups on sailing excursions as part of the Waterfront Wednesdays program established in collaboration with the Hudson Sloop Club.

Sam said, "The people that notice the boat tend to be the people I want on board. We create a bit of an entrance when we arrive, so people consistently walk up to the boat and begin asking questions. There has been so much recent negative dialogue on transportation and the effects on climate. I want to reinforce that transportation can be a positive thing. This is a win-win situation for me because it makes people think about how they receive their goods and the environmental impact. It also introduces them potentially to restaurants, markets, and vendors they might not ordinarily be acquainted with that are a part of this system." Sam is achieving all of this while dodging ferry traffic in New York Harbor and setting the twenty-first century record for the most tacks by a sailing cargo vessel in the city's East River.

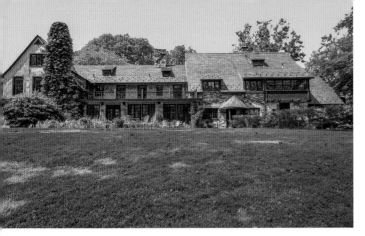

AGRITOURISM

Agritourism can be thought of as the crossroads between agriculture and tourism. This listing provides a selection of what you need while exploring the region. Check the farmers market websites carefully as seasonal schedules change. For those looking to further research the subject, I've included some noteworthy organizations that support farming.

RESTAURANTS AND BREWERIES

COLUMBIA COUNTY

Bartlett House
2258 NY Route 66
Ghent, NY
518.392.7787
bartletthouse.com

Cooper's Daughter Spirits
284 NY Route 23
Claverack, NY
518.721.8209
coopersdaughter.com

Gaskins
2 Church Avenue
Germantown, NY
518.537.2107
gaskinsny.com

Otto's Market
215 Main Street
Germantown, NY
518.537.7200
ottosmarket.com

Swoon Kitchenbar
340 Warren Street
Hudson, NY
518.822.8938
swoonkitchenbar.com

The Aviary Kinderhook
8 Hudson Street
Kinderhook, NY
518.610.8543
theaviarykinderhook.com

The Maker Restaurant
302 Warren Street
Hudson, NY
518.509.2620
themaker.com

Universal Café and Bar
Central House
220 Main Street
Germantown, NY
518.537.7722
centralhouseny.com

West Taghkanic Diner
1016 NY Route 82
Ancram, NY
518.851.3333
wtdinerny.com

DUTCHESS COUNTY

Barbaro
3279 Franklin Avenue
Millbrook, NY
845.677.4440
barbaromillbrook.com

Canoe Hill
3264 Franklin Avenue
Millbrook, NY
845.605.1570
canoehillny.com

Champêtre
2938 Church Street
Pine Plains, NY
518.771.3350
@champetre.ny

Chelley's
237 Pitcher Lane
Red Hook, NY
greigfarm.com/chelleys

**Culinary Institute of America
American Bounty Restaurant**
1946 Campus Drive
Hyde Park, NY
845.451.1011
americanbountyrestaurant.com

Del's Roadside
6780 Albany Post Road
Rhinebeck, NY
delsdairyfarm.com

Dia Beacon Cafe
3 Beekman Street
Beacon, NY
845.440.0100
diaart.org

Fortunes Ice Cream
55 Broadway
Tivoli, NY
845.757.2899
fortunesicecream.com

Foster's Coach House Tavern
6411 Montgomery Street
Rhinebeck, NY
845.876.8052
fosterscoachhouse.com

From The Ground Brewery
301 Guski Road
Red Hook, NY
845.309.8100
fromthegroundbrewery.com

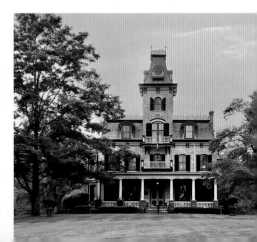

Gigi Hudson Valley
6422 Montgomery Street
Rhinebeck, NY
845.876.1007
gigihudsonvalley.com

Lasting Joy Brewery
485 Lasher Road
Tivoli, NY
845.757.2337
lastingjoybrewery.com

Market Street
19 West Market Street
Rhinebeck, NY
845.876.7200
marketstrhinebeck.com

Obercreek Brewing Company
59 Marlorville Road
Wappingers Falls, NY
845.632.1078
obercreekbrewing.com

{pretty to think so}
6417 Montgomery Street
Rhinebeck, NY
845.516.4556
prettytothink.so

Stissing House
7801 South Main Street
Pine Plains, New York
518.771.3064
stissinghouse.com

Tenmile Distillery
78 Sinpatch Road
Wassaic, NY
845.877.6399
tenmiledistillery.com

The Amsterdam
6380 Mill Street
Rhinebeck, NY
845.516.5033
lovetheamsterdam.com

The Corner
53 Broadway
Tivoli, NY
845.757.2100
hoteltivoli.org

Troutbeck
515 Leedsville Road
Amenia, NY
845.789.1555
troutbeck.com

Westerley Canteen
(at Tenmile Distillery)
78 Sinpatch Road
Wassaic, NY
westerlycanteen.com

GREENE COUNTY

Stewart House & 1883 Tavern
2 North Water Street
Athens, NY
518.444.8317
stewarthouse.com

ORANGE COUNTY

Lodger
188 Liberty Street
Newburgh, NY
sacralenclaves.com

PUTNAM COUNTY

Café Silvia
Magazzino Italian Art
2700 Route 9
Cold Spring, NY
845.666.7202
magazzino.art

Dolly's Restaurant
7 Garrison's Landing
Garrison, NY
845.424.6511
dollysrestaurant.com

ULSTER COUNTY

Hudson House Distillery
1835 NY Route 9W
West Park, NY
845.834.6007
thehudsonhouseny.com

Hutton Brickyards Restaurants
200 North Street
Kingston, NY
845.514.4853
huttonbrickyards.com

Phoenicia Diner
5681 Route NY 28
Phoenicia, NY
845.688.9957
phoeniciadiner.com

TOP ROW FROM LEFT: The stone house at Troutbeck in Amenia was built in 1919; a view of two of the rooms at Troutbeck decorated by Champalimaud Design; a Scottish Highland steer at June Farms in West Sand Lake, near Albany; the Hobbit House tucked into a hill at June Farms. BOTTOM ROW FROM LEFT: The fire pit at Inness, a country retreat in Accord, overlooking the surrounding hills; Central House in Germantown is an inn and the home to the Universal Café and Bar; Edgewood, the 1873 home of brick merchant John Cordts, now part of the Hutton Brickyards in Kingston; the retreat's outdoor sauna overlooking the Hudson River and modern cabins; the arched entrance to Hutton Brickyards.

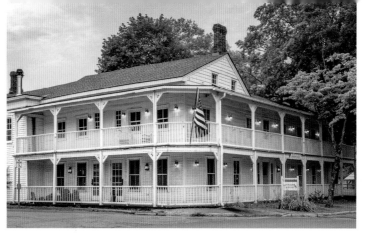

Restaurant Kinsley
301 Wall Street
Kingston, NY
845.768.3621
hotelkinsley.com

Wildflower Farms
2702 Main Street
Gardiner, NY
845.419.4728
aubergeresorts.com

WESTCHESTER COUNTY

Blue Hill at Stone Barns
630 Bedford Road
Tarrytown, NY
914.366.9600
bluehillfarm.com

LODGING

COLUMBIA COUNTY

Central House
220 Main Street
Germantown, NY
518.537.7722
centralhousehotelinn.com

Gatherwild Ranch
331 Roundtop Road
Germantown, NY
518.303.2864
gatherwild.com

The Maker Hotel
302 Warren Street
Hudson, NY
518.509.2620
themaker.com

The Wick
14 Cross Street
Hudson, NY
518.249.6825
thewickhotel.com

DUTCHESS COUNTY

Beekman Arms & Delamater Inn
6387 Mill Street
Rhinebeck, NY
845.876.7077
beekmandelamaterinn.com

Hotel Tivoli
53 Broadway
Tivoli, NY
845.757.2100
hoteltivoli.org

Old Drovers Inn
196 East Duncan Hill Road
Dover Plains, NY
845.832.9311
olddroversinn.com

The Baker House Bed & Breakfast
65 West Market Street
Rhinebeck, NY
917.680.1855
thebakerhouserhinebeck.com

The Dutchess
2434 NY Route 9G
Clinton, NY
thedutchess.com

Troutbeck
515 Leedsville Road
Amenia, NY 12522
845.789.1555
troutbeck.com

Wing's Castle
717 Bangall Road
Millbrook, NY
845.677.9085
wingscastle.com

GREENE COUNTY

Deer Mountain Inn
790 County Route 25
Tannersville, NY
518.589.6268
deermountaininn.com

The Woodhouse Lodge
3807 County Route 26
Greenville, NY 12083
518.819.1993
thewoodhouselodge.com

PUTNAM COUNTY

The Bird and Bottle Inn
1123 Old Albany Post Road
Garrison, NY
845.424.2333
thebirdandbottleinn.com

RENSSELAER COUNTY

June Farms
275 Parker Road
West Sand Lake, NY
518.444.3276
junefarms.com

ULSTER COUNTY

Foxfire Mountain House
72 Andrew Lane
Mt. Tremper, NY
845.688.2500
foxfiremountainhouse.com

Hasbrouck House
3805 Main Street
Stone Ridge, NY
845.687.0736
hasbrouckhouseny.com

Hutton Brickyards
200 North Street
Kingston, NY
845.514.4853
huttonbrickyards.com

Inness
10 Banks Street
Accord, NY
845.377.0030
inness.co

Mohonk Mountain House
1000 Mountain Rest Road
New Paltz, NY
855.883.3798
mohonk.com

Starlite Motel
5938 US Route 209
Kerhonkson, NY
845.626.7350
thestarlitemotel.com

Wildflower Farms
2702 Main Street
Gardiner, NY
855.472.3188
aubergeresorts.com

WESTCHESTER COUNTY

Castle Hotel & Spa
400 Benedict Avenue
Tarrytown, NY
castlehotelandspa.com
914.631.1980

FARMERS MARKETS

COLUMBIA COUNTY

Chatham Farmers & Makers Market
248 NY Route 295
Chatham, NY
visitchathamny.com

Copake Hillsdale Farmers Market
Roeliff Jansen Park
9140 NY Route 22
Hillsdale, NY
518.929.3255
copakehillsdalefarmersmarket.com

Germantown Farmers Market
50 Palatine Park Road
Germantown, NY
germantownfarmersmarket.com

Hudson Farmers Market
Columbia and Sixth Streets
Hudson, NY
518.300.3496
hudsonfarmersmarketny.com

Hudson Farmers Winter Market
201 Harry Howard Avenue
Hudson, NY
518.300.3496
hudsonfarmersmarketny.com

Kinderhook Farmers Market
US Route 9 at Albany Avenue
Kinderhook, NY
518.755.9293
kinderhookfarmersmarket.com

DUTCHESS COUNTY

Beacon Farmers Market
223 Main Street
Beacon, NY
845.231.4424
beaconfarmersmarket.org

Fishkill Farmers Market
1004 Main Street
Fishkill, NY
845.897.4430
vofishkill.us

Hyde Park Farmers Market
4390 NY Route 9
Hyde Park, NY
845.229.9336

Millbrook Farmers Market
3263 Franklin Avenue
Millbrook, NY
millbrooknyfarmersmarket.com

Millerton Farmers Market
Dutchess Avenue
Millerton, NY
518.789.4259
neccmillerton.org

Pawling Farmers Market
10 Charles Colman Boulevard
Pawling, NY
917.941.8762
pawlingfarmersmarket.org

Rhinebeck Farmers Market
61 East Market Street
Rhinebeck, NY
845.876.7756
rhinebeckfarmersmarket.com

TOP ROW FROM LEFT: Del's Dairy Creme, on Route 9 in Rhinebeck, makes their own ice cream and has been open since the early 1960s; Stissing House in Pine Plains, built in 1782 as a tavern and hotel, now has Clare de Boer as the proprietor and chef; Foster's Coach House and Tavern has been serving Rhinebeck since 1890; outdoor dining at Troutbeck; one of the fresh meals served at Troutbeck, where Vinny Gilberti is executive chef; Chelley's, based at the Greig Farm in Red Hook, is known for their brisket tacos and Hawaiian shaved ice. BOTTOM ROW FROM LEFT: Molly Levine and Alex Kaindl of Westerly Canteen serve meals in a 1971 Airstream using local produce on the grounds of Tenmile Distillery in Wassaic; the Hotel Tivoli is the home of The Corner, which offers meals with Mediterranean and Moroccan influences prepared by chef Christopher Colby Miller; chef de cuisine Stephanie Skiadas serves eclectic dinners at Gaskins in Germantown; Tivoli General stocks sandwiches and basics.

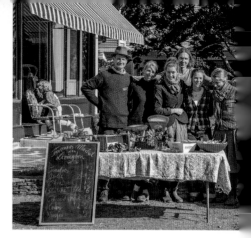

GREENE COUNTY

Catskill Farmers Market
145 Water Street
Catskill, NY
catskillfarmersmarket.org

ORANGE COUNTY

Cornwall Farmers Market
Town Hall
183 Main Street
Cornwall, NY
845.534.2070
cornwallrecreation.com

Goshen Farmers Market
255 Main Street
Goshen, NY
845.294.7741
goshennychamber.com

Newburgh Farmers Market
97 Broadway
Newburgh, NY
845.231.4424
newburghnyfarmersmarket.com

PUTNAM COUNTY

Cold Spring Farmers Market
Boscobel House and Gardens
1601 NY Route 9D
Cold Spring, NY
csfarmmarket.org

ULSTER COUNTY

Kingston Farmers Market
285 Wall Street
Kingston, NY
kingstonfarmersmarket.org

Kingston Winter Farmers Market
Old Dutch Church
272 Wall Street
Kingston, NY
kingstonfarmersmarket.org

Saugerties Farmers Market
115 Main Street
Saugerties, NY
845.419.1555
saugertiesfarmersmarket.com

Woodstock Farm Festival
Mountainview Parking Lot
Woodstock, NY
woodstockfarmfestival.com

WESTCHESTER COUNTY

Peekskill Farmers Market
Bank Street
Peekskill, NY
discoverpeekskill.com

White Plains Farmers Market
59 Court Street at Main Street
White Plains, NY
914.422.1411
whiteplainsfarmersmarket.com

FARMING RESOURCES

Agrarian Trust
agrariantrust.org

Agricultural and Farmland Protection Plan
dutchessswcd.org

Agricultural Environmental Management
agriculture.ny.gov/soil-and-water/
agricultural-environmental-
management

Agricultural Stewardship Association
agstewardship.org

American Farmland Trust
farmland.org

Berkshire Taconic Community Foundation
berkshiretaconic.org

Black Farmers' Network
blackfarmersnetwork.com

Black Farmers United NYS
blackfarmersunited.org

Columbia Land Conservancy
clctrust.org

Community Foundations of the Hudson Valley
communityfoundationshv.org

Cornell Cooperative Extension
cals.cornell.edu/cornell-
cooperative-extension

Dutchess County Conservancy
dutchessland.org

Eatwild
eatwild.com

Farmland for a New Generation New York
nyfarmlandfinder.org

Farmland Information Center
farmlandinfo.org

Farmland Protection NYS Department of Agriculture and Markets
agriculture.ny.gov/land-and-
water/farmland-protection

FarmOn! Foundation
farmon.org

Foodtank
foodtank.com

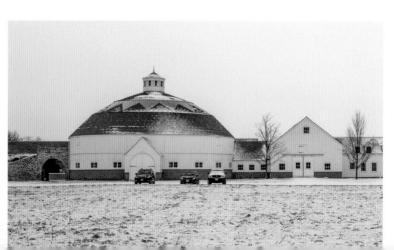

4-H
4-h.org

Glynwood Center for Regional Food and Farming
glynwood.org

Good Food Org Guide
goodfoodorgguide.com

GrowNYC
grownyc.org

Home Grown
homegrown.org

Hudson River Valley Greenway
hudsongreenway.ny.gov

Hudson Valley AgriBusiness Development Corporation
hvadc.org

Hudson Valley CSA Coalition
hudsonvalleycsa.org

Hudson Valley Farm Hub
hvfarmhub.org

Hudson Valley Seed Company
hudsonvalleyseed.com

International Federation of Organic Agriculture Movements
ifoam.bio

Iroquois Valley Farmland REIT
(Real Estate Investment Trust)
iroquoisvalley.com

Jewish Farmer Network
jewishfarmernetwork.org

Just Food NYC
justfood.org

Land Trust Alliance
landtrustalliance.org

Lenape Center
lenape.center

Local Harvest
localharvest.org

National Black Farmers Association
blackfarmers.org

National Young Farmers Coalition
youngfarmers.org

New York Cider Association
newyorkciderassociation.com

New York FarmNet
nyfarmnet.org

Northeast Farmers of Color Land Trust
nefoclandtrust.org

Northeast Organic Farming Association of New York
nofany.org

NoVo Foundation
novofoundation.org

Scenic Hudson
scenichudson.org

The Center for Post Carbon Logistics
postcarbonlogistics.org

The Cornucopia Institute
cornucopia.org

The Female Farmer Project
femalefarmerproject.org

The Gay Farmers
@thegayfarmers

The Valley Table
valleytable.com

United Farmworkers
ufw.org

Upstate Farms
upstatefarmsny.com

WILDSEED Community Farm & Healing Village
wildseedcommunity.org

Winnakee Land Trust
winnakee.org

TOP ROW FROM LEFT: Some of Nancy Wu Houk's honey made for NYBUZZ; Tenmile Distillery brews single malt whiskey in an old dairy barn in Wassaic; Chad Wisser and the Leifer family at the Livingston Living Saturday farmers market; sheep grazing at Glynwood; a storm approaching from the Catskill Mountains in Livingston; sheep and horses in a pasture surrounded by beautiful fall foliage in Millerton. BOTTOM ROW FROM LEFT: From The Ground Brewery on the Migliorelli Farm in Red Hook; the centerpiece of Churchtown Dairy in Hudson is the round barn designed by architect Rick Anderson for Abby Rockefeller; the cheesemaking room at Churchtown Dairy is visible off the hallway in the main building; a gate in Millbrook made of split rail fencing; an unusual red-colored barn roof in a field of harvested corn in Columbia County.

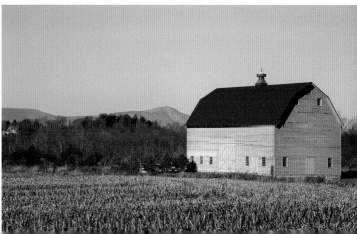

BACK TO THE LAND CONTACTS

All For One One For All
Goshen, NY
alloneoneall.com

Ardith Mae Farmstead
Stuyvesant, NY
ardithmae.com

Chaseholm Farm
Pine Plains, NY
chaseholmfarm.com

Claudine Farm Resort
Copake, NY
claudinefieldapothecary.com

Damian Abrams, Forager
Hillsdale, NY

Davoren Farm
Cold Spring, NY
davorenfarm.com

Ever-Growing Family Farm
Kerhonkson, NY
ever-growing-family-farm.square.site

Fishkill Farms
Hopewell Junction, NY
fishkillfarms.com

**Four Corners
Community Farm**
Red Hook, NY
fourcornersfarm.org

Full Circus Farm
Pine Plains, NY
fullcircusfarm.wordpress.com

**Glynwood Center for Regional
Food and Farming**
Cold Spring, NY
glynwood.org

Gulden Farm
Germantown, NY
guldenfarm.com

Heermance Farm
Tivoli, NY
heermancefarm.com

Hepworth Farms
Milton, NY
hepworthfarms.com

Hudson Valley Hops & Grains
Ancramdale, NY
hudsonvalleyhopsandgrains.com

Jennifer Solow, *Edible Hudson Valley*
East Chatham, NY
@jennifersolow

Lasting Joy Brewery
Tivoli, NY
lastingjoybrewery.com

Leifer Homestead
Livingston, NY
@livingston_living

Migliorelli Farm
Red Hook, NY
@migliorellifarm

Montgomery Place Orchards
Annandale-on-Hudson, NY
montgomery-place-orchards.com

NYBUZZ
Tivoli, NY

Philip Orchards
Claverack, NY
philiporchardsny.com

Obercreek Farm
Wappinger, NY
obercreekfarm.com

Rise & Run Permaculture
Stuyvesant Falls, NY
riseandrunpermaculture.com

Rose Hill Farm
Red Hook, NY
pickrosehillfarm.com

Schooner Apollonia
Hudson, NY
schoonerapollonia.com

Shoving Leopard Farm
Barrytown, NY
shovingleopardfarm.org

Sky High Farm
Ancramdale, NY
skyhighfarm.org

Sparrowbush Bakery
Hudson, NY
sparrowbushbakery.com

**Stone Barns Center
for Food & Agriculture**
Pocantico Hills, NY
stonebarnscenter.org

Stonegate Farm
Balmville, NY
stonegatefarmny.org
cultivateapothecary.com

Stonewood Farm
Millbrook, NY
stonewoodny.org

Sugar Shack
Rhinebeck, NY

Tivoli Mushrooms
Hillsdale, NY
tivolimushrooms.com

Turkana Farms
Germantown, NY
turkanafarms.com

ABOUT THE AUTHOR: Pieter Estersohn is a renowned photographer of architecture and interiors, whose work is seen in top shelter publications. He is a contributor to the *World of Interiors* and *Elle Decor*. Author of *Life Along the Hudson,* he is on the boards of Historic Red Hook and the Calvert Vaux Preservation Alliance. Estersohn is also the photographer for numerous Rizzoli lifestyle books.

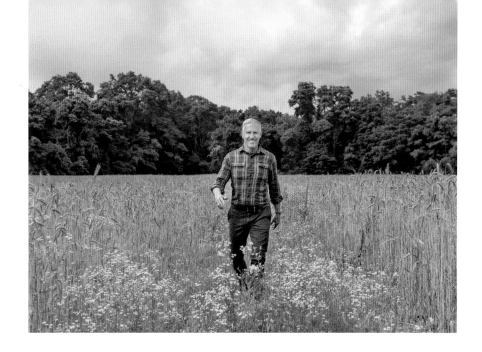

ACKNOWLEDGMENTS

With close to 1,500 emails involved in scheduling all of the farm visits to scout sites, and for shoots and interviews, as well as the back and forth involved in the design and editing process, it's no wonder that there have been quite a few people involved with this book. Here, I'd like to sing their praises, as this was truly an extremely dedicated and talented team.

Sandy Gilbert, my editor at Rizzoli, simply does not stop. When we get on the phone, there's seldom a salutation, as we know each other so well after working on book projects over the years; we just shortcut the intro and jump right in. Her ability to opine and give feedback on both text and imagery is rare; her art history background is flawless; and her profound commitment to this book was evident during each meeting.

Publisher Charles Miers saw early on the importance of printing this book despite the fact that there was little precedent to validate its production. I am grateful for his willingness to take a risk on this subject, which is tangential to many previously lining the shelves at Rizzoli.

David Byars is not just a book designer, although he is masterful in the beautiful work that he does. The depths of his knowledge on subjects that we have collaborated on over the years is impressive, and when he doubts my claim that an image illustrates a particular insect, flower, or fruit, he follows up with research that proves to be correct.

Meg Downey's job is to help smooth the text along, but her expertise as a resident of the region and on the subject covered here was invaluable. I gave her the book, *I Judge You When You Use Poor Grammar*, on the last day of edits, and we had a laugh.

Frank Carbonari helped me optimize the images in this book with his post-production prowess.

Of course, the heroes of this book are the farmers profiled, but being part of this community in the Hudson River Valley has its perks—namely lots of wonderful friends who, when they heard that I was going to be addressing this subject in a book, came forth with wonderful farms and paths to consider. Huntley Gill, Joan Davidson, Margaret Davidson, Dana Cowin, Hadrien Coumans, Joan Burroughs, Suzy Welch, Claudine Klose, Véronique Firkusny, Jill Revson, Jennifer Carlquist, Bernadette Murray, Thea Burgess, and Randy Florke, were all amazing friends who listened, introduced me to new ideas and farmers, and inspired me to dig deeper.

Melody Brynner, my rep at Art Department, gave me passes on "real" work so that I could pursue my passion for farming and this book.

And Elio, my son, was extremely supportive and understanding when I couldn't spend all my time with him. Oh, wait. He's twenty, and it was all OK.

DESIGN BY DAVID BYARS

First published in the United States of America in 2024
by Rizzoli International Publications, Inc.
300 Park Avenue South
New York, New York 10010
rizzoliusa.com

2024 2025 2026 2027 / 10 9 8 7 6 5 4 3 2 1
Printed in Hong Kong
ISBN 13: 978-0-8478-9993-7
Library of Congress Control Number: 2023948301
Project Editor: Sandra Gilbert Freidus
Editor: Margaretta Downey
Editorial assistance: Hilary Ney
Production: Rebecca Ambrose
Visit us online:
Facebook.com/RizzoliNewYork
instagram.com/rizzolibooks
twitter.com/Rizzoli_Books
pinterest.com/rizzolibooks
youtube.com/user/RizzoliNY

QUOTE CREDITS: Page 3: From a letter sent by George Washington to Sir John Sinclair, 20 July 1794, *Founders Online*, National Archives; page 40: *The Horticulturist and Journal of Rural Art and Rural Taste,* Vol. II, No. 4, October 1847, (Andrew Jackson Downing); page 49: *Poughkeepsie Sunday New Yorker*, May 21, 1944, (Henry Morgenthau Jr.)

COVER: The apple orchard and barns at Migliorelli Farm in Red Hook at sunset. FRONT ENDPAPERS: Facades of barns and farm buildings in the Hudson Valley. A rustic barn door closure. BACK ENDPAPERS: Dairy optimism on a barn exterior. A continuation of barn and farm building facades. PAGE 1: Looking over the vegetable and grain fields at Heermance Farm to Round Top and the Catskill Mountains. PAGES 2–3: Apple trees in blossom at Migliorelli Farm with views to the east. PAGE 4: An arbor of roses leading toward the greenhouse at Stonegate Farm. PAGE 6: Coastal Star romaine lettuce grown at Stonewood Farm. PREVIOUS PAGES: A rural sign for drivers to be aware of farmers on the road. Author Pieter Estersohn walking in a wheat field at Staats Hall. ABOVE: A sign posted at Rose Hill Farm.

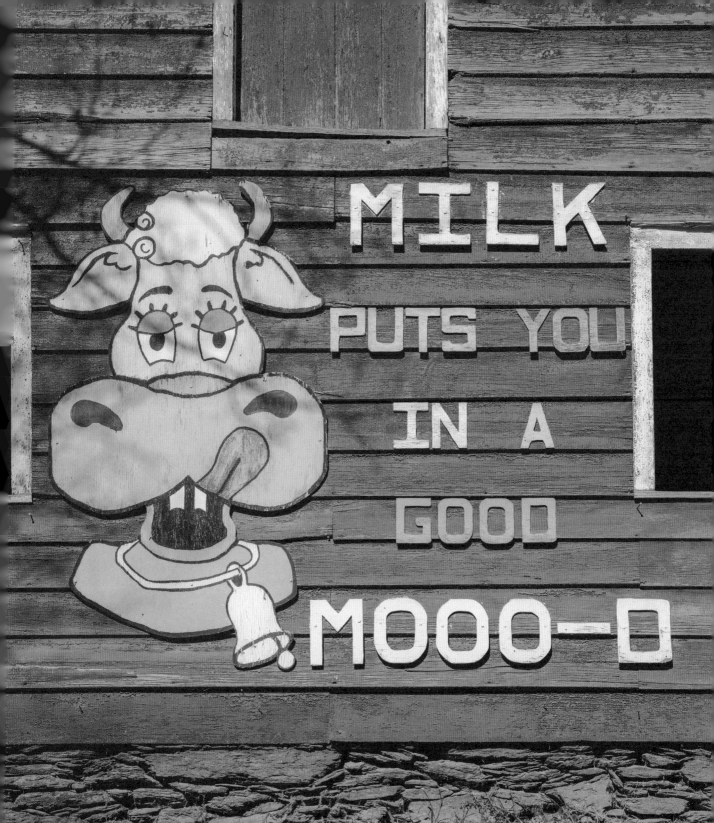